GIMP 2 for Photographers

Klaus Goelker

GIMP 2 for Photographers

Image Editing with Open Source Software

rockynook

Klaus Goelker Klaus.goelker@goelker-online.de

Editor: Gerhard Rossbach
Copyeditor: Diana Hartmann
Layout and Type: Josef Hegele
Cover Design: Helmut Kraus, www.exclam.de
Printer: Friesens Corporation, Altona, Canada
Printed in Canada

ISBN-10 1-933952-03-2
ISBN-13 978-1-933952-03-9

1st Edition
© 2007 by Rocky Nook Inc.
26 West Mission Street Ste 3
Santa Barbara, CA 93101-2432

www.rockynook.com

First published under the title "Fotobearbeitung und Bildgestaltung mit GIMP 2"
© dpunkt.verlag GmbH, Heidelberg, Germany

Library of Congress catalog application submitted

Distributed by O'Reilly Media
1005 Gravenstein Highway North
Sebastapool, CA 95472-2432

Contents

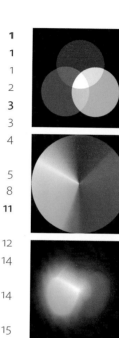

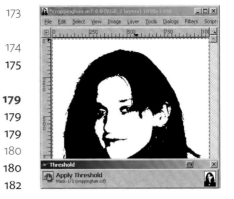

1 Basics

1.1 Introduction

1.1.1 Using GIMP 2—About this Tutorial

If you are reading this book, you are probably interested in learning how to touch up your digital photographs or create your own graphics or logos. However, before investing hundreds of dollars on expensive software, you may want to make sure that manipulating digital photographs is something you truly enjoy. That's where "The GIMP 2"—a free digital image editing program—comes in. Would you like to learn how to use this free software to improve your photographs?

This book is designed to facilitate your entry into the world of digital image editing with the help of the GIMP. Using hands-on examples, this book will provide solutions to common problems encountered when editing digital images. The instructions are structured in a step-by-step fashion. Each editing tool and function of GIMP 2 will be explained in simple language. You will learn the fundamentals of digital editing, familiarize yourself with common image editing tools and their functions, and acquire a working knowledge of the GIMP 2 program.

This book is not a reference guide for GIMP 2. It was created to provide you with a set of "learning-by-doing" instructions that will explain how the GIMP works, what the program's most important functions are, and how to easily locate and use these tools.

Since the GIMP was born of the Linux world, it is free of cost to use. On the attached CD, you will find the GIMP 2, along with several "plug-ins" utitlities. You'll also find copies of the sample images used in the exercises contained in this book.

Digital image editing programs often seem more complex than the more common software programs, such as word-processors. Sometimes you must perform a number of preparatory steps before you can see a result on the computer screen. However, if you're experienced with computers, certain commands should be familiar to you.

Whether you're a Windows, Linux, or a Mac OS user, the GIMP works essentially the same way, with the exception of the installation process. The GIMP is often packaged with Linux distributions. If you use Windows or

Mac OS, you will have to install the program. This tutorial will show you how.

Once you have explored the GIMP 2 and learned how to use it, you may not need—nor want—to buy another image editing program. If you do decide to migrate to another program, you will have to familiarize yourself with a new interface. However, you'll quickly discover that the basic commands, functions, and tools of alternative digital imaging applications are similar to GIMP 2 in more ways than not.

The GIMP 2 also contains a built-in help system. In addition, there are many existing books about the software, including several free online texts. Please refer to the Appendix of this book for a list of references regarding the GIMP.

1.1.2 Brief—About GIMP 2

The **GIMP** is an acronym for **GNU Image Manipulation Program**. GIMP was bred from the Linux world and is an open-source software program covered by the **GPL** (General Public License). **GNU** means "GNU's Not Unix" and refers to a collection of software based on the UNIX operating system and maintained by the Free Software Foundation.

The GIMP is "the Photoshop of the Linux world"—*the* best free image editing program. GIMP 2 was introduced in 2004. This enhanced version of GIMP meets the functionality requirements of even the most exacting digital photographer. Its interface is highly efficient and easy to use once you know your way around.

In fact, the book you are reading right now originally was created using GIMP Version 2.2.3 (released in January 2005). In July 2006, Version 2.2.12 was released, and that is the program version used for this edition. So for all general purposes this book is current.

Image Editing

The GIMP's primary function is to create and edit pixel or bitmap images, but it also can be used for other tasks. The program will help you touch-up your digital photographs, create digital art, or author a new logo for your company's Web page. And that's just the tip of the iceberg.

Vector graphic programs are often used to create original or complex images and/or animations. The GIMP supports vector graphics. You can draw an image using the GFIG plug-in and the Path tool. However, you should be aware that the GIMP was not designed to be a designated environment for the creation and editing of complex vector images.

Video Editing

With the GAP animation package, the GIMP offers a range of useful tools for creating small animations on a frame-by-frame basis. For example, you can use the GIMP's GAP package to read or write AVI and GIF formatted videos and animations. You can also use GAP to open and read videos in MPEG format.

1.2 Introduction to Digital Image Editing

1.2.1 Characteristics of Pixel Images

The GIMP is used primarily for editing **pixel** or **bitmap** images. Pixel images are made up of tiny dots called pixels; these images are somewhat like mosaics in structure. Because almost all photographic or photorealistic images captured by a digital camera or by a scanner are pixel images, the pixel image is considered standard.

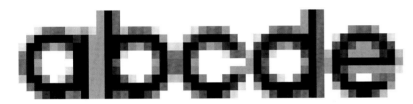

Figure 1.1: The image dots (pixels) become visible when a pixel image is overly enlarged. This "sawtooth outline" is known as the "step effect" or "aliasing", when to be seen in normal enlargement.

Size and resolution are the most important characteristics to take into account when manipulating pixel images. Since pixel images are composed of tiny dots, it can sometimes be tricky to enlarge them. If you enlarge an image too much, the individual dots will become visible and the photograph will lose its integrity.

The size and resolution of an image also determines the file size (i.e., storage volume measured by kilobyte or megabyte) of any given image. Uncompressed pixel images normally result in very large file sizes.

The manner in which you can edit an image is influenced by the structure of its pixels. Basically, each image dot can be edited in terms of brightness and color. The GIMP 2 supplies appropriate and easy-to-use tools for editing single dots, as well as groups of dots.

When you make a general change to a pixel image, usually, the whole image will be affected. Therefore, if you wish to only manipulate a specific area of an image, you should use a "selection tool" to designate that area. You may even want to cut a desired selection from the image so you can work with layers (transparent "foils" containing distinct image objects that can be manipulated separately and are layered one on top of the other).

Selections, masks, and layers are advanced techniques for detail work that are provided by image editing programs like the GIMP. These topics will be dealt with extensively in the hands-on exercises that follow.

In contrast to pixel images, vector graphics are used when creating original graphics and logos. Rather than editing image pixels, novel image elements using vectors can be created. Vector images are made up of lines, curves, circles, rectangles, and fills. The size of each of these elements can be scaled; the contour can be filled with color or gradients. For graphics, this is less data-intensive. Vector or contour shapes can also be selected and edited individually. At any time, you can tweak the shape or change the color of a fill.

You should know that: vector graphics are almost boundlessly scalable.

However: The editing of vector images is not entirely supported by the software used to edit pixel images.

Bottom line: Photos and other pixel images can only be converted to vector graphics in an extremely simplified form, and sometimes not at all.

Figure 1.2: Comparing pixel and vector images.

Pixel Vektor

1.2.2 Resolution

Pixel images are always rectangular or square shapes comprised of image dots or pixels. The density of the dots contained in any given pixel image is called its "resolution". Resolution is normally measured in **dpi** (dots per inch). In the metric system, the resolution is the number of dots per 2.54 centimeters. You can also refer to an image's resolution in pixels per centimeter (the standard measurement in most European four-color printing companies). Although dpi seems to calculate only the length or width of an image, changing the resolution of an image will influence its height as well. For example, doubling the resolution of an image will result in a fourfold increase of the number of pixels.

An image's size (the dimension in inches, millimeters, or pixels) is directly dependent on its resolution. If you transform an image with a resolution of 300 dpi to a resolution of 72 dpi using the GIMP, the image size (width · height) increases more than threefold, even though the number of image dots remains the same.

300 dpi will produce an image of quality resolution. 300 dpi is recommended when scanning an image, especially if you intend to edit and print the image at a 1:1 scale.

If you want to enlarge an image, you'll want to scan it at a higher resolution. As a rule of the thumb, if you plan to double the image size (width or height), scan at twice the resolution desired for the final image. If you simply want to reduce an image's dimensions, the image quality will usually stay the same or get better so you need not worry about losing resolution.

Four-color printing uses various standard resolutions (e.g., 150, 300, 600, or 1200 dpi). These are typical values.

Images on the **Internet** often use lower resolutions, such as 72 or 96 dpi, which are values that correspond to the standard resolution of PC monitors. A low resolution keeps the file sizes of images small enough to be efficiently and quickly transmitted over the Internet. Low resolution images will still yield printouts of acceptable quality on inkjet printers.

Bottom line: A higher resolution, comprised of a higher quantity of finer dots, will result in an excellent image that can be enlarged to a certain extent without compromising quality. On the other hand, if you reduce the resolution of an image without reducing its dimensions, the image quality will decrease. It is important to make a copy of the original image when experimenting with size and resolution as the process cannot be reversed.

1.2.3 Colors on the Screen—Color Models, Color Depth, Numerical Color Values

The GIMP Version 2.2.X understands three color models: RGB colors (red, green, blue), grayscale, and indexed colors.

The GIMP uses the **RGB colors,** or **colors of light,** as its default. Together, these colors form what is known as the **additive color model.** It uses the three primary colors—red, green, and blue—to create a color spectrum containing approximately 16.78 million colors. This is called "true color" as it represents the maximum number of colors that a computer monitor or television screen can display.

Mixing two primary colors in RGB mode will result in the creation of a secondary color, such as yellow, cyan, and magenta. No color (or the absence of light) creates black, while the sum of all colors results in white.

The term **color depth**, given in bits, is sometimes used to specify the number of colors of an image or color model. The **RGB color model** has a color depth of **24 bits** (24 bits = 2^{24} colors = 16.78 million colors).

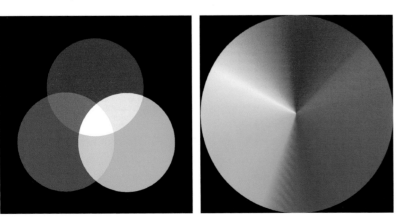

Figure 1.3: The RGB color model.

Figure 1.4: The linear color spectrum of the RGB color model

Figure 1.5: Approximated representation of the Figure 1.6: 256 gray levels in the
set of colors in the RGB color model.. About RGB color model.
16.78million colors are shown, with black at
one extreme and white at the other.

If you wish to specify a color for a printer or want to choose a unique background color for your webpage, the following information should be considered.

Specific colors correlate to unique numerical values. In the RGB color model, each of the primary colors (red, green, and blue) has a decimal color value ranging from 0 to 255, with black as 0 and white as 255. Hence, there are 256 color values. The total number of potentially resulting colors is calculated by the following multiplication:

$$256 \cdot 256 \cdot 256 = 16{,}777{,}216 \text{ colors}$$

These values apply to color as well as black-and-white images. In the world of digital image editing, black-and-white photographs are called gray-level images. In addition to the black and white "colors", gray-level images contain all possible shades of gray.

Since the color values of the three primary colors must be identical in order to produce purely gray levels, the number of gray "color" values amounts to 256.

Gray-level images have a **color depth** of 8 bits.

In the RGB color model, colors are normally defined by **decimal numbers**. As mentioned earlier, each single color can have a value between 0 and 255. You can use the Eyedropper tool located in the Toolbox of the GIMP to measure a color. The Color Picker will show you the number corresponding to a color's exact value so you can easily transmit the information to your colleagues or work partners.

Color			
Black	0	0	0
Red	255	0	0
Green	0	255	0
Blue	0	0	255
Yellow	255	255	0
Cyan	0	255	255
Magenta	255	0	255
Medium gray	128	128	128
White	255	255	255

The primary and secondary (mixed) colors in decimal notation.

If you want to assign a color from an existing image as the background color for a webpage, you will need to specify **hexadecimal numbers** (base 16). To obtain hexadecimal numbers, the decimal numbers (see above) are converted into hexadecimal numbers, which are simply denoted by adding a "#" symbol in front of the number. You can use any tool for this conversion, including the Windows calculator (Start > Programs > Accessories > Calculator > View > Scientific).

The GIMP conveniently performs this conversion for you. Its Color Picker tool will provide you with the hexadecimal number value for every color.

Indexed Colors

Some image file formats used on the Internet use indexed colors rather than RGB. Indexed color images dispose of a defined color palette, wherein the number of colors is limited to 256. Indexed images are usually smaller than RGB images since they possess a color depth of 8 bits instead of 24 bits. When converting an image to "indexed color", a predefined color palette or a set of colors derived from the image itself will automatically be formulated. The palette can contain a maximum of 256 colors. File formats that automatically create images with their own color palettes include the compressed GIF format, as well as the 8 bit PNG format. Indexed images can also include gray-level images (with a maximum of 256 shades of gray).

However, you may find using an indexed palette cumbersome since it won't allow you to access all of the GIMP's editing options. Indexed images are normally edited in RGB mode. After editing, the indexed palette is automatically created and attached to the image when saving and exporting the file for use on the Internet.

The CMYK Color Model—Cyan, Magenta, Yellow, Key (Black)

Digital pre-print in **four-color printing** uses the **CMYK color model**. The CMYK model behaves quite differently than the RGB model. For one thing, CMYK has four color channels rather than three like RGB so the nominal number of colors increases in CMYK. Nevertheless, the color *range* of CMKY is smaller than RGB. Thus, when you convert an image from RGB to CMYK, it may appear paler or darker due to the loss of image information, or the insertion of additional black. To avoid fading or darkening, edit your image in the RGB mode before converting it to CMYK mode. Also, because changes often result when shifting modes, you should avoid converting an image from RGB to CMYK, and vice-versa, unless it is necessary.

Since the **CMYK color model** has four color channels, it possesses a total number of approximately 4.3 billion potential colors, which translates to a **color depth** of **32 bits**.

The colors of this model are subtractive primary colors. This means that the CMYK model behaves inversely to the RGB model. For example, if we apply the RGB model to CMYK, then 256 shares of cyan, 256 shares of magenta, and 256 shares of yellow *should* produce black. However, what you will actually see is a dirty dark brown. To obtain real gray and black shades, you have to add black. CMYK is actually an acronym for "Cyan, Magenta, Yellow, Key, where "Key = Black").

Currently, the GIMP does not have a feature for converting and editing images directly in CMYK mode. However, the GIMP can produce the chromatic components necessary for use in four color printing processes. If you want to edit in CMYK, you can use the Image > Mode > Decompose menu command to decompose your image into the four color channels. Each of these channels can then be saved, edited, and shared as separate images, which can be re-integrated prior to printing.

1.2.4 Important File Formats for Practical Work

When saving an image you should select a file format that corresponds to the requirements of the image as well as your stylistic intentions. This section will introduce you to the most commonly used file formats.

XCF: The GIMP's Native File Format

The **XCF format** of the GIMP was created for the primary purpose of **saving images with layers**; however, it can also be used to save images that aren't yet finished. The XCF format saves image layers by employing a lossless compression method. Also, the file size of an XCF formatted image will be smaller than most other high-quality image file formats.

Since overly large files are cumbersome and can be unmanageable, the GIMP's native XCF format is the best choice for storing images with layers.

The only drawback is that, in the current version of the GIMP, XCF files cannot be opened in another image editing program. If you want to export an XCF file image into another program, you must first convert a copy into JPEG, PNG, or TIF. If you plan to consistently use other programs in conjunction with the GIMP 2, you should save images with layers in the PSD format.

XCF	Characteristics
	• 16.78 million colors, 24-bit color depth • Alpha transparency (color gradient from transparent to opaque) • Lossless compression • Supports layers

PSD: Adobe Photoshop's Native File Format

PSD (PhotoShop Document) is the native file format of Adobe Photoshop, one of the most popular image editing programs. This file format is considered a de-facto standard and can be used by almost all other image editing programs, including the GIMP. It is a high quality format that is frequently used to export images with layers. Notice, that the GIMP does not support all possible features of the PSD file format, only the most important ones.

The downside of saving images in PSD is that the files are often quite large, since the format provides no compression options.

PSD	Characteristics
	• 16.78 million colors, 24-bit color depth • Alpha transparency (color gradient from transparent to opaque) • Supports layers

PNG: Portable Network Graphics

The PNG format is capable of preserving the transparencies of an image with full 24-bit color depth. Moreover, it uses a high lossless compression method that considerably reduces the image file size.

The PNG format is also suitable for Internet use.

PNG	Characteristics
	• 265 or 16.78 million colors, 8- or 24-bit color depth • Alpha transparency (color gradient from transparent to opaque) • Lossless, settable compression • Suitable for the Internet • Interlaced (immediate display, layered refresh rate in Web pages)

JPG/JPEG: Joint Photographic Experts Group

Photographs and photo-realistic images with a color depth of 24 bits can be efficiently compressed with JPEG format, which reduces image files to a fraction of the original size. However, the compression method used by the JPEG format is not lossless. This means that the image quality will suffer in correlation with the degree of the compression as well as the decrease in file size. The JPEG format was developed primarily as a way to quickly load photographs on the Internet. JPEG format should be avoided when archiving digital photographs. You should also refrain from repeatedly saving an image in the JPEG format as the quality of your image will drop with each subsequent save. To preserve the integrity of your images, use the PNG format to archive your images after you've finished editing them.

For exporting images in the JPEG format, the GIMP offers a programmable compression option with a preview feature. This option will display the file size and visible quality of the compressed photo prior to saving it.

JPG	Characteristics
	• 16.78 million colors, 24-bit color depth
	• High lossy compression; settable by the user
	• Suitable for use on the Internet
	• Progressive (faster display in Web pages, layered image refresh rate, comparable with the "interlaced" characteristic

GIF: Graphics Interchange Format

Unlike other file formats, the GIF format requires a color palette. This means that a maximum of 256 colors can be saved in conjunction with an image. The GIMP can create these color palettes automatically, but there is a major drawback to doing so. Converting images with an original color depth of 24 bits (or more) to GIF will usually produce an unsatisfactory result.

However, if you save an image with 256 colors or less (such as a simple logo) to GIF, the GIF compression is lossless. In addition, GIF files allow the saving of one transparent color, as well as simple animations ("Animated GIF").

GIF format is often used to upload images on the Internet.

GIF	Characteristics
	• 2 to 256 colors, 8-bit color depth
	• Lossless compression for images containing up to 256 colors
	• Suitable for use on the Internet
	• One color can be transparent
	• Interlaced (immediate display, layered refresh rate in Web pages)
	• "Animated GIF" available

BMP: Windows Bitmap

BMP is supported by most image editing programs using Windows and is considered a suitable format for image sharing between different programs. BMP has a color depth of 24 bits and the image resolution remains unchanged when exporting. However, because the size of BMP files is normally quite large and no other features like transpareny or lossless compression are supported, this file format only plays a minor role in digital imaging. The format is not particularly suitable for the Internet, as it is only supported by the Microsoft Internet Explorer.

BMP	Characteristics
	• 16.78 million colors, 24-bit color depth • Rather unsuitable for use on the Internet (for Microsoft Internet Explorer only)

TIF/TIFF: Tagged Image File Format

This is one of the oldest image file formats still in use. Almost all image editing programs can read and write a TIFF formatted image, even if they're being run on different operating systems. For this reason, it is the best file format to use when sharing high-quality images *without* layers.

The TIFF format preserves all transparencies of an image with the full color depth of 24 bits. It uses a lossless, but not particularly high compression method. The major drawback of using TIFF is that it doesn't support layers (except in Adobe Photoshop).

TIF	Characteristics
	• 16.78 million colors, 24-bit color depth • Alpha transparency (color gradient from transparent to opaque) • Lossless LZW compression • Different settings for saving on IBM and Macintosh computers

1.3 Loading and Managing Digital Photos on the Computer

Before you can edit a digital image, you must import it from your camera, memory card, or scanner to your computer.

Images should be imported to and stored in the format they were shot in, especially if your camera supplies RAW formats known as "digital negatives". Even if your camera can save images in JPEG format, you should archive the original image files in the original capture quality, so that you can always access and reuse the original if needed.

The GIMP offers basic functions to edit RAW formats. If they are not sufficient, there are separate plug-ins for reading RAW images. If you are

using Windows, you can convert RAW images with the aid of a specific program, such as IrfanViewer, or with the software packaged with your camera. After "developing", save your images in a high-quality file format, such as TIFF or PNG.

1.3.1 Using the Operating System's File Management to Import Images from a Camera

Your computer's operating system offers options to import images from the camera to the computer.

If you use the Windows platform, your computer probably came with an appropriate USB driver previously installed. Alternatively, you may have received an USB driver along with your camera (typically on a CD packaged with it). However, if you do not have the driver, you can usually find a downloadable one on your camera manufacturer's website.

Figure 1.7: Windows ME and XP offer a wizard to import images from a camera.

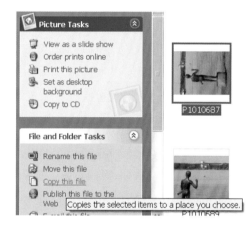

Once you have connected the camera to the computer via the USB port, the operating system will recognize it as a removable storage device—an additional drive. Simply drag the images or entire image folders from the storage drive and drop them into a folder on your computer. Once you copy the images to your computer, the viewing, selecting and editing options offered by your operating system will become available. After you have copied the images to your computer, you can delete them from your camera's memory card.

Windows ME and XP provide a "wizard" to help you select images, assign file names, as well as rotate and copy images. To use the wizard, a special driver that functions as an image editing device particular to your camera must be installed on the operating system. Note that such drivers are not available for all camera models.

If you plug your camera into the USB port and your computer simply detects it as a removable storage device, you can still use My Computer or File Manager in Windows to select images or entire image folders, and thus copy them onto your computer, as shown in the example in Figure 1.8.

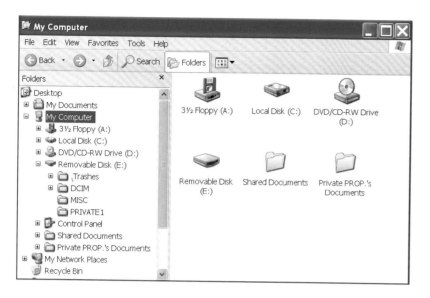

Figure 1.8: Windows detects the camera at the USB port as a removable storage device and shows it as a normal drive in My Computer.

Under Windows ME or XP you can additionally use *View > Movie* in Windows Explorer to see a preview of your images, turn them right side up, or rotate them 90 degrees.

However: Although the *Quick View* function of Windows supports commonly used file formats, including JPEG, GIF, PNG, and TIFF, and sometimes PSD, it cannot read camera RAW formats.

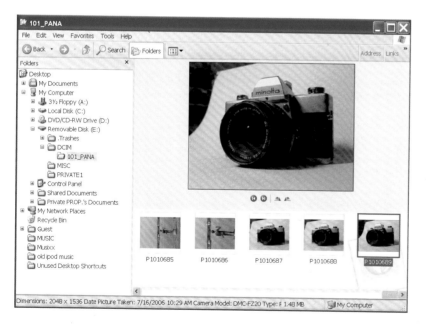

Figure 1.9: The Explorer window shows the folder contents of a memory card. Like any regular folder, you can view the folder content and select either single image files or the entire folder when copying to another folder on your hard drive.

The importing of images under Linux is supported by the Digikam and gPhoto programs. Even if your digital camera is not supported by these programs, you can load images directly from the memory card if you have

an USB card reader. Linux normally uses USB-Storage to support the popular USB card readers when reading data from a camera's memory card. Instead of using a cable to connect your camera to your computer, simply insert the camera's memory card into the card reader and copy the data to your hard disk; the process is similar to that described for Windows.

You can find further information about these programs at:

http://www.digikam.org
http://www.gphoto.org
http://wiki.linuxquestions.org/wiki/Digital_Cameras_And_Linux
http://www.gagme.com/greg/linux/usbcamera.php

1.3.2 Using Wizards to Import Images

Many digital camera manufacturers package their cameras with programs that import images and handle basic image management and image editing tasks, such as composing photo albums and slide- shows, removing red-eye, and rotating and cutting images. In addition, these programs normally offer printing options.

When copying images to the computer, folders are created and organized by default. However, if you prefer to create and organize your own folders, you can use the options provided by your operating system and do entirely without these programs. Be aware that in some events the installation of a packaged program may block the Import Wizard available in Windows ME or XP. If you're having problems locating the Wizard, uninstall the program that came with your camera and restart your computer.

1.3.3 Using the Operating System's File Management to Organize Photo Collections

For managing, sorting, collecting, and renaming images, the options offered by the Windows operating system are usually sufficient. It is important to organize your collection with a logical system so that you can quickly locate images at a later date. You may want to consider the following criteria:

▶ Organizing images by topic, e.g., family, vacation, events
▶ Organizing images by motif, e.g., flowers, cities, landscapes, still life
▶ Organizing images by date

Use the File management menu to create the folders. Then you can rename, move, or copy your images using Windows Explorer.

Windows offers several **view options** to facilitate the representation of image files in folders. You can preview images as movies or slideshows, or as thumbnails with Quick View, or as a small icon with a descriptive text with Details.

Figure 1.10: The View menu in My Computer > Windows Explorer.

1.3.4 Helpers: Image Management Programs for Windows and Linux

If you need to comfortably manage large image collections, you can use an image viewer or image management program under Windows, such as:

- **ACDsee** (http://www.acdsystems.com/)
- **ThumbsPlus** (http://www.thumbsplus.com/)
- **CompuPic** (http://www.photodex.com/)
- **IrfanViewer** (free) (http://www.irfanview.com/)

The Linux world has created a Windows plug-in for the GIMP called **smart-print aka GUASH.** This plug-in is integrated in the **GUASH** file browser under the File menu. You can find it on the Internet at:

http://jlhamel.club.fr/FILES/smartprint_20050119.zip

The following program works under Windows and Mac OS:

- Adobe Photoshop Album (http://www.adobe.com/)

The following programs are available for Linux:

ImgSeek, KuickShow, KView, XnView, gThumb, pornview

For additional information about Linux programs, visit

http://www.linuxlinks.com/Software/Graphics/Viewers/

The programs above allow you to **preview images**, as well as to manage and rename files. Some of them also contain a **file browser** similar to Windows Explorer, so you can create new folders and copy images. Some offer a **batch processing** tool, which will enable you to rename an entire image series or create **screen slides**.

Most of these programs provide options for **image correction**, including tools for modifying and adjusting orientation, brightness, contrast, image size, and resolution.

In addition, these programs possess **printing options**, which allow you to output contact prints, image packages, and print several images onto one page. If you use Windows, you'll find similar options if you launch the Photo Printing Wizard. The Wizard is located in the left window: under *Picture Tasks.* Just click Print Pictures.

These programs can also **convert files to other formats.** The more recent versions can read and convert camera RAW formats.

Particularly notable is the free IrfanViewer. Although the IrfanViewer is not the most user-friendly of the bunch, it is considered *the* image viewer for Windows, as it can open and display virtually any image file or camera format currently in existence.

You can find more about what these programs can specifically do for you if you visit the above- listed websites and follow the links.

1.3.5 Converting Camera RAW Image Formats under Windows and Linux: Freeware and Plug-ins

If your digital camera uses a proprietary file or RAW file format to capture images, you should use it. Taking photos as digital raw data will result in a higher quality image after correction, particularly when compared to photos taken in the highest quality JPEG format.

Saving images in their native camera or RAW format will also ensure that the originals will be archived in the best possible quality.

Version 2.2.6 and higher of the GIMP supports RAW formats, so you can directly open and edit RAW formats with the program. Unfortunately, the GIMP does not work with all proprietary camera RAW formats, so you'll need to make sure that it can read your camera's individual format.

If the GIMP can read the RAW format of your camera, the images will be available with a 24-bit color depth (8 bits per color channel). Remember to save the finished image in a high-quality standard format, such as TIFF or PNG.

RAW formats offer more than a means to optimally save your photos. RAW also permits you to adjust the color and brightness settings, using the RawPhoto or UFRaw plug-in (see below) with a color depth of 16 bits per color channel. This means that you can edit underexposed photos with more efficient options than those offered by the GIMP. Working with digital images is called "developing" and refers primarily to adjusting color and brightness values, just as it does in analog photography. RAW formats are sometimes referred to as digital negatives.

If you have Windows, you can develop photos in RAW format by using the software that came with your camera, or you can use one of the above mentioned plug-ins for the GIMP.

You can thank Pawel Jochym for creating these excellent Linux tools. He wrote a special plug-in called **RawPhoto** that acts like a RAW file import filter for the GIMP, using Dave Coffin's **DCRaw command-line program**. Both of these programs are now available for the GIMP under Windows.

You can visit Dave Coffin's home page at http://www.cybercom.net/~dcoffin/index.html. You will find links to download the program file for **dcraw.c**, the plug-in for Linux platforms.

Visit the website at http://www.cybercom.net/~dcoffin/ and navigate to "Decoding raw digital photos in Linux". You'll find installation instructions for Linux, as well as some helpful hints.

However, as mentioned earlier, these plug-ins do not support all camera-specific RAW formats. You can find a list of the cameras that are supported by DCRaw at http://www.raw-converter.com/. Use search keywords like *RAW software* or *dcraw*.

Below is a brief summary of how to **install the plug-ins on Windows**:

▸ Copy the unpacked (unzipped) *cdraw.exe* file to the *\bin* subdirectory in your GIMP-2.x program folder.
▸ Copy the unpacked *rawphoto.exe* file to the *\lib\gimp\2.0\plug-ins* sub-directory in your GIMP-2.x program folder.

Now you should be able to open RAW files in the GIMP. The image will load into the plug-in window; you can then use the correction options to adjust your image.

If the programs do not support the RAW format of your particular camera, try the **UFRaw** plug-in by Udi Fuchs. Similarly to RawPhoto, this program is capable of developing digital negatives with a color depth of 16 bits per channel, which is a higher color quality than the GIMP currently offers, since the GIMP is limited to a color depth of 8 bits per color channel. UFRaw provides a separate program window, where you can perform color corrections, and adjust exposure settings and light balance, prior to loading the image in the GIMP for further editing, exporting, and storing images.

Once you have installed UFRaw, you can use it in three different ways. Firstly, it can be used as an independent program for editing and storing your digital negatives. Secondly, if you open a RAW with the GIMP, you can use the UFRaw tools within the GIMP. And thirdly, the program contains **UFRaw-batch**, a function that can convert several RAW files simultaneously.

UFRaw can be downloaded from http://ufraw.sourceforge.net/Install. html. It is available for download for Windows and with various Linux distributions.

Installing UFRaw on Windows is a simple process: Just double-click the installation file and follow the instructions. No additional downloads are required. The **dcraw** is integrated in UFRaw.

To use UFRaw as a stand-alone program, you must install GTK on your computer. If you want to use UFRaw as a GIMP plug-in, the GIMP must be fully installed prior to installing UFRaw.

You can find a detailed description on how to use UFRaw at http:// ufraw.sourceforge.net/ Guide.html.

This book will introduce UFRaw and show you how to use it to open a digital negative or RAW file and pass it on to the GIMP.

If neither the GIMP nor any of the above mentioned plug-ins can read the RAW format of your camera, you can work around the problem by converting your images to a "readable" file format, such as TIFF or PNG, using either the software that came with your camera or a third-party application.

If no software is available from your camera manufacturer, you can use IrfanViewer. IrfanViewer is a universal image viewer, but it can do much more than view images (see Section 1.3.4). In addition to the main

program, there is a secondary file which contains plug-ins that support several proprietary camera formats. It is recommended that you download and install both of these files.

With these two files installed on your computer, **IrfanViewer** can read the following file formats:

- ▸ **CAM**—Casio Camera File (JPEG version only)
- ▸ **CRW/CR2**—Canon CRW files
- ▸ **DCR/MRW/NEF/ORF/PEF/RAF/SRF/X3F**—camera formats
- ▸ **KDC**—Kodak Digital Camera files
- ▸ **PCD**—Kodak Photo CD
- ▸ **RAW**—RAW image files

After opening an image, you can rename and save it in a suitable file format, such as TIFF or PNG, using the File > Save as menu options. Alternatively, you can use the batch processing feature of IrfanViewer to simultaneously convert large numbers of images by going to the File > Convert > Batch Conversion/Rename ... menu.

Figure 1.11: Using the batch conversion and file renaming options of IrfanViewer.

1.4 Getting the GIMP Running

1.4.1 Where Can I Get the GIMP?

The GIMP is a free image editing program designed and developed for the (largely) free Linux operating system. When Microsoft Windows users discovered the GIMP, their interest motivated the development of a Windows version which has been available for several years now. The Windows version and additional helpers or plug-ins can be downloaded for free from the Internet addresses listed below.

▸ The GIMP's home is at http://www.gimp.org/. You'll find links to versions available for the Linux/Unix, Windows, and Mac OS X operating systems, as well as many other interesting things.

▸ You can find the GIMP, GTK+, and additional packages for Windows at http://www.gimp.org/~tml/gimp/win32/ or http://gimp-win.source forge.net/stable.html.

▸ GhostScript and GhostScriptViewer, the PostScript (PDF) programs for Linux and Windows, can be found at http://www.ghostscript.com/ or http://www.cs.wisc.edu/~ghost/.

▸ Visit http://gimp-savvy.com/BOOK/index.html or http://www.gimp.org/books/ for a free GIMP user manual.

A revised version of the GIMP hack called **GIMPshop** by Scott Moschella has been published. This GIMP variant is especially designed for migrants: those desiring to replace Adobe Photoshop with the GIMP. GIMPshop features a GIMP menu structure adapted from Photoshop, so its interface differs from the "original" GIMP.

Information about GIMPshop and the downloads are available on Scott Moschella's website at http://plasticbugs.com/?page_id=294. The program is available as an installation file for Windows and Mac OS X. For Linux, it comes in the form of source code to be compiled.

And there is yet another free computer program, derived from the GIMP: CinePaint, formerly known as Film GIMP. It is a program to paint on and touch up bitmap frames of movies. For more information on CinePaint see http://en.wikipedia.org/wiki/CinePaint. Or visit the projects homepage, to find information and free downloads for all mayor operating systems: http://www.cinepaint.org.

1.4.2 Installing the GIMP and Plug-ins

The GIMP works on the three major operating systems—Windows, Max OS, and Linux—as well as on some less popular systems, such as BSD and Sun Solaris.

This section concerns itself with installing the GIMP on your system.

Note: The CD included with the book contains all files required to install the GIMP on Linux, Windows, and Mac OS X.

Installing the GIMP under Windows

The **GIMP** doesn't run by itself on Windows. You will need to install a runtime environment, a separate file provided by **GTK+**. It is sometimes necessary and often advantageous to also install **GhostScript (GS)** and the GhostScriptViewer (GSView). You will need the GhostScript program to use GIMP's PostScript capabilities. Once you've installed GhostScript and othe GhostScriptViewer, you should install GTK and the GIMP. You might also want to install GAP, the GIMP's animation package, and, lastly, the help system.

Note: The order in which you install these programs is important.

Below is the recommended installation sequence for Windows:

1. **GhostScript GS** (e.g., *gs851w32.exe*).
2. **Optional: GSView** (GhostScriptViewer, e.g., *gsv47w32.exe*). This is a freeware program which works without registration. (The registered version costs 40 AUD and prevents the registration dialog from popping up each time you start the program.) It is not required for the GIMP. It is a user interface (program together with GhostScript) to view PostScript, EPS, and PDF files.
3. **GTK+** (e.g., *gtk+-2.8.18-setup-1.exe*).
4. **GIMP** (e.g., *gimp-2.2.12-i586-setup.exe*).
5. **GAP** (GIMP animation package: *gimp-gap-2.2.0-setup.exe*).
6. **GIMP help** (*gimp-help-2-0.9-setup.exe*).

Note that there are two GTK versions available for the more recent versions of the GIMP (2.2.10 to 2.2.12): *gtk+-2.8.18-setup.exe* for Windows 2000/XP and *gtk+-2.6.10-20050823-setup.exe* for Windows 98/ME/NT.

All these files are compressed to reduce data volume and speed up the download. Once you've downloaded the files, you'll need to unpack them with a designated program, e.g., WinZip for ZIP files. Make sure you create a new folder on your computer to save the decompressed files in.

Open the new folder and locate the file ending with .exe or with the word setup in its name. Double- click on it to start the program. Follow the installation instructions, confirm the GNU License Agreement by clicking the Accept button, then continue by clicking Continue or Next. Don't change the factory settings unless you know exactly what you are doing. The default settings are sufficient.

Installing the GIMP under Mac OS X

GIMP Version 2.2 is currently available for Apple computers running **Mac OS** Version X 10.2 and higher. Visit the website at http://www.gimp.org/macintosh/ for general information about the GIMP for Mac OS, current installation packages, and system requirements.

To install the GIMP on a Mac computer, you need **X11** as an XWindow application for all Mac OS X versions. Together with the GIMP, this configuration is recommended and proven to work properly.

For **Mac OS X 10.2**, you need the installation file *X11UserForMac OSX. dmg.bin*. For **Mac OS X 10.3** and **10.4**, you need the installation file *X11User. dmg*. These files should be on the installation CD that came with your system.

If you don't have your installation CD, you can download the file from the Internet. Find XWindow for the Mac at http://www.apple.com/downloads/macosx/apple/x11formacosx.html. Alternatively, you can use a search engine to find *download X11 Mac OS*.

Once you have installed the XWindow application, continue with the actual GIMP installation: *Gimp-2.2.11.dmg*. Download the GIMP from http://gimp-app.sourceforge.net/.

It is recommended that, unless specified, the plug-ins and helpers for the GIMP are installed previous to the GIMP itself. Users of Mac OS X V 10.2 "Jaguar" should have already installed **Ghostscript** (ESP Ghostscript—ESPGS), the program which opens PostScript files in the GIMP. Download it from http://gimp-print.sourceforge.net/MacOSX.php3. Keep in mind that Ghostscript is no longer required for later versions of the Mac OS.

Gimp-Print 4.2.7 is the most recent and stable variant of printer drivers for the GIMP for Mac OS X. The file includes 225 drivers that support more than 600 printers. The *dmg* file includes an OS X installation package, an uninstaller package, and an user-friendly, illustrated document to guide you through the printer setup routine. Go to http://gimp-print. sourceforge.net/MacOSX.php3.

GIMP and Linux

The easiest way to install the GIMP for Linux is by using the software packaged with the Linux distribution (SUSE, Mandrake, Fedora, etc.). This works in conjunction with the installation interface of YAST for SUSE Linux. However, since pre-packaged installation software is normally not up to date, you may want to visit http://www.gimp.org/unix/ to find the most current GIMP version. This website also provides installation hints and instructions, as well as the source code for the GIMP, which you may want to install if you are an experienced Linux user.

1.4.3 Starting the GIMP for the First Time

When you launch the GIMP for the first time (by double-clicking the GIMP icon on the desktop or using the Start > Programs > Gimp > Gimp2 menu), a dialog box pops up. Use it to set up the GIMP according to your personal preferences. For standard use, accept most of the settings and click Continue to proceed. When you are asked to choose a temporary directory for the GIMP, you can type C:\Windows \Temp, which is Window's default directory for temporary files. It can be easily cleaned by using Windows tools (Start > Programs > Accessories > System Tools > Disk Cleanup). Accept the recommended suggestions provided by the installation dialog or create your own directory.

COMMON ERRORS

Figure 1.12: Dialog (prompt) due to program errors (GIMP 1.2.5).

So far, you should not have encountered any problems. However, if a black dialog window pops up with an error message (see Figure 1.12) the first time you start the program, simply close the program by clicking the X in the GIMP toolbox (see arrow in the figure). When you restart the GIMP, the warning message should be gone. Don't worry too much about it: the problem is specific to older versions of the GIMP and rarely occurs with the GIMP 2.

If any further error messages pop up, minimize them and immediately save the image you're working on. If you can, just ignore the message and continue as usual. Or close the program and restart it. If the error windows pop up frequently, you may want to reinstall the program.

You can find **support** by visiting the user forums. On the GIMP User Group (http:// gug.sunsite.dk/), you can find answers to your questions about running various GIMP versions on different operating systems. The GIMPWIN User Group website (http://groups.yahoo.com/group/

gimpwin-users/) is for Windows users. Mac users can find help at http://
www.macgimp.org/.

The Worst Case

In the unlikely event that the program crashes or gets stuck each time you
start it up, you should uninstall both the GIMP and GTK (for Windows go
to Start > Settings > Control Panel > Add/Remove Programs). You should
also delete all the GIMP and GTK program files from your computer. Please
note that there is no need to delete image files created in GIMP before rein-
stalling!

 If you downloaded the GIMP using the default suggestions, you can
find the program files at: C:\Program Files\Gimp, C:\Program Files\GTK,
and C:\Program Files\Common Files\GTK. Delete all related folders and
their contents. In critical cases, you can search Windows by going to Start
> Find > Files or Folders and typing the name of the file you're looking for
(i.e. GIMP).

 Once you have removed all relevant files, reinstall GTK and the GIMP
from scratch.

1.4.4 Is The GIMP Risky?

Like any program, the GIMP may crash unexpectedly or behave strangely.
Since the GIMP is GNU software, there are no guarantees. But other soft-
ware programs don't provide guarantees either, not even expensive ones—
just read the end-user license agreements for a typical Windows program!

 A program's stability depends partly on the technical aspects of the
computer running it, along with its drivers and preexisting software.

 Studies have shown that the GIMP is more stable when used by a
computer running Windows NT, Windows 2000, or Windows XP than
Windows 98/98 SE/ME. Also, your computer's RAM plays a key role in the
GIMP's performance. In general, more memory equals more stability. The
minimum memory requirements for the GIMP are 128 MB RAM for
Windows 98 and 256 MB RAM for Windows XP.

 If Adobe Photoshop is installed on your computer in addition to the
GIMP, the GIMP may warn about a missing file called *Plug-ins.dll* that the
program will not start without. If this occurs, search the Adobe Photoshop
folder for that file. Once you find the file *Plug-ins.dll*, simply copy it to the
Windows folder *system32*.

 Many people find the GIMP extremely useful, but you should be aware
that the GIMP is not a replacement for Adobe Photoshop, particularly if
you're using Photoshop professionally. Photoshop offers features that are
not yet available on the GIMP. However, if you are a semi-professional or
amateur who simply wants to edit your digital photographs, the GIMP's

price-to-performance ratio is unbeatable. The GIMP 2 is definitively on its way to becoming a professional tool.

A brief comment about the GIMP's interface: If you're a Windows user and this is the first time you're using the GIMP, you may find the interface somewhat unfamiliar. If you're using an older version of the GIMP, you should be aware that the GIMP 2 has been modified to appear more like a typical Windows program. For example, the image editing window now has an integrated menu bar.

Nevertheless, some users find it awkward that the GIMP provides a separate button in the Windows Taskbar that corresponds to each open window. If you find this distracting, you can remove it by using the small plug-in described below.

1.4.5 Many Windows or One Main Window

The Background Window Plug-in (the GIMP De-weirdifyer)

As the name implies, this plug-in removes any weird habits that the GIMP' weird might have and makes it behave more like a typical Windows program, such as Adobe Photoshop. More specifically, the plug-in prevents the GIMP from creating a separate button in the Taskbar for each open window. Instead, all the GIMP windows are summed up in one main window on the user interface. Pressing the Alt and Tab keys will now allow you to toggle between your open Windows programs as usual, rather than stepping one-by-one through all windows open in the GIMP.

This plug-in was developed by Joe Marshall, and is downloadable at http://registry.gimp.org/ plugin?id=3892; of course, you could also launch your favorite search engine and look for "Gimp Deweirdifyer".

If the Deweirdifyer's installer does not automatically open when you double-click the unpacked .exe file, simply copy the .exe file and the .dll file from the unzipped installation package to your GIMP plug-ins folder, which should be in C:\Programme\GIMP-2.0\lib\gimp\2.0\plug-ins or in the subdirectory lib/gimp/<versionNumber>/Plug-ins in the GIMP installation folder.

Be aware that the installation files for the GIMP version numbers 1.X and 2.X differ.

In versions higher than the GIMP 2.0 (e.g., 2.2.X), when you restart the GIMP, the individual GIMP windows will remain in the Taskbar, even though the background window is open. In order to fix this, you have to tell the background window what GIMP version it is in charge of. Use the Edit menu in the background window to enter the correct version number in the Setup > GIMP Application option. For example, enter gimp-2.2.exe for versions higher than GIMP 2.0.

If you desire to name the main window, you can also use the GIMP Window Name option; the name will appear in the title bar.

If you prefer to use the GIMP without the deweirdifiyer, uninstall the plug-in. Just delete the files *backgroundwindow.exe* and *backgroundwindowhook.dll* from the GIMP folders (see above).

1.4.6 The Main GIMP Interface

The GIMP's main interface consists of several windows on the desktop. If you've used Adobe Photoshop or another Windows imaging program that works with palettes, you'll notice many similarities.

Figure 1.13: This loading screen appears when the GIMP starts.

In Version 2 and higher, the GIMP's menu will pop up in the familiar place. You'll find commonly used commands, such as File > Save or Edit > Copy. The GIMP's menu can also be accessed by right- clicking with the mouse.

However, when you start the program, the **image window** may be missing. You can manually open the image window by selecting one of the options in the Toolbox's File menu. Use these options to create a new image, open an existing image, or import an image from the clipboard or scanner.

In Figure 1.14, you'll see the **Toolbox** (or Tools palette) with the menu items File - Xtns - Help. This is the main window of the GIMP.

In the Toolbox, the GIMP 2 opens the settings for any tools you've selected. It looks like a single window, but there are really two windows open within a single dock—the tool selected and that tool's settings. A dock is a kind of container window.

Figure 1.14: After the program start.

Figure 1.15: Docking windows.

You can click the X at the top right-hand corner to close the docked Tool Preferences window if you need more space on your desktop. Next time you double-click a tool icon, the settings of that tool will appear in a separate window. You can dock this window to the palette by holding the left mouse button down while clicking on the name of the attributes (located right below the blue title bar). You can then drag an icon from the window, while holding the left mouse button down, and subsequently dock (or drop) it along the blue lines of the Toolbox.

1.4.7 The Toolbox

The central window of the GIMP is the Toolbox. From within the Toolbox, you can set the look and the attributes of the GIMP. For example, accessing the menu File > Dialogs will enable you to select the windows that you want to automatically open at start-up. If you click the X at the top right-hand corner of this window, the work session will be terminated and the program closed.

Figure 1.16: The File menu.

The menu items in the Toolbox contain all options necessary to begin working on an image, configure the program to your personal needs, or obtain help while you work. The *File* menu also has submenus that let you create, open, and/or acquire images from a hard drive, clipboard, or scanner. The Preferences submenu lets you access the most important properties of various program windows.

The Dialogs submenu enables you to open additional windows, such as windows to manage layers, channels, and paths, as well as image history.

The submenu Quit closes all windows and the program.

The Xtns (extensions) menu configures settings and options for plugins.

Finally, the Help menu lets you access the program's help functions.

Take care when shutting down the GIMP as it will start up by opening the windows in the same way they were when you last quit the program.

Undoing Editing Strokes (Document History)

Similar to many other image editing programs, the GIMP lets you undo editing strokes applied to an image. By default, you can revert your image to how it appeared five steps back in the editing process. (Though the default setting is 5 steps, actually the number of steps you can undo is greater.) You can increase the number of steps back you can take if your computer has enough memory to do so. To increase the number of "undo" strokes, access the File > Preferences menu. Select the menu entry Environment to enter the desired number of undo steps, along with the amount of memory you wish to allocate for this process. A number between 15 and 25 will allow you to undo even complex editing mistakes.

If you have enough memory installed in your computer, it is a good idea to reserve more memory for the GIMP's document history—the number of undo steps—than the factory default provides. As a rule of the thumb, you can reserve approximately 10% of your computer's available memory capacity for document history and about 25% for the GIMP program in general. If these values use too much of your computer's memory, the program or your computer may freeze up. To remedy this problem, just reduce the allocated memory value by two.

Figure 1.17: The Preferences > Environment
window lets you set the number of undo
steps and the amount of memory allocated
to the GIMP..

Figure 1.17: The Preferences > Environment window lets you set the number of undo steps and the amount of memory allocated to the GIMP..

Figure 1.18: The Document History dialog.

Figure 1.19: The Toolbox, the central window of the GIMP.

When you are satisfied with the new values, click OK to accept your changes.

If you want to undo one or several editing steps while editing an image, you can use the keyboard shortcut Ctrl+Z, which will undo editing steps one at a time. Alternatively, you can select the menu option Edit > Undo.

A more convenient way of undoing multiple editing steps is available in the **Document History** menu, where you will find the Layers/Channels/Paths/Undo window. This window accesses a preview pane so you can see exactly how many steps you want to go back. Since you will be able to view each change in sequence, you can easily judge whether the editing improved the image.

The Tools in the Toolbox

In addition to the basic program functions, the Toolbox offers these fundamental editing tools:

▸ Selection tools that select specific areas of your image that you wish to edit, manipulate, and/or add new elements to
▸ Tools that can select colors, minimize or magnify view, and measure and position image elements
▸ Tools that can transform the size and shape of image objects
▸ Text, painting, and touchup tools
▸ Tools to manipulate an image's or partial image's sharpness, brightness, and contrast

▸ Tools that define colors, fillings, and fill patterns
▸ Tools that select, create, and edit brush pointers

The following **tools overview** will describe the tools available in the Toolbox.

First row, from left to right:

	Rectangle Selection tool (selects rectangular regions of an image) Sections 3.1.2, 3.9.1; see 3.2.2		**Ellipse Selection tool** (selects circular and elliptical regions from an image) Sections 3.1.2, 3.2.2, 3.9.3
	Free Selection tool ("Lasso") (lets you create a selection by drawing it free-hand with the pointer [not very precise, but simple and quick]) Sections 3.1.2, 3.5.2		**Fuzzy Selection tool (Magic Wand)** (selects areas of the current layer or image based on color similarity) see Sections 3.1.2, 3.5.2
	Select By Color tool (similar to Magic Wand; it selects areas of an image based on color similarity) Sections 3.1.2, 3.5.2		**Scissors tool** ("magnetic lasso", free-hand selection: This tool produces a continuous curve passing through control nodes, following any high-contrast edges it can find, according to the settings; it is not very precise) Section 3.1.2

Second row, from left to right:

	Path tool (creates and edits paths) Section 3.10		**Color Picker** (eyedropper; finds colors on the active layer or image) Section 3.5.2
	Magnify tool (changes the zoom level) Section 2.2.7		**Measure tool** (measures pixel distances and angles) Section 2.4.4
	Move tool (moves layers or selections) Section 3.5.3		**Crop tool** (crops or clips an image or layer) Sections 2.2.8, 2.4.6

Third row, from left to right:

	Rotate tool (rotates layers or selections) Section 2.4.5		**Scale tool** (scales images, selections, or layers) Sections 3.5.5, 3.9.3, 3.11.1
	Shear tool (shifts a partial image, layer, selection, or path to one direction, while shifting the rest of the image to the opposite direction) Sections 3.10.5, 3.11.1		**Perspective tool** (changes the perspective of layers) See Section 3.11.1
	Flip tool (flips layers or selections horizontally or vertically)		**Text tool** (adds text to an image) Section 3.6.2

Fourth row, from left to right:			
	Bucket Fill tool (fills a selection or layer with the chosen color or pattern) Section 3.5.2		**Gradient tool** (fills the selected area or layer with a gradient blend of foreground and background colors) Section 3.5.4
	Pencil tool (draws free-hand lines with a hard edge) see Section 3.9.4		**Paintbrush tool** (paints fuzzy brush strokes) Section 3.9.4
	Eraser tool (removes areas of color from the current layer, selection, or image) Section 3.9.4		**Airbrush tool** (paints soft areas of color, similar to a traditional airbrush) see Section 3.9.4
Fifth row, from left to right:			
	Ink tool (paints solid brush strokes) see Section 3.9.4		**Clone tool** (repairs and fills problematic areas in digital photos or paints with a pattern) Section 2.6.3
	Convolve tool (Blur/Sharpen) (blurs or sharpens an image, depending on the tool settings; sharpen doesn't help in high-resolution images)		**Dodge/Burn tool** (lightens or darkens the colors in an image)
	Smudge tool (smudges colors on the active layer or selection, mixing them) Section 3.5.2		**Color and Indicator area** Double-clicking the color area activates the Color Picker (Section 3.5.2) Double-clicking the indicator area causes the brush tool options dialog to pop up: brush (Section 2.6.2), pattern and color gradient (Section 3.5.4)

Note: Double-clicking the left mouse button on an icon in the Toolbox pops up a window displaying the current tool settings, either as a docked window, or as a separate, floating window. The window displays options that can be used to configure tools for specific tasks.

2 Using the GIMP: Correcting and Touching Up Your Images

2.1 Getting Started

2.1.1 Opening and Developing a RAW Format, or "Digital Negative" with the GIMP

This section of the book will teach you how to open RAW files, or digital negatives.

If you've read the first chapter, you already know that the GIMP 2 can open *most* RAW formats. If you saved your photos in JPEG, you can also open them directly with the GIMP. Opening images directly from the GIMP is probably the most efficient method to touch-up your photos.

However, if you want to develop your digital negatives with a color depth of 16 bits per channel (rather than 8 bits) in order to make fine-tuned corrections and/or print a higher quality photo, you'll need to use a plug-in. Either RawPhoto or UFRaw will do. Once you've integrated one of these plug-ins into the GIMP, it will automatically activate when you open a RAW file with the GIMP. Let's first take a look at the UFRaw plug-in since it can be installed standalone or as a plug-in, as described in Section 1.3.5.

UFRaw can be used in three different ways. If used as a GIMP plug-in, when you open a RAW file in the GIMP, the UFRaw preview window will automatically open. You can set corrective options for color and brightness values in the preview window.

You can simply click *OK* on an open image to load it into the GIMP. Then you can use the GIMP's tools for corrections—a legitimate practice. Since UFRaw supports a color depth of 16 bits per color channel, this method allows you to make detailed adjustments while using the GIMP's familiar tools. (Without UFRaw, you'd be limited to 8 bits.)

In addition, UFRaw can be used as a stand-alone program for developing digital negatives. With the UFRaw stand-alone, you can save images in the PPM, TIFF or JPEG file format with a 16-bit color depth per channel for PPM and TIFF. The example images in this section were produced with UFRaw stand-alone.

Moreover, UFRaw offers a batch mode (available for the Linux platform; to obtain information about this feature, enter man ufraw or ufraw—help in the Linux console).

The main UFRaw window is designed so that the various working commands are displayed in the sequence in which they will be applied to the image. You can open an image in UFRaw and experiment with the options to see how they affect your image.

Figure 2.1: An unedited digital negative was just opened in the preview window. The left panes show color histograms and setting options.

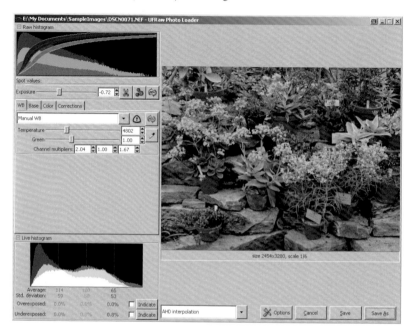

Figure 2.2: The edited image with minor color corrections. Note that the left pane reveals the slight changes that were made on the Corrections curve.

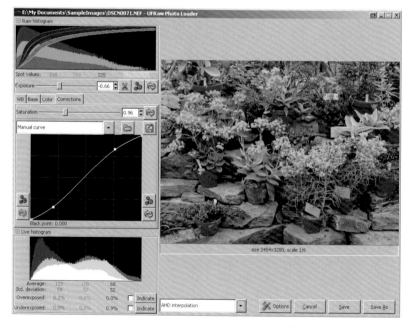

The RAW Color Histogram

The dented color curve in the top left corner of the window is the color histogram of your RAW image. It displays the luminosity, or the image brightness according to color values. The color curves beyond the histogram show how the RAW data will be converted on the finished image.

Right-clicking the RAW histogram pops up a menu which allows you to scale and size the histogram.

Exposure

You can digitally change the original photo exposure. Increasing the exposure is a simple process; the downside is that the noise in the image increases as you increase the exposure. Decreasing exposure is a trickier process, as it is impossible to recover clipped highlights.

The ✂ Unclip Highlights option usually produces a subtle effect. UFRaw might clip highlights that were not clipped in the RAW file. Setting this option may add undesired color to your clipped highlights, so use with caution.

Clicking on the 🐞 Auto Adjust Exposure icon will automatically correct the exposure settings. Since the correction is done prior to setting the actual color, the result is not very precise. Other functions in UFRaw also allow you to automatically set options.

Clicking the 🔄 Reset Exposure to Default button resets the exposure to the program's default values.

You will notice that there is a reset button available for every option so that you can undo any optional changes and revert back to UFRaw's default values.

Be aware that Reset White Balance button behaves slightly differently than the other reset buttons. Rather than resetting UFRaw's default values, this button resets the white balance to the value corresponding to the one that was loaded with the image.

Bottom Line: UFRaw will "remember" any settings that you might have defined while editing an image; it will automatically apply those settings to the next image unless you click the 🔄 Reset button to reset the option settings to the program default beforehand.

WB White Balance

The WB White Balance settings control the ratio between the three color channels. You can set the Color Temperature to make your picture warmer or colder. The Temperature option primarily controls the blue color channel. There is a second control for the green color channel.

In addition, you can set the white balance to Camera WB, Auto WB or Manual WB. You can move the controls sliders or click on the ↗ Spot White Balance icon (eyedropper), then click on a white, neutral gray or

black area of the image. Holding the mouse button down while you drag
the curser will increase the selected area. Clicking the eyedropper icon
again will recalculate the white, gray, and black values of the selected
area.

Base Curve

Base Curve offers you two choices: Linear Curve or Manual Curve. Linear
Curve corresponds to the pre-settings of the image. Manual Curve lets you
correct the brightness and contrast settings separately, using various bright-
ness ranges (see Section 2.4.9 on Gradation Curves). If you click the lower
area of the linear curve and drag it downwards while holding the left mouse
button down, you'll notice that the dark shades in the image become darker.
Repeat the process for the upper area of the curve, dragging upwards this
time, and the bright colors become brighter. By experimenting you can cor-
rect any brightness problems or just creatively play with the image. You can
produce a color inversion of a true photo negative by dragging both end
points of the curve vertically.

Various camera manufacturers and other sources offer similar tonal-
ity curves on their websites. You can also create curves of your own and
save them to reuse with your images by clicking on the Diskette icon. To
load a curve that you've downloaded or created on your computer, click the
Folder icon. Also, you might want to peruse the ready-made curves found
on Udi Fuchs's website at http://ufraw.sourceforge.net/Contribute.html.

Color Management

Color management refers to the working color space of the mode used,
which is mainly RGB for our purposes. You can find detailed information at
http://ufraw.sourceforge.net/Colors.html.

Clicking the Use Color Matrix control increases color intensity, but the
individual colors tend to overexposure or underexposure.

Corrections

Moving the Saturation slider to the right increases the color saturation of
your image, while preserving both hue and brightness. Moving the slider to
the left desaturates the image, reducing the colors until you have a pure
black-and-white image.

The curve in the Corrections settings affects the brightness of the
image. You can edit this curve in the same way as the Base Curve to increase
image contrast. The Base Curve is intended to apply readily available curves
to the image. When simply touching up the contrast of an image, use the
Corrections control.

Live Histogram

This is the histogram of the preview image, which is updated whenever you change the settings. By right-clicking on the live histogram, options pop up that allow you to set the curve's size and representation.

There are two modes in which you can control the exposure. Clicking the controls or buttons underneath the Live Histogram will show you the Overexposed or Underexposed pixels in the image. The numerical values next to the controls indicate the amount of overexposure or underexposure per channel in percentages. These values provide objective information, enabling you to correct the exposure and color settings, thus preventing a faulty exposure. Of course, the desired exposure naturally depends on the atmosphere you wish to create in your image.

Interpolation

The interpolation defines how the image dots should be recalculated when you save the final image.

The default is AHD Interpolation. It provides the best results, but may enhance the noise in the photo.

VNG Interpolation provides very good results.

VNG Four Color Interpolation should be used if you find Bayer pattern artifacts in your photo (see Section 2.4.7 on the Moiré Effect).

Figure 2.3: An image that was saved and reloaded shows a disturbing colored grid pattern, commonly known as Bayer pattern artifacts.

Bilinear Interpolation is a very basic interpolation, but it is fast.

Half-size Interpolation is the fastest interpolation method. It generates a single pixel out of every four original pixels. This option appears only in

the GIMP plug-in; in the stand-alone version you can achieve the same effect by setting the Shrink Factor in the Save As dialog to 2.

Options

All settings not directly related to image editing are hidden in the Options dialog. Please visit Udi Fuchs' website at http://ufraw.sourceforge.net/Guide.html for more information.

Saving Your Image

If you are using UFRaw as a plug-in, just click OK to send the image to the GIMP. The plug-in version will not save images, so you'll have to revert to the GIMP's interface in order to save your image.

In the UFRaw stand-alone version, you can save your image in either of two ways: Save or Save As. Clicking the Save button saves the image as a TIFF file in the same folder that you initially opened the RAW image in. You cannot select a different file name or file type with this option. If you hover your cursor over the *Save* button, a summary of where and how the image will be saved will pop up.

Clicking the Save As button pops up a familiar window in which you can select a file name, file type and folder. Windows users might find the file browser a bit awkward. It will be discussed in more detail in Section 2.2.8.

Figure 2.4: The Save Image (Save As) dialog of UFRaw. Clicking the checkbox next to Folder Browser opens the folder browser.

The Save Image dialog lets you choose one of three file formats: PPM, TIFF, and JPEG. The first two file formats will save your image in the highest qual-

ity. TIFF is probably the most widely used high-quality format used when importing images to other programs. Both the PPM and TIFF file formats let you save images with either 8-bit or 16-bit color depth per color channel. If you opt for 16 bits, make sure that the program you'll be using for further editing or when opening your image supports 16-bit color depth per channel. Remember that the GIMP is limited to 8-bit color depth.

You should be aware that UFRaw does not yet support **Embed EXIF Information**. The feature is under development, but current builds of UFRaw can only embed EXIF information for Nikon NEF, Canon CR2, and Pentax PEF files in the JPEG image format.

If you are interested in saving EXIF information, check out the **ExifTool** by Phil Harvey.

Exchangeable Image File Format (EXIF) is a standard format developed by the Japan Electronic Industry Development Association (JEIDA) that modern digital cameras can use to save data. Visit http://en.wikipedia.org/wiki/Exif for more information.

This first section focused specifically on the requirements of photographers working with RAW formats. The following chapters will explore requirements for working with images directly in the GIMP image editing program.

The Procedure

Below is a summary of preparatory steps you'll need to take in order to practice the procedures described above:

▸ After installing the GIMP on your computer, install the UFRaw plug-in.
▸ Insert the CD packaged with this book into your computer's CD-ROM drive.
▸ Start the GIMP. In the main window, select the File > Open menu item from the Toolbox to open an image (see Section 2.2.2).
▸ Locate the CD in the File Browser and browse through the *SampleImages* folder. You will find an image labeled *DSCN0071.NEF* (Nikon RAW Format).
▸ Double-clicking on the sample image will simultaneously launch the UFRaw plug-in and open the image. Have fun experimenting with the settings introduced above.

2.2 Editing Images in the GIMP

2.2.1 Opening, Setting and Storing an Image—the Steps

Once you have saved an image from an external source, such as a digital camera, onto your computer, you can:

> ‣ Open it in the GIMP
> ‣ Set the size and resolution
> ‣ Rotate the image
> ‣ Change the image's size on the screen (zoom in or out)
> ‣ Save the image in a high quality format
> ‣ Prepare it for printing

2.2.2 Opening an Image

From the File menu in the Toolbox select the menu item Open. The **File Browser** will pop up.

Figure 2.5: The Open Image window.

Double-click on the drive or directory where you want to search for an image in the left pane.

The middle pane will now display subdirectories, which you can double-click on to open until you've found the folder containing the image you want.

The buttons above the search boxes show where you are within the specified directory path. If you're in the wrong sub-folder, use these buttons to move back to the main folders and start again until you've found the appropriate file.

The middle pane will now display the files contained in the selected folder, sorted alphabetically by name.

You'll notice a scrollbar on the bottom right-hand side of the Name box. Pull the bar up or down to quickly search through the folder.

Now click the name of the desired image in the Name box. A preview of the selected image will appear in the right-hand pane.

If no preview appears, or if a message pops up telling you that no preview could be created, double-click on the Preview box to get a preview of the image.

Once you've found the desired image, click on it to select it; then click the Open button to load it. Or just double-click the image name in the Name box.

A few tips:

▸ If you've opened a folder that you'll be using frequently, you can "bookmark" it by clicking on the Add button in the left box of the window.
▸ Clicking the All Files button will display a list of file formats the GIMP can read. If you select a specific format from the list, the file browser will only display files in that particular format.
▸ You'll also see an option called Determine File Type, which is set to *Automatic* by default. Clicking this button will provide a pop-up window listing file formats. If the GIMP doesn't automatically recognize the format of the image you selected, you can use this option to specify the file format of that image.

2.2.3 The Image Window—Your Workspace

The **image window** is the main window that appears when you open an image. This is your actual workspace. Although initially the window will show your image in full size, you can decrease the size of your image so you can use the remaining space in the window to lay your palette and tools.

Figure 2.6: The image window.

The **blue title bar** displays the image's file name, color mode, the number of layers, and the original size in pixels.

In GIMP Version 2 and higher, the image window features a **menu bar** where you will find the familiar menus, such as File, Edit, View, and so on. We will discuss the menu items one by one later on. You will also find these menu items in the image window's **context menu** (right-click the image window to open it). Some users find that it's quicker to work within the context menu.

In addition, the image window is bordered at the top and left by **rulers**. By default, the rulers measure pixels (px). You can change the measuring unit of the rulers to inches or millimeters by clicking the pulldown menu in the status bar at the bottom of the window.

However, if you hover the cursor over a ruler, then left-click while holding the mouse button down and pulling, you can drag **guides** into the image. Guides are very helpful when checking an angle or selecting an area you want to crop from the image.

If you click the Magnify tool button ⊞, you will notice that the image inside the window will automatically adapt to whatever size you change the window to.

The two smaller buttons, ⊞ and ⬜, at the bottom left serve to toggle the view between selection and mask modes (more about using these later).

Clicking the ✛ button will reveal a small preview image of the open file. This is particularly helpful when you have zoomed into the image and want to see how a change affected the entire image without having to zoom out. If you hold your mouse button down, you can move around the image and click on the areas you want to view. You'll notice that the larger image in the window will move in correlation with your movements on the preview image. The section chosen with the preview image will remain in the main window after closing the preview window.

The **status bar** at the bottom of the main window also supplies useful information:

▸ The upper left corner of the image will reveal the current cursor position in pixel coordinates.

▸ The next field from the left displays the measuring unit for the rulers. The default is "px" (or pixels), but you can opt to display the rulers in inches or millimeters.

▸ Next, there is a hot-key for the zoom button so you can quickly enlarge your image.

▸ The next field displays the name of the current layer, as well as the uncompressed file size of the image. When calculating a change effected to the image, a progress bar appears in the status line. In addition, a Cancel button may appear so that you can stop the process.

▸ In general, the status bar is also used to output various values, such as the Measure tool.

The image window (and all other windows in the GIMP) behaves like a typical Windows window. If you move the cursor outside the border of a page or to a corner point of a window, it will morph into a dual arrow, enabling you to manipulate the window size by dragging it while holding the left mouse button down.

To move windows on the desktop, click the blue title bar and, while holding the left mouse button down, pull the window to the desired position.

All program windows feature the three familiar buttons on the upper right corner that minimize, maximize, and close the window.

2.2.4 Rotating an Image by Fixed Values

Suppose the image you just opened is rotated 90 degrees clockwise. To set the image straight, click on the image with the right mouse button. The working menu will pop up. Select Image > Transform > Rotate 90 degrees CCW.

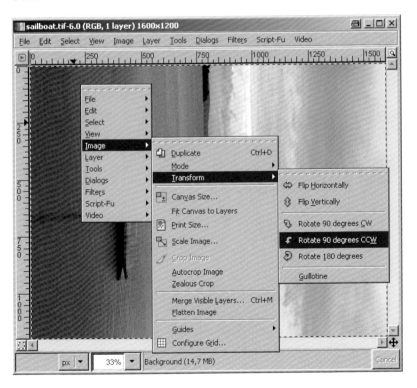

Figure 2.7: The working menu of the GIMP will pop up when you right-click on an open image.

2.2.5 Setting the Image Size and Resolution

The image should now be upright. Next, you'll want to set the size and resolution. Let's imagine that you want your image to be about the size of a photo print, 4.5 × 6.0 in, so it can easily fit on one print page. The target resolution of the image is 300 dpi.

Note: As mentioned earlier, you can find all necessary commands in the working menu located on the menu bar above the image, as well as in the context menu, which opens when you right-click on the image. If you prefer working with your mouse, the context menu should be easier and faster to use. However, if you prefer to work with keyboard, you'll probably want to use the keyboard shortcuts. Keyboard shortcuts are displayed next to the corresponding menu items.

Options for setting the size and resolution are located in the image window; just go to Image > Scale Image.

When the Scale Image window pops up, you can set the measurement for Resolution X to 300 pixels/in (= dpi). In the text field, just overwrite the default value and press *Enter* to accept your changes. Both resolution values should now be 300 pixels/in.

Figure 2.8: The Scaling Image window.

Make sure that the chain icon near the resolution is closed, and that the X and Y resolutions are equal (see Figure 2.8).

The next step is to set the image size (measured in pixels, inches or millimeters). In the upper part of the window, you will see two values: Width and Height. If you want to use inches as your size unit, set inches as the measurement unit by clicking the arrow next to the Pixel field (to the right of the Height field) and select *inches*. Then type the number 6 for the value in the Height field. Press Enter to accept your changes. The value for the width should now be 4.5. (**Be Aware**: GIMP 2.2 can be a little fussy when changing theses values, so you may have to repeat this process more than once.)

Next you'll want to select the quality of the pixel recalculation, i.e. to the interpolation Cubic (Best). Click to open the dropdown menu, which

was probably set on Linear by default. Click the Scale button to accept your changes. The program will now calculate the new image size, which will change as the calculation progresses. If you want to see the full image in the working window again, you can choose one of the various tools at your disposal to change the view.

2.2.6 Changing the Resolution and Size

When you open an image imported from your digital camera, the GIMP tells you what the image dimensions are in the Image > Scale Image window. For example, it might read: 1200 px × 1600 px = 16.66 x 22.22 in = 423.33 mm × 564.44 mm with 72 ppi (ppi = pixels per inch).

If you want to modify the image to print size of, say, 4.0 × 6.0 in, you have to multiply the resolution using a factor of 22.22 : 6 = 3.70. The calculated value is approximately 267 ppi. For example, you would set the resolution to 267 ppi in the Image > Scale Image window and subsequently click the *Scale* button to accept your changes. The image will be recalculated to a size of approximately 4.5 × 6.0 in, but the number of pixels and the quality will remain roughly the same. Only the dimensions are changed.

Your image is now ready for high-quality print. All you have to do before you print is to modify (or crop) the canvas to the desired size by using the Image > Canvas Size menu item; see Section 2.2.8).

To size your image for use on the Internet (or to send via e-mail transmission or use on a webpage), simply leave the resolution at 72 ppi (or 96 ppi) and change the dimensions in inches. This recalculation will reduce the number of pixels: 324 px × 432 px = 4.5 × 6.0 in with 72 ppi. In this case, the image must be recalculated. So select the Image > Scale Image > Interpolation: Cubic (Best) to create the highest quality image.

The following representation shows how resolution, image size, and quality interrelate:

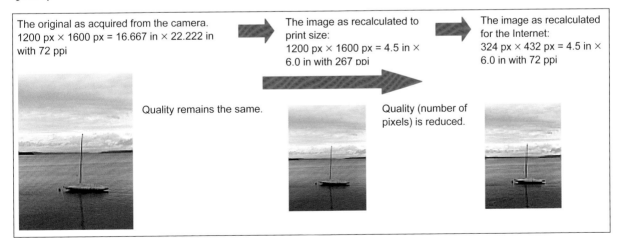

The original as acquired from the camera. 1200 px × 1600 px = 16.667 in × 22.222 in with 72 ppi

Quality remains the same.

The image as recalculated to print size: 1200 px × 1600 px = 4.5 in × 6.0 in with 267 ppi

Quality (number of pixels) is reduced.

The image as recalculated for the Internet: 324 px × 432 px = 4.5 in × 6.0 in with 72 ppi

In other words if you choose to enlarge an image, you must reduce the resolution by the factor by which you want to enlarge the image so that the number of pixels and, thus, the quality of the image, will remain the same. When printing the enlarged image, you should consider the fact that resolutions of less than 150 ppi will often produce poor results, even on a modern inkjet printer.

There is an option to artificially enlarge an image, using interpolation to increase both the size and resolution of the image. This process calculates new image dots and adds them to the image. But if you enlarge an image beyond a certain size, it will usually become spongy and blurred.

2.2.7 Changing the Image View Size (Zooming)

Note: Changing the view size of your image will not affect the actual image or file size. The view options customize how you see the image on your computer screen, allowing for easier editing and detail work.

You can zoom in and out on an image selection by using the Magnify tool, which can be found in the Toolbox. Click the Magnify icon. The cursor will change into a magnifier icon. Clicking the magnifier on your image will enlarge that particular section, and the spot where you clicked will become the center of the image. If you press the Ctrl button, hold it down and click on the image again, the image section will be reduced in size. You can repeat these steps until your image has been reduced or enlarged to your specifications.

Alternatively, you can use the zoom tool in conjunction with the left mouse button to pull a rectangle over the section of the image you wish to select. When you release the mouse button, the image you "lassoed" with the rectangle will be displayed in the image window.

Figure 2.9: The View > Zoom menu.

The View > Zoom menu offers options to select the displayed size of an image.

- ▸ **Zoom Out** (makes the image progressively smaller)
- ▸ **Zoom In** (makes the image progressively larger)
- ▸ **Fit Image in Window** (fits the image *inside* the existing window)
- ▸ **Fit Image to Window** (fits the image so that it will be the exact size specified by the window's width or height, rather than inside it)
- ▸ **Nine specific zoom levels**
- ▸ **Other** (lets you customize a scale)

The View menu also allows you to select and hide elements and attributes so you can work on specific areas without distractions. You can also make the grids and guides magnetic, which will cause tools and image objects to automatically orient themselves to the guides and grids (similar to "snap to" functions). Two particularly interesting viewing options are:

- ▸ **Shrink Wrap** (which resizes the window to the image height or width)
- ▸ **Full Screen** (which displays the image in full screen, without a window. Press the Esc key to toggle to window mode)

2.2.8 Cropping (Clipping) an Image

In the previous step you reduced the image proportionally (i.e., in the same page ratio); therefore, you obtained a width of 4.5 in, rather that 4.0 in, the width you wanted.

To get a width of 4.0 in, you need to crop the image by 0.5 in.

In the Toolbox you'll find a Crop tool (which toggles between Crop and Resize modes) that you can use to crop or clip your images. In the example, you cut 0.25 in from both the right and left margins. Now click on the upper left corner of the image window, and while holding down the left mouse button, pull it to the bottom right corner point. Then click the Crop button in the Crop/Resize window to crop the image. If you click the Resize button, the margins will be covered or hidden rather than removed. Doing this affects only the image size, not the working area (or canvas) which is what you want to do. Modifying the canvas is comparable to working with a photographic mount in analog photography.

In this example, however, you want to crop the image to a numerical measure. Go to Image > Canvas Size to access the pop-up menu for this. (see Figure 2.11).

The term "Canvas" is commonly used in image editing programs to designate the working area where images are placed. The canvas can be larger than the visible image content, but by default, the canvas size will coincide with the image size.

Figure 2.10: The Image menu.

Figure 2.11: The Canvas Size window.

You can enlarge or reduce the canvas size without modifying the image it contains. By enlarging it, you create a border around the image that can be used to insert other image elements or text. For example, you may need to enlarge a canvas if you want to create a collage or paste more than one image on it, as shown in Section 3.12.2.

Reducing the canvas size may result in cropping the image. But in this case, the image size changes to the new dimensions. You can use the steps described below to crop the canvas by the pixel.

The Procedure

▸ Set the measurement unit to inches.
▸ For this example, you will crop only the width of the image. To do this, you must click the chain icon next to Canvas Size in the upper window to remove the link between width and height.
▸ Set the value for Width to 4.0.
▸ Next, you have to set the offset; if you do not, the image will be cropped on the right side only. Since you want to crop the image equally by 0.5 in, you must set the Offset to X: -0.25 in, as 0.25 is half of 0.5 in. Alternatively, you can click the Center button to center and crop the image equally on both sides. Or you can select the image section by clicking the preview image and move it within the cropping frame, while holding down the left mouse button.
▸ Finally, click the Resize button to crop the image. Again, only the visible image section will be reduced. If you want to remove image information which has simply been hidden thus far, an extra step is needed. Go to the Image > Fit Canvas to Layers menu to remove previously hidden image data.

2.2.9 Saving your Image

Now that you finished editing the image, it's time to save it. In fact, it would be wise to make a habit of saving any image you are planning to modify immediately after opening it. Just save it as a new file with its own file name. This preparatory step will ensure that:

▸ Your original remains unchanged
▸ You do not overwrite your original by mistake
▸ You can save any desired change to the new image immediately

It is recommended to use a file format such as XCF, TIFF, or PNG for your working image. These formats guarantee best image quality. Of course, if the image contains layers, the GIMP will limit your format choice to XCF or PSD.

Compressed files in JPEG or GIF format should be created only as copies of the original or working image.

The submenus to save images are found in the menu bar of the image window. The File menu offers two options:

Save simply saves your modified image onto itself. The existing version will be overwritten. After you close the image, you cannot undo this process. It is highly recommended to save your image whenever you modify it to your liking. This will ensure that you won't lose your work in case of a power outage or program crash.

Save as: Select this option if your image is new, or if you want to save your image under a different file name and/or in a different file format.

You can enter a name and a file extension for the image that you intend to save in the text field beside Name. The Save in folder dropdown list displays the location where the last image you saved was stored. Click the arrow to display the options and select the folder you wish to store the image in. Click the + sign next to Browse for other folders to open a new dialog, similar to the Open Image dialog. This dialog will let you find and select the folder you want to save your image in. Or you can create a new folder by clicking the Create Folder button. Clicking the + sign next to the Determine File Type: By Extension option pops up a dialog that lets you select a (different) file type for the image you intend to save.

Figure 2.12: The File menu in the image window.

Figure 2.13: The simplest version of the Save dialog. The "Save in folder" dropdown list lets you select a storage location from your main folders or Favorites.

Figure 2.14: The Save Image dialog with all panes open.

Always choose a high quality file format for saving and archiving your images. You can type in the desired file extension or select the desired file type from the Determine File Type: By Extension dropdown list in the Save Image dialog. The list includes the XCF, TIFF, and PNG formats, all with compression. It is a good idea to create a separate folder for your working images. (Just click on the Create Folder button in the top left part of the Save Image dialog.)

When you save your image, a new dialog box will pop up and give you the option to export the image in the desired file format, depending on the format you selected. Click OK to proceed.

Another dialog will now prompt for desired image file attributes. For the TIFF format, select LZW Compression. This compression method is lossless and reduces the file size. Click OK to accept. Your image is now "in the can".

When exporting an image, the layers it contains can be merged into one background layer; that is, if you chose a file type (tif, jpg, png, etc.) which is unable to save layers. After the image is exported, the modified image will still be open in the image window.

Don't worry: if you saved your original image prior to changing the file attributes, it will not be overwritten. You can quickly reopen the original from within the Toolbox by selecting File > Open Recent. Remember: Always save images with layers in a layer-enabled format (xcf or psd).

The Save a Copy item differs from the Save as. The image will be saved as a copy in the desired file format within the selected storage location, but the original will remain open in the image window.

Finally, you should be aware that you can create templates for eventual reuse with new images. For example, if you want to use the same dimensions, resolutions, background attributes, and file format for multiple graphics, creating a template will save you time. Save the setting for the first image by accessing the File > Save as Template menu item. To reuse the template with a new image, select the File > New menu item and refer to the Template option in the pop-up dialog.

2.2.10 Printing Images

To print images from within the GIMP, you'll obviously need to connect a printer to your computer, and make sure that a recent driver is installed in Windows. Whether your printer is connected to a parallel port or a USB port can be a factor. The GIMP recognizes some printers at the parallel port only, even though the printer works flawlessly over the USB port when accessed from within other programs. Ideally, you should connect your printer to the parallel port (normally LPT1 for Windows). If you still have trouble printing images from within the GIMP, you might find a solution from the GIMP User Group (http://gug.sunsite.dk/). For questions relating to GIMP under Windows, visit the WinGIMP Forum.

Figure 2.15: The GIMP's Print dialog. Click the Attributes (Properties) button to set printer options.

Nevertheless, driver problems can arise, preventing you from printing directly from the GIMP program. Epson printers seem to have the most problems. But you can work around most of these problems by printing your images from within another program, such as IrfanViewer.

The **Print** dialog is found in the image window under the File > Print menu. If you installed a print program specific to your printer or other device (such as a scanner), a device-dependent program window will pop-up, which you can use to configure your settings. Otherwise, the GIMP's standard print window will appear.

The following settings are available in the Print dialog:

▸ Printer (dropdown list for selecting the appropriate printer, such as the printer at the parallel port (LPT1), if you have more than one printer installed)

▸ Print Range (to print specific pages of a multi-page document, such as EPS or PS [PostScript] files)

▸ Number of Copies (to print more than one copy)

Clicking the Properties button pops up a dialog where you can set the following options, depending on your printer:

▸ Page orientation (Portrait or Landscape)

▸ Media Choice (type of paper)

▸ Print type (color, gray levels, or black and white)

▸ Resolution (sometimes this is set automatically, depending on the paper selected)

▸ Depending on your printer, there may be more settings available, such as paper size and other variables

Keep in mind that you can always burn your images on a CD and take them to a photo shop for exposing and printing.

Note: Most large photo shops expose with a resolution of 300 dpi and accept only the JPEG file format. If you plan to take your images to a photo

shop, collect and save your images in 300 dpi resolution and JPEG format before burning them on the CD.

2.3 Working with Scanned Images

Of course, you can use scanned images and edit them in the GIMP, in addition to images from your digital camera. The following sections give you important information and detailed instructions.

2.3.1 Prerequisites for Scanning

Before you can read an image from a scanner in an image editing program, you must properly connect the scanner to your computer and install the scan program that came with the device. If you work under Linux, you can use the XSANE interface.

What image editing programs generally do is provide a scanning connection (usually referred to as the Twain source for Windows platform and SANE if you're using the Linux or Mac OS). An independent scanning program or XSANE is necessary for scanning, and can be accessed from within the image editing program. Scanning under Windows is described in Section 2.3.2; the same process works on all operating systems.

As mentioned above, scanning under Linux is supported by the SANE ("Scanner Access Now Easy") library. You can find SANE in many Linux distributions, including SUSE Linux. The graphical interface for scanning is called XSCANIMAGE or XSANE. If you've already installed SANE and XSANE, it can be accessed by going to File > Acquire > XSANE: Device Selection (i.e., your scanner) in the File menu of the Toolbox.

XSANE provides a graphical interface that allows you to choose settings for the current scan process, similar to the steps described in Section 2.4.2.

Additional information about SANE and XSANE can be found on the Internet at:

▸ http://www.sane-project.org
▸ http://www.xsane.org

The SANE library is also helpful for those running Mac OS X. From within the GIMP, it is accessed over a TWAIN-SANE interface. Mattias Ellert offers the required installation files (Mac OS X binary packages) for download from http://www.ellert.se/twain-sane.

Depending on your scanner, you may need to customize a few settings after installation for it to work optimally. Information regarding optimal scanner settings can be found at the Internet address above and on the SANE Project's website at http://www.sane-project.org.

2.3.2 How Scanners Work

Scanner Types: Flatbed, Drum, and Slide Scanners

Flatbed and slide scanners are popular with many home computer users. Following is a brief summary on how these scanners work and what their most important technical features are. Flatbed and slide scanners are sometimes used in professional environments, in addition to the higher-resolution drum scanners.

Flatbed scanners have a physical resolution of 300/600/1200/2400/ 4800 dpi and higher.
The decisive factor when choosing a good scanner is "physical resolution" (see the above values). Keep in mind that the higher values boasted by scanners utilizing so-called interpolated resolutions are calculated by "adding" image dots. This type of interpolation (supersampling) doesn't actually increase the accuracy or quality of an image; also, you can interpolate your image by using the image editing program.

How a Flatbed Scanner Works:
When using a flatbed scanner, place the original face down on the glass plate. Underneath that plate is a sled that carries the CCD (Charge-Coupled Device) on two rails. The CCD consists of light-emitting components and sensors that measure the light values reflected from the original document, and line by line relays them to the computer as image data. The physical resolution achieved is dependent on the number of light elements and sensors, as well as the sled's speed.

There are two types of flatbed scanners: single-pass and three-pass scanners.

In a single-pass scanner, the sled passes only once underneath the original document, capturing the color values for the three primary colors at once. Three-pass scanners use three passes, one pass each for red, green and blue.

Some flatbed scanners provide additional features, such as automatic page feeders, or templates you can use to hold small photos, transparencies or slides in place. These negatives and slides are scanned like regular original documents. However, they are exposed to an external light source.

Slide scanners: These scanners use a sensor chip that is similar to the capture chip in a digital camera. The maximum resolution depends on the arrangement and density of sensors on the chip. Most chips range up to 4800 dpi, and professional devices provide even higher resolutions. However, many professional slide scanners only accept (framed) slides, negatives, or film formats.

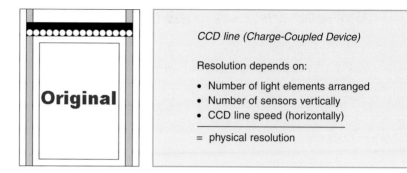

2.3.3 Problems When Scanning Printed Originals— the Moiré Effect

Certain original documents are poorly suited for scanning, especially printed images. When rippling or superimposed halftone screens create an interference pattern on a scan, it is referred to as the moiré effect.

Some image editing programs have wizards which automatically prevent the moiré effect. Many programs have several effect filters, such as the Gaussian Blur in the GIMP, which can be used to reduce or remove the moiré effect. Section 2.4.7 provides a detailed description of this function.

Most modern scanning programs are equipped with a corrective filter that can be used before the image is transferred to the image editing program to prevent the moiré effect.

2.3.4 Calculations To Consider Before Scanning

Before you scan something, consider the following:

1. How large is the image? (Determine its original size.)
2. How large will my image be? (Determine its output size.)
 Enlarging or reducing an image with your scanner will affect the resolution.
3. Which output medium are you creating the image for? Internet, screen, or print?
 Always opt for the highest quality resolution appropriate to a given medium. (As mentioned above, an internet image will be in a lower resolution than a print image.)
4. Determine the color depth (i.e. text [black and white], grayscale image [black-and-white], or full color).

Color Depth				
	Line art, text (one color; bitmap)	Grayscale (BW photo)	Special GIF (indexed colors)	Color (color photo)
Color depth	1 bit	8 bits	8 bits	24 bits (true color)
Second power	2^1	2^8	2^8	2^8 x 2^8 x 2^8
Number of color values	2	256	256	approx. 16.78 million

Selecting a Resolution

Let's review resolution since it is tremendously important. The resolution determines the number of image dots (pixels) per length unit (inch or centimeter) in any given image. The screen resolution is normally measured in dots per inch (dpi). In the printing industry, resolution is usually calculated on the basis of a screen that refers to the number of lines per inch.

When scanning original documents on a flatbed scanner for printing purposes, you should select the highest possible resolution. If the image is to be printed in its original size, 300 dpi is a good standard.

When scanning images for publication on the Web, it is a good idea to initially select a higher resolution for editing purposes. A high resolution will keep the sharpness and contrast of the image high while you edit, even if you'll eventually be reducing the resolution. Remember to reduce the resolution on a copy of the original image, as the process cannot be reversed.

Formula for the Scanning Resolution

Scanning original materials will allow you to calculate a scanning resolution for your print output. (Professional scanners achieve a much higher resolution than flatbed scanners manufactured for home use.)

$$\textbf{Resolution (desired)} \times \textbf{scaling factor} \times \textbf{scan factor} =$$
$$\textbf{scanning resolution}$$

(A scan factor between 1.4 and 2.0 will normally provide a good result.)

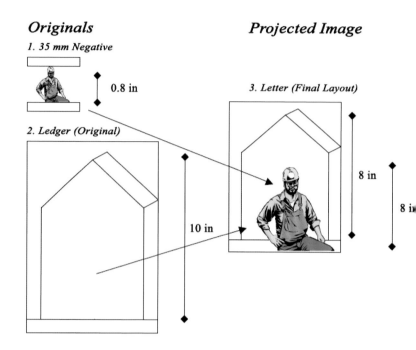

Example

Scaling factor = desired size/original size

For **screen output**, you should initially aim for a target resolution of 100 dpi (rounded down from 96 dpi):

1. In the example image, the worker in the miniature slide measures 0.8 in in the original image. Let's say that you want him to be 8.0 in in the screen output. This means you have a scaling factor of 10. So you would select 2 as your scanning factor.

2. The house measures 10 in in the original, and you want it to be 8.0 in in the new image. So you reduce it, obtaining a scaling factor of 0.8. Again, you can choose a scanning factor of 2.

Calculation by the formula:

Resolution (desired): for 1: 100 dpi; for 2: 100 dpi
Scaling factor: for 1: 8.0 in : 0.8 in = 10; for 2: 8.0 in : 10.0 in = 0.8
Scanning factor (selected): for 1: 2; for 2: 2
Scanning resolution for 1: 100 dpi × 10 × 2 = 2000 dpi
Scanning resolution for 2: 100 dpi × 0.8 × 2 = 160 dpi

For the **print output**, select a target resolution of 60 dots per centimeter. This screen is multiplied by 2.54 to convert it to dpi. The other settings remain the same.

Calculation by the formula:

Printer screen (selected): for 1: 60 dot/cm; for 2: 60 dot/cm
Resolution (calculated): for 1: 60 × 2.54 = 150 dpi; for 2: 60 × 2.54 = 150 dpi
Scaling factor: for 1: 8.0 in : 0.8 in = 10; for 2: 8.0 in : 10.0 in = 0,8
Scanning factor (selected): for 1: 2; for 2: 2
Scanning resolution: for 1: 150 dpi × 10 × 2 = 3000 dpi
Scanning resolution: for 2: 150 dpi × 0.8 × 2 = 240 dpi

2.4 Scanning and Editing an Image

2.4.1 The Procedure

▸ You decide you want to scan an image and import it into the GIMP.
▸ The image is tilted, so you need to rotate it to make it upright.
▸ Next, you want to remove the **moiré effect** (using the Gaussian Blur tool) and correct the contrast and the brightness (using tonality correction and curves).
▸ The image should be saved in high quality format using the name *miami-impro*.
▸ **Sideline**: Overview of the functions in the Image > Colors menu item.
▸ Finally, a copy of the image should be made for use on the Internet and email, so you'll want to lower the resolution and save a copy in a compressed JPEG file format).

2.4.2 Scanning Your Image

As mentioned earlier, a separate program (usually the scan program that came with your scanner) actually processes a scan, even though you're capturing the image within the image editing program. Because scan programs vary according to the make and model of the scanner, the example dialogs may be slightly different than what you will actually see on your computer screen.

To scan an image from within the GIMP, select the File > Acquire menu item in the Toolbox.

You now have the following choices:

▸ You can load an image that you previously copied on the clipboard (using the Copy menu item) as a new image in the GIMP (Paste as New).
▸ You can insert the contents of the clipboard that you copied from another application as your new image (From the Clipboard).
▸ You can produce a screenshot (i.e. a copy of what is currently displayed on your computer screen) in the GIMP, which will then automatically become the new image (Screen Shot).

Figure 2.16: The File > Acquire menu in the GIMP Toolbox.

Figure 2.17: Selecting the (TWAIN) source.

▸ And lastly, if you want to scan an image, you can select the TWAIN menu item. This will pop up a dialog in which you can select your scanner (or another TWAIN source connected to your computer).

"TWAIN" is an acronym for "Technology Without an Interesting Name"; it's also the standard "name" used when referring to image capturing devices for the Windows platform. However, if you are a Linux user, you will be using the XSANE program instead.

Click to select your scanner; then click the *Select* button to accept your choice.

If both your scanner and your scanner's software were properly installed, a dialog will pop up. Because this dialog comes directly from your scanner's software, rather than the GIMP, it might work a little differently than in the example.

By now, you should have already placed the material or image you want to capture facedown on the scanner. The dialog will determine how your image will be scanned.

Figure 2.18: Example of a scanner software dialog.

Most scan programs provide the following options:

▸ Number of colors to be scanned, i.e. color depth (black and white, gray-scale, color).
▸ Original document type (text, image, or film [some scanners come with an add-on device that allows scanning of photo negatives and slides]).
▸ Scanning resolution (usually selectable in predefined values, given in dpi).
▸ A Preview button that activates a low-resolution preview scan.
▸ A Scan button that starts the scanning process.

Insert your original document in the scanner. If you click the Preview button, the image will be quickly scanned and displayed in the preview window. The scan software will automatically identify the image margins and mark them with a dotted line that is sometimes referred to as the "selection frame" or "marquee". You can resize the selection frame by hovering the mouse above it, then clicking and dragging the dotted line until you've selected the desired area of your image.

Click the Scan button to activate the actual scan process.

Once the image is read, the GIMP will open a new document for the scanned image. Close the scan program, and don't forget to save the new image.

Exercise: Scanning an image from within the GIMP.

2.4.3 Editing a Scanned Image

To help you practice the editing steps described below, you'll find an image called *miami.tif* in the *SampleImages* folder on attached CD. Open the file (using the File > Open menu item in the GIMP's Toolbox) and save it as *miami-impro* in an exercise folder on your hard disk. Save the image in a high-quality file format, such as XCF or TIFF.

After you open the file, you may notice a few defects. The image tilts to the right, because it wasn't inserted properly in the scanner.

In addition, the borders of the image jut out because it wasn't properly cut, so it needs to be cropped.

The image also suffers from the **moiré effect** caused by an interference of the print screen with the scanner screen. This particular image was captured from a newspaper; this type of moiré effect does not occur in scanned photographs.

Figure 2.19: The GIMP's working window displaying the image miami.tif.
(Photo Claudius Seidl)

2.4.4 Determining the Angle and Number of Dots in Your Image

Figure 2.20: Using the Measure tool to determine the image angles.

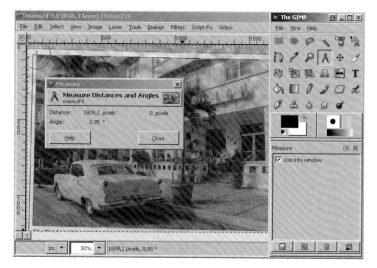

Obviously, the image needs to be straightened out. To specify the rotation angle, drag a guide on the image. Click the top ruler and while holding down the left mouse button, drag it downwards. Position the guide on the upper left-hand corner of the image. You now have a horizontal selection area .

Using the Measure tool 　, measure the angle of the tilt, so you can use the same amount to rotate the image upright. Click on the Measure tool in the Toolbox. You can check the Use Info Window option, which will show you the values obtained by the measure tool. However, for your convenience, the measured values are also displayed in the status bar at the bottom of the image window.

The cursor should have changed into a cross hair marker or sighting reference. Click on the upper left corner of the image while holding down the left mouse button down, and drag it to the upper right corner of the photo. The status bar (and the Info window if you opened it) now shows an angle of approximately 1 degree, the exact amount to rotate the image in order to un-do the tilt.

2.4.5 Rotating an Image

Select the *Rotate* tool 　 from the Toolbox. From the Affect option, select *Rotate Layer or Selection*. You can also access this tool from the Tools > Transform Tools > Rotate menu.

Let's take a detailed look at the options available in this dialog:

▸ **Affect**: Use this option to choose what should be affected by the transform. You can affect the Layer, the Selection, and/or the Path. Select the Transform Layer option.

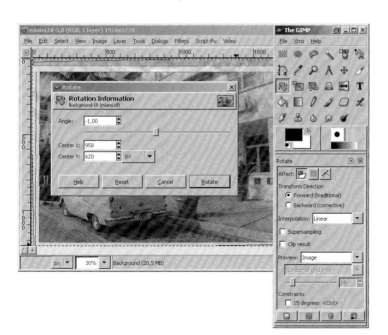

Figure 2.21: The Rotate dialog with the Rotate Layer or Rotate Selection options.

▸ **Direction**: This option sets the direction in which a layer will be rotated. *Traditional* rotates the layer clockwise, Corrective rotates counterclockwise. You can also change the rotation direction by entering a – (negative/counter clockwise) rotation angle.

▸ **Interpolation**: Select Cubic (Best) from the drop-down list to determine how missing pixels should be calculated from surrounding pixels.

▸ **Supersampling**: Check this option for highest quality (and longest computing time). The color values of surrounding pixels will now be included in the interpolation calculation.

▸ **Clip Result**: This option will clip the rotated layer to the original layer size.

▸ **Preview**: This drop-down list lets you select a preview of the rotated image, an outline, grid, image or grid and image, while rotating the image.

▸ **Constraints**: This option allows you to constrain the rotation to angles divisible by 15 degrees.

Start by rotating the image. With the Rotate tool selected, click on the image. The Rotate dialog pops up. Enter a rotation angle by typing over the default value. If you selected the Traditional transform direction, the value entered for the rotation angle must be negative.

Alternatively, you can set a rotation angle by clicking the arrows or the slider. If you want to rotate an image manually, click on the image.

In the Rotate dialog you'll find the options Center x and Center y. Use these options to select a **rotation point** other than the image center point (which is the default setting).

Click the Rotate button to accept your changes. The image will be straightened out automatically.

Tip: All tools available in the Toolbox can also be accessed from the Tools menu in the image window.

2.4.6 Cropping an Image

Now that your image is in the upright position, you'll want to crop the jutting borders. Use the guides to highlight the borders.

Select the Crop / Resize tool ![icon] from the Toolbox. The mouse pointer will again change to a cross hair cursor.

Point the cursor to the upper left corner of the desired image section. Click while holding down the left mouse button; then drag it over the image to the lower right corner. Release the mouse button. The section you traced is now masked dark.

You can correct the strips at the edges by pointing the cursor at the upper left and lower right corners of the highlighted rectangle and dragging it.

When you are satisfied with the boundaries of your selection, click Crop to accept your changes. The image will be cropped.

Figure 2.22: The Crop Info window and tool settings.

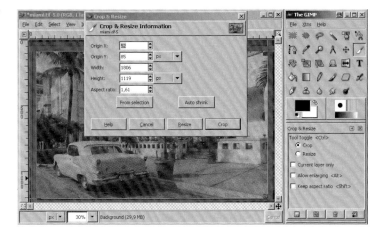

The Resize option can also be used to reduce the visible image section, but the surrounding image data will be hidden.

You can also resize and/or crop images by using the image coordinates and entering the appropriate values.

2.4.7 Using the Gaussian Blur Filter to Remove the Moiré Effect

Next, you'll want to remove the moiré effect from the image. For this action, you will use a filter called Gaussian Blur.

The filter can be found on the image window menu. Go to Filter > Blur.

Note: As a rule, most filters that blur images should be used after you've finished with all other image editing work. Remember to save a copy of the image before using a blur filter. However, the Gaussian Blur is an exception, if you are using it to remove the moiré effect.

After selecting the Gaussian Blur filter, use the dialog to set the amount of blur desired. A higher value will produce more blur.

The filter can also be used to blur the background of an image. If you paste a sharply drawn object in the foreground, it will seem even clearer in contrast to the blurred background.

However, since in this case you are only concerned with correcting the **moiré effect**, the image will retain most of its contour sharpness.

In the Gaussian Blur dialog, select the RLE option. (RLE stands for Run-Length Encoding, an algorithm for lossless data compression. Repeating values are replaced by specifying a value and a counter.)

Enter a value between 2 px and 4 px in each of the two Radius fields. In this example 4 px was selected. Non-integer values can be selected by typing them in the fields.

The filter dialog provides a preview, so that you can see the effect of your settings. Again, a double arrow appears in the bottom right corner of the preview pane. Click on the arrow to select the image section in the preview. Click OK to accept your changes. The program will recalculate (render) the image.

At this point in the exercise, you have completed several important steps. This is a good time to save the image. Selecting File > Save is the simplest way to save at this point, particularly since you've already named the image when you first begun the process.

Now take a look at your image: What further improvements can be made to enhance the quality of the image?

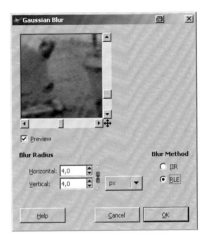

Figure 2.23: The Gaussian Blur window.

Figure 2.24: The image after rotating and cropping it and removing the moiré effect.

The moiré effect is gone. But if you take a closer look, you will notice that there are waves and shadows on the facades of the buildings. (This probably resulted because the image was damp or rumpled instead of flat and dry when it was scanned.) The image touchup option will come in handy when correcting this problem. Also, you'll notice that the image is a little dull and the colors are muted. Taking the following actions might help:

▸ Correcting the tonality (color levels)
▸ Setting the brightness or contrast
▸ Setting the hue or saturation

You will find options for setting color depth, brightness, contrast, and color in the Tools > Colors menu.

But first, let's explore the two most important submenus in detail:

▸ **Levels** (tonality correction)
▸ **Color Balance** (color correction)

2.4.8 Setting the Contrast and Color—Levels (Tonality Correction)

Tonality correction will improve the quality of almost any image. You'll find several options to do this, of course.

The setting options for the **Levels** (tonality correction) can be found in the Tools > Color Tools > Levels menu or in the Layer > Colors > Levels menu.

Note: The Layer > Colors > Levels submenu has an Automatic button. Clicking this button will apply a tonality correction that is automatically calculated from the image values. For many images, this function is sufficient to optimize the image quality.

The most striking effect in the Color Levels dialog is the black curve, which is sometimes referred to as the **color histogram** of the image. Initially, this color histogram is created from the image's RGB color channel (Channel: Value).

The curve shows how the color lightness values are distributed in the image. In the recently modified *miami.tif* image, you can see that the curve starts a short distance from the left margin and ends before the right margin. Roughly speaking, this means that the image does not possess "real" black values (shadows). It also tells you that the image has only a small amount of "real" white values (highlights).

Underneath the histogram are the numerical values for the image's lightness (target values). Below these numerical values is a black to white slider bar, which corresponds to these values. You can move the triangles under the slider bar to change the lightness of the image. This tool works similarly to the settings under the Brightness-Contrast menu. However, you'll probably find that the histogram options are more comfortable to work with.

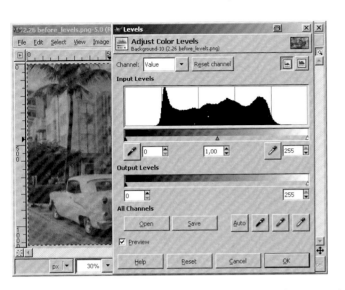

Figure 2.25: The Color Levels window.

Underneath the slider, you'll see a black, gray, and white triangle which corresponds to the shadows, midtones, and highlights in the image. These are initially positioned at the margins of the histogram window, and in its center.

By moving these triangles from the border into the histogram curve, the lightness values of the image are moved towards the target values of the image. For example, if you move the black triangle towards the right, the dark colors in the image become darker. Likewise, when you move the white triangle, the bright colors become brighter. In addition, you can correct the lightness of the midtones in the image by moving the gray triangle, which increases the color extent and contrast of the image.

Make sure the Preview option is checked in the Color Levels dialog so you can see the effect of your changes as you edit.

When you are satisfied with the result, click OK to save your changes.

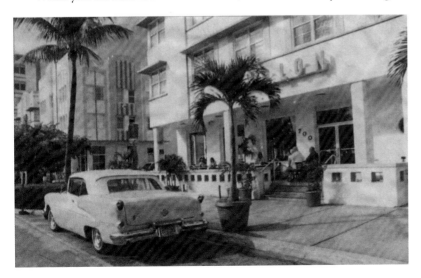

Figure 2.26: Comparing the image, before.

Figure 2.27: Comparing the image, after.

Click the Channel: Value button (top left in Figure 2.25) to edit each of the red, green, and blue color channels individually. This is important when working with images with color cast (more about that later).

To the right of the Channel: Value button, you'll see two additional buttons. If you hover your cursor over these buttons, you'll see that the left button is called *Linear*, while the right button is called Logarithmic. Depending on the button you select, the representation of the histogram curve will change. The logarithmic method is more data-intensive, but more exact.

You will also find buttons represented by black, gray and white eye-dropper icons. If you select the black eyedropper and click on an area of the image that should be set in pure black, the program will recalculate the lightness values. The same holds true for the white eyedropper. Using the black and white eyedroppers may be sufficient to obtain a good tonality correction. The additional gray eyedropper can be used to set the midtones of the image. This can be helpful when working with color-cast images as it tells the program what hue you want to assign to a gray shade (e.g., a shadow on a white surface). Unfortunately, in the current GIMP versions this function often leads to faulty results; but this bug will probably be removed in future versions.

2.4.9 Setting the Contrast and Color Extent— Brightness and Color Levels (Curves)

The *Curves* tool is the most sophisticated tool for adjusting the color, contrast, and brightness of an image. However, this tool requires some effort to learn. By contrast, it is easier to handle other tools, such as Levels (tonality correction), Brightness-Contrast and Color Balance or Hue-Saturation.

You can access the *Curves* tool from the Tools > Color Tools > Curves or Layer > Colors > Curves menu.

The Curves Tool Options

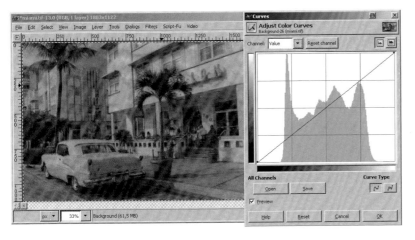

Figure 2.28: The Curves tool when it is activated.

Click the Channel button (top left) to determine whether you want to edit and correct your image by using the RGB color channel (Level) or by setting the red, green and blue color channels individually.

The two buttons in the top right corner let you to select a method by which to calculate the color histogram, either Linear and Logarithmic. The default setting is Linear.

The large pane displays a histogram of the image (i.e. the color or bright-dark distribution). A control curve has been drawn from the bottom left corner of the histogram to the top right corner. This is the neutral gradation curve of the image in its current state.

At the bottom left of the histogram are two bars ranging from black to white, which represent the brightness distribution in the histogram.

You can use the two Curve Type buttons to select whether you prefer the curve to be a smooth line or whether you want to draw your curve freehand with the mouse.

The Smooth curve type lets you place points on it by clicking on the curve. Moving these points along the curve will change the brightness values of the image. The program will calculate the curve based on the points placed on a smooth line. If you accidentally placed too many points on the curve, just click and drag them off the line to delete them.

If you use the Free curve type, the bright-dark values will be calculated exactly as you draw the curve. In theory, you can use the curve you have drawn to configure all lightness values in the image individually. You can then toggle to the Smooth mode and allow the program recalculate the curve.

The Preview button should be checked (click the box) so that you can see your changes to the gradation curve immediately.

The Reset button permits you to delete all changes made to the gradation curve without closing the tool.

Using the Gradation Curve to Correct the Tonality

The tonality of your image can be corrected by moving the bottom end point of the diagonal gradation curve horizontally towards the inside of the histogram while holding the left mouse button down.

You can now place additional control points along the curve. In our example image, the colors in the depth range (dark colors) were moved slightly upwards. This caused them to become more distinct and brighter. The same correction was applied to the colors in the highlight area. As a result, the wavy shadows in the image appear more balanced and the highlights in the image are brighter.

Figure 2.29: Using the gradation curve to correct the tonality.

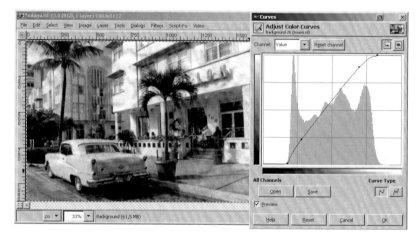

Using the Gradation Curve to Set the Brightness

Figure 2.30: Using the gradation curve to make an image brighter.

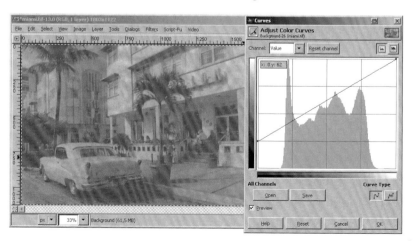

Similar to the Brightness-Contrast function, the gradation curve can be used to brighten or darken an image. Simply move the end points of the curve upwards (for brightening) or downwards (for darkening). Again, you can insert control points to make specific color areas brighter or darker.

Correcting the tonality and setting the brightness can either be done in consecutive steps, or by one process.

Using the Gradation Curve to "Solarize" Images

You can also use the gradation curve to set the color values of an image and produce an effect similar to solarization (partial color inversion).

"Solarization" is a term used in film development for the effect created when a photographic film is exposed to light during or after its development. When film is re-exposed to light after being developed up to a certain point, it results in extreme brightness or color inversion: the phenomenon causes a strong graphical distortion in the picture or image.

As shown in Figure 2.31, a similar effect can be achieved if the gradation curve is created to mirror the histogram curve.

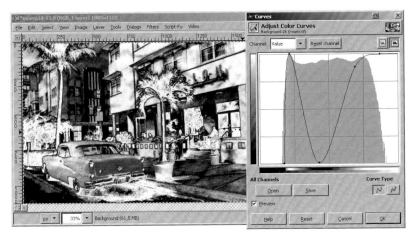

Figure 2.31: Appropriately setting the gradation curve can yield color inversions.

2.4.10 Overview of the Functions in the Image > Colors Menu

Menu Function	Explanation
Color Balance	Used to adjust colors in an image, and to modify color levels of red, green, blue, cyan, magenta, and yellow separately by shadows, midtones, and highlights. Also used to correct images with color cast.
Hue-Saturation	Hue: Changes colors in relation to each other. Provides limited possibilities for correcting colors, including images with color cast. Suitable for graphical effects and the distorting or colorizing of image elements. Saturation: Increases or reduces the saturation (intensity) of an image's colors (up to gray levels). Lightness: Lets you additionally adjust the lightness of an image. You can decide whether changes will apply to all colors of an image or a specific color only.
Colorize	Renders the image as a grayscale image as seen through a colored glass.
Brightness-Contrast	Sets the brightness and/or contrast (light-dark distribution) of an image.
Threshold	Lets you set a threshold between black and white image sections, which serves as the value from which the image is converted into a pure black-and-white image.
Levels (tonality correction)	Lets you adjust the light-dark distribution in an image (together with the color extent and contrast). Creates real new shadows and highlights (black-and-white tones) in an image. It can also be used to correct the brightness of an image by adjusting the midtones. Each color channels can be modified separately. Provides an option for automatically setting the levels.
Curves (gradation curves)	Lets you adjust color curves, similar to Levels and Brightness-Contrast, but with a purely graphical interface for the settings. You can use this function to achieve inverted and graphical distortions similar to solarization.
Posterize (Reduce Number of Colors)	This tool can gradually reduce the number of colors in an image, or harmonize the colors. You might find it helpful when converting a photograph into a graphical image for screen printing.

2.4.11 Saving an Image in Compressed Format (JPG/JPEG) for the Internet

After you finish editing your image, the following steps are recommended before saving an image for use on the Internet (or webpage or e-mail attachment):

1. Adjust the image size.
2. Reduce the resolution to 72 dpi (or 96 dpi).

The example image *miami.tif* has a resolution of 300 dpi. This resolution is too cumbersome for Internet or computer use. Due to the large file size, the image would require unnecessarily long transmission times to upload or download.

To adjust the image size, access the Image > Scale Image menu and set the values. Change the values for the resolution firstly and the image size secondly. 72 dpi is recommended for the resolution, and 6.43 × 4.0 in for width × height. It may be convenient to crop the image to 6.0 × 4.0 in, but it is not necessary for the following steps.

Figure 2.32: Adjusting the size and resolution of an image in the Image > Scale Image menu.

Don't forget to set the measuring unit (*Pixels/in* and *inches*).

Click Scale to accept your changes. The image will become smaller in the image window, but this time, it's not a zoom effect. The image has actually become smaller; the pixel count has been reduced. Because some image data is lost in the reduction process, you should always use a copy of the original image before reducing resolution or size. If you forget to save a copy first, you can discard the changes when you save the original.

To get a better view of the changes you will be trying out next, use the Zoom function to enlarge the view.

Go to Image > Filters > Enhance > Sharpen to sharpen the contours of your image. This filter has little or no effect on high-resolution images. Once you have reduced the resolution of an image, however, the Sharpen filter can greatly improve the edge sharpness and clearness of the reduced contours.

To save an image in a compressed format (JPEG, PNG), start in the usual way: Open the File > Save as menu. Select the folder you want to store the image in. Enter a file name for the image and select a file format, in this case, you'll choose a compressed file format, such as JPEG or PNG.

Figure 2.33: The Exporting File dialog when
saving an image in JPEG format.

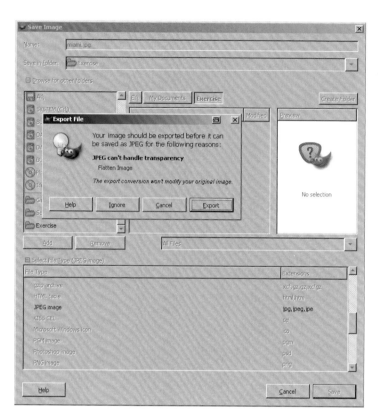

When you click *Save*, you will notice a dialog asking you to export the image as you save it. This ensures that the original will not be overwritten. Click on the Export button.

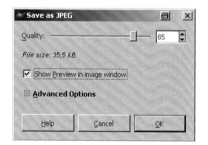

Figure 2.34: The Save as JPEG dialog.

Saving to JPEG—the Actual JPEG Compression Dialog

At this point, the dialog for setting the file compression will pop up. Click the checkbox next to the Preview in Image Window option so you'll be able to see the changes in quality in the image window as you use the slider to adjust the compression. Zoom into the image to better see where the **compression artifacts** (squares in which the colors are heavily unified) occur.

Settings for Advanced Options

▶ Make sure the option Optimize is checked. This improves the ratio between the quality/compression and the file size (so that as the file becomes smaller, the quality remains the same).

▶ Select a compression method in the *Subsampling* pulldown menu. The pre-selected 2x2,1x1,1x1 is a good standard.

▶ Selecting Floating Point from the DCT Method (Speed/Quality Tradeoff) pulldown menu provides the most exact method for calculating the

compression. Although it is the slowest method to calculate, it results in the highest quality.

▸ The actual compression (along with the file size in KB, top left) is adjusted by moving the Quality slider. A quality setting of 100 will give you the best image quality and the largest file size. As you move the slider to the left, both the image quality and file size are reduced. Initially, the quality deterioration is so small that it cannot be noticed, but as you increase the compression (thus reducing the quality), the compression artifacts or block artifacts become visible in the image. Watch the preview in the image window.

▸ As soon as compression artifacts become clearly visible in the border area, you can slightly improve the image quality while further reducing the file size by using the Smoothing slider.

▸ The Force Baseline JPEG option refers to the standard encoding used by the compression method.

▸ The Progressive option refers to a faster display rate and a gradual image refresh rate when represented on the Internet.

Indicative value for the file size: For an image with a size of about 4 × 6 in, a file size of approximately 24 KB is a good value. The visible quality will be decent. Try it, then click OK to accept your changes. The compressed image will be saved in the folder previously selected. You can retrieve from that folder when you want to publish it on the Internet or attach it to an e-mail.

The time required to transmit this image over a 56-kbit/s modem is approximately five seconds. An image with a size of 1024 KB (1 MB) would take about four minutes. The previously cropped original image *miami-impro.tif* had a file size of approximately 4.41 MB before reduction.

Figure 2.35: Advanced options in the Save as JPEG dialog. The image window displays the enlarged image with clearly visible compression artifacts.

2.5 Touchup Work 1—Removing Color Cast

2.5.1 What is Touchup Work?

So far you have learned about the basic program functions and how you can use these functions to improve the quality of your images. In the previous sections, you have used these functions to edit or modify your image as a whole.

However, an image may have additional blemishes that you wish to correct:

▸ An image may have significant color cast
▸ Older, scanned photos may have scratches and spots, scanned slides may have dust, bits of fluff, or unwanted image elements, such as embedded text, which can be removed
▸ People with red pupils resulting from taking photos with a flashbulb, (i.e., the red-eye effect)
▸ Some images may have a pale, dull, or stale sky that needs to be freshened up

The work required to remove such blemishes is called image touchup.

The following sections explain techniques and tools for **constructive touchup** that will teach you how to remove the image blemishes mentioned above by using examples. The last two touchup steps belong in Chapter 3: Working with Layers and Masks, since they require masks.

How Does Color Cast Happen?

Color cast can be seen as a discoloration throughout an image. You might notice the blue color cast that results from taking in bright light under the sky without skylight filter, or the yellow color cast that results from taking pictures without a filter in artificially illuminated rooms. Color cast can also result by improperly developing the image in the lab or using the wrong settings.

2.5.2 Color Correcting Options

The tonality correction (Levels tool) is quite suitable for editing images with color cast. In this exercise, you will edit the red, green, and blue color channels individually. Color correction can also be employed to remove color cast, particularly when the discolorations are minor. The following section provides step-by-step instructions for using these two functions.

2.5.3 Using the Levels Tool to Correct Color Cast

Open the image *colorcast.png* in the folder *SampleImages* on the CD and save it in your exercise folder.

You will notice that the image has a distinct red color cast, which means that the red color channel values are faulty.

You can use the tonality correction in the Layer > Colors > Levels menu to correct the bright-dark values in the image. Using the Levels dialog that pops up, first change the settings of the **RGB color channel** by clicking the Auto button.

The image should be visibly improved, as now the real black and white tones can be seen.

Clicking the Channel pulldown menu on the top in the Levels window accesses the **red, green, and blue color channels separately** so that you can correct each color individually. Select the red color channel.

Figure 2.36: The colorcast.png image has a strong red color cast.

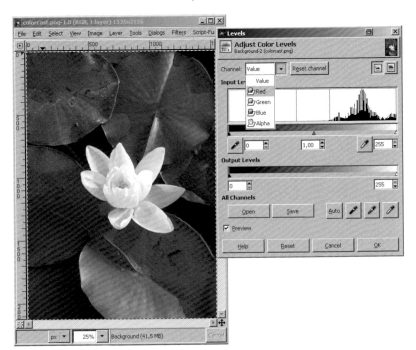

Figure 2.37: colorcast.png after automatic tonality correction has been applied (prior to correcting the red color channel).

In the Levels window you should see the histogram for the red color channel. Underneath the histogram are the adjustable triangles that you are now familiar with. You can skip the black triangle for shadows and the white triangle for highlights—let's just say that the automatic correction did a perfect job balancing them.

Click the left mouse button on the gray triangle and drag it to the right, while holding the left mouse button down. Doing this will change the **midtones of the red color channel**. If you check the Preview option in the Levels window, you can immediately view the adjusted image.

What next? Simply adjust the color according to your personal preference, and voila! Save the image as *colorbalance1.png* in your exercise folder, and you're done.

Another method for correcting images with color cast is by using the black and white eyedroppers in the Levels window. You can click either of these buttons to select a black or white spot.

In order to use this secondary option, your image must contain true black or white areas (i.e. areas that the program will accept as black or white.) Select the Black eyedropper and click on the black area of the image. Then proceed to use the White eyedropper on the white area. This procedure is often sufficient to correct the color levels.

You might notice that there is a third Gray eyedropper. Its *raison d'etre* is to allow you to select a neutral gray as your reference color, but it is not completely stable and sometimes results in distorting the colors. This is a GIMP program bug that hasn't been fixed as yet.

Note: You can use the tonality correction (Curves) to correct almost every "normal" color cast. For images with a red, green, or blue color cast, it is generally sufficient to adjust an individual color channel.

However, if you come across an image with a color cast created by a secondary color in the RGB color model (such as Cyan, Magenta, Yellow), you may have to adjust two, or even all three, color channels. A yellowish color cast will require correction of the red and green channels, at the very least.

2.5.4 A Second Method to Remove Color Cast—Color Balance

Color Balance not only corrects images with color cast, it also can be used to adjust colors in general, freshen up colors, or even to change or intentionally distort colors.

▶ Open the image *colorcast.png* from the CD again.
▶ Access the Color Balance function from the Image > Colors > Color Balance menu.

Figure 2.38: The Color Balance window with a preview of the image.

Within the Color Balance window, you will see three sliders set at the zero position. Their purpose is to Modify Selected Range's Color Levels, and there are three buttons, each specifying a range to be modified: Shadows, Midtones, and Highlights.

You can move the sliders to one side to increase the color level of a certain color in the image, or you move them towards the complementary color, i.e., Cyan, Magenta or Yellow to balance out the color. Select Range to Modify: You can pre-select the range of luminosity for the colors of the image that will be affected by your adjustments.

Uncheck the option next to Preserve Luminosity, but leave the Preview option checked.

This function is appropriate for minor color corrections or to intensify colors.

The following values will yield a good result when applied to the example image:

Shadow	**Cyan – 50** Magenta **Yellow – 50**	0	Red Red Blue
Midtones	**Cyan – 50** Magenta **Yellow**		Red **Red 50** **Blue 50**
Highlights	**Cyan – 50** Magenta **Yellow**	0	Red Green **Blue 50**

Of course, you can change the other colors and adjust the image to your taste. Feel free to experiment!

If you like, you can subsequently perform a tonality correction or post-edit the brightness and contrast using the Brightness-Contrast function.

Save the finished image as *colorbalance2.png* in your exercise folder.

Note: The **Channel Mixer** is yet another function of the GIMP that can be used for color balancing. What's more, you can use this tool to create fancy or even psychedelic atmospheres for your image. Find this tool in the Filters > Colors > Channel Mixer menu.

2.6 Touchup Work 2—Removing Spots, Dust, and Scratches

Older images or slides often have blemishes, such as creases, dog-ears, spots, dust, scratches, and missing edges.

The touchup work involved to fix such images is called "constructive touchup" since it involves "reconstructing" image elements. Constructive touchups also include removing image elements, such as unwanted text.

In times long gone, photographers armed themselves with brushes, clone maskers, and airbrushes when fixing damaged images. Nowadays, images are scanned "as is" while the photographer's repair tools are supplied by his or her image editing program. But the techniques are similar, the main difference being that the tools are now in digital form. It seems as if every new version of a digital editing program introduces new tools for the correction and stylization of images.

2.6.1 Why You Need Smooth Brushes—the Clone Tool

The Clone tool uses image data and patterns to "draw" not only colors, but color structures. These structures are actually pieces of your image that you previously copied from a defined area in the same image. This tool is capable of doing more than just working with "normal" opacity. Since you can set the tool's spacing between brush marks when you trace out a brush stroke with the pointer, you can use this fuzzy painting technique to create smooth transitions. The Clone tool is considered *"the"* touchup tool.

The Clone tool uses the same brush pointers that are available to the drawing tools. Accessing the Dialogs > Brushes > Pointers menu, you will find brush pointers with hard, sharp edges that draw like pens with fixed widths, as well as pointers with soft edges or feathering that draw more like a paintbrush, with rich color in the center that fades as it moves towards the edges. Moreover, there are brush pointers in the form of patterns that apply color in structures.

For this exercise, you will want to use the Clone with "soft" pointers. Brushes with hard edges will create image patterns with sharp edges: this may be acceptable for a single color, but if you are working with structures, even similar structures, the image would appear as if it had been strewn with confetti. A softer brush pointer creates a smooth transition.

Because the GIMP doesn't come with a large array of brushes, it provides a simple way to create new brushes. You should create a certain choice of additional brush pointers in advance, so that you can change a pointer quickly when you're working. Once you have created a brush, you can save and reuse it.

2.6.2 Preparatory Work: Creating New Brush Pointers

To create new brush pointers for future use, access the File > Dialogs menu from the Toolbox or the Dialogs > Brushes menu in the image window, or simply click the brush pointer symbol in the bottom right field of the Toolbox.

In the Brushes window, click the New Brush button (second button from the left in Figure 2.39). The Brush Editor window will pop up.

Begin by selecting a Shape for the new brush (Figure 2.40): Circle, Square, or Diamond.

Figure 2.39: The Brushes selection window.

Use the Radius option to define the radius between the center and the edge of the new brush.

Hardness defines the amount of feathering that will occur. A value between 0.00 and 0.50 is recommended for soft, wide feathering.

If you want to create a calligraphic effect, you can use the Angle option to build a nicely angled brush. A page ratio greater than 1.0 is also required.

When working with the Clone tool, a round brush is best, so leave the angle values at 0.0 and page ratio at 1.0, for now.

In the text field, enter a name for the new brush. Include the size and properties of the brush for future reference. (i.e., Circle feathering 50%, 45 × 45 (px, diameter).

Click the Save button. Your new brush can now be found in the Brushes window; just click on its name whenever you wish to use it.

Create a total of six new brush pointers with soft edges and diameters of 25, 35, 45, 65, 100, and 200 (i.e., Radius: 12.5, 17.5, 22.5, 32.5, 50, 100). This will give you a good array of brush choices. Smaller soft brushes sized from 3 × 3 to 19 × 19 were installed with the GIMP.

You can use the Brush Editor at any time to edit your custom brush pointers, or to create new ones. The maximum brush radius is 1000 px.

When setting the size in the Brush Editor, first use the sliders to get an approximate size. Next fine-tune your new brush using the cursor keys (arrows), or by typing the exact value desired in the text fields.

2.6.3 Preparing the Clone—Tool Options

Before you start editing your image, take a look at the **tool options** for the Clone. As mentioned earlier, these settings can be accessed in the bottom dock window of the tools palette, or by double-clicking the icon in the GIMP Toolbox.

Opacity: When applying a brushstroke with the pointer; opacity influences the application of a color or pattern from completely opaque (100%) to transparent (0%). The Clone's default is an opacity of 100%. This means that the color or pattern will completely cover the image details underneath.

In some cases, you may need to use a more "fuzzy" painting technique to achieve a desired result. For example, you can set the opacity to 10%, so that the color will be applied transparently, which means that the colors and structures underneath that area will remain visible. Opacity allows you to apply a colored "glow" as well as produce seamless transitions.

Mode: The Mode menu describes how the color is applied to the image and what effect it will have. Normal mode will apply color without mixing or stacking elements from the underlying image background.

Brush: You can access the Brushes selection window wherever you see this icon.

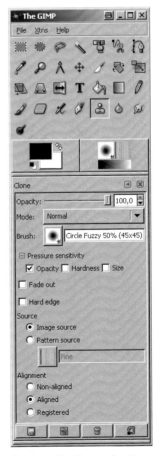

Figure 2.40: The Brushes selection window. Clicking the New button pops up the Brush Editor window.

Figure 2.41: The Clone tool options.

Pressure Sensitivity: This option only applies when using graphics tablets and pens. It allows you to manage opacity by the amount of pressure used when drawing with the graphics pen. You can also use this option to decide whether you want a tool's hardness or a brush's size to increase in conjunction with pressure.

Fade out: The Clone can be used to wipe an image, similar to a brush with the color fading out while painting. If you click the Fade out checkbox to select it, the brush application will fade towards transparent. You can also select the length of the feathering effect.

Hard Edge: Produces a hard, edgy result, even when using brushes with feathering.

Source: Use this option to select whether the information to be cloned should be copied from the image (Image Source) or from a pattern in a palette (Pattern Source).

Alignment: Non-aligned means that a point in the image will be used as selection area for application with the Clone. No matter where you apply the Clone, the information will be taken from the same image point.

Aligned means that you will select a point in the image, from which the information will initially be taken. You can then click on the area where you want the color to be applied. Next time you apply color, the point where the image information was picked up is linked to the pointer. It now follows the pointer with the same distance and angle.

The Registered mode requires two images, taking information from one image and inserting it in the other. In both images, the tool's starting point is the upper left image corner. In *Registered* alignment mode there is no offset between the point supplying information and the point where color is inserted.

Select the following Clone tool options:

▸ Opacity: 100%
▸ Mode: Normal
▸ Pressure Sensitivity: Nothing
▸ Face out: Nothing
▸ Hard Edge: Nothing
▸ Source: Image Source
▸ Alignment: Aligned

Leave the Brushes window open.

2.6.4 Using the Clone for Touchup Work

Open the image *dustandscratches.png* in the *SampleImages* folder from the CD and save it in your exercise folder.

You should see the image window (with the sample image) and the Brushes window (Dialogs > Brushes menu). In the Brushes window, select small brushes with soft edges (hardness 0.0). You'll need a brush with a diameter of about 45 px or 65 px to remove spots, and one with a diameter

of approximately 25 px or 35 px to remove the dog-ear and the scratches. Select the Clone tool from the Toolbox and start with a brush of 65 pixels diameter.

Collecting Image Information and Adding it to the Image

The first step is to select the point from which the image information is to be copied so you can transfer it to the blemish and correct it. Point the mouse cursor at an appropriate image area near a blemish. Press the Ctrl key and hold it down. The cursor will take the shape of a cross hair. Point on this spot and click the left mouse button to copy data from the image, while holding the Ctrl key down.

Figure 2.42: The image dustandscratches.png before the touchup.

First release the mouse button and then the Ctrl key.

Now when you left-click on the blemish, the image information previously taken will be placed there. Point to another blemish and repeat the process. Since you have selected the Aligned option, the point from which the image information was taken will move around the image as you shift the mouse. Continue working until you need to copy new image data to correct blemishes in different areas. Repeat the process described above, i.e., select a new point to copy information, press and hold down the Ctrl key, left-click, release mouse button and Ctrl key, then "stamp" out the blemish by left clicking on it.

Changing Brush and View

The selected brush, 45 px or 65 px, was perfect for removing spots along the wall and in the flower beds. If you want to remove the scratch or dog-ear in the upper right corner, you should select a brush with a smaller pointer from the Brushes window.

In order to edit the scratched area more comfortably, use the Zoom tool (View > Zoom menu) to access a more detailed view of the area.

Undoing a Step

The **Undo (History)** function was discussed at the beginning of this tutorial. If you inadvertently clicked on the wrong area, just use the Ctrl+Z keyboard shortcut (or the Edit > Undo menu item) to undo a step. In the Tools palette under File > Preferences > Environment you should have already defined the number of steps you can undo.

Figure 2.43: The image from Figure 2.42 after the touchup.

Alternatively, you can use the Undo Palette by going to History in the File > Dialogs menu in the GIMP Toolbox.

In addition to removing blemishes with the Clone tool, you can remove unwanted elements from an image, such as an ex-boyfriend or ex-girlfriend. Don't forget to save your image when you're finished.

3 Using Masks and Layers— Painting, Filling, and Color Tools

3.1 Introduction to Masks and Selections

Masks and selections are two sides of the same coin. Whenever you select an image area for editing, you are in fact simultaneously laying a mask over the original. This mask serves to protect the original image, thus enabling you to undo any undesirable changes you may have made. (FYI: Editing refers to any kind of adjustment made to an image, including painting, copying, adding shapes and/or text, rotating, using filter effects, etc.)

The GIMP works in the selection mode by default. If youdo the recommended exercises, you will probably notice that a selection is defined by a broken line of "marching ants". In the image window, you can toggle between ⬚ selection mode and ⬛ mask mode (Toggle QuickMask). In mask mode, the masked or "protected" area of the image is marked with an overlay of transparent red—hence the name "mask".

In this chapter, you'll be exploring selection tools, layers, masks, and, of course the options available for these amazing tools.

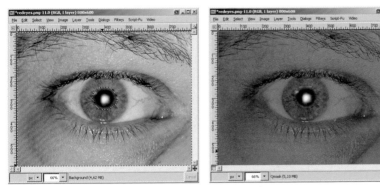

Figure 3.1: An image in selection mode: "Marching ants" trace the selection area. Take a look at the small buttons on the bottom left of the window.

Figure 3.2: The image from Figure 3.1 in mask mode: The selected area is covered with a red mask. Now you can freely edit the unmasked area without worrying about affecting the masked area.

3.1.1 Overview of Selection Tools in the Toolbox

	Rectangle Selection tool Selects rectangular regions of the image Keyboard shortcut: Shift for square selections
	Ellipse Selection tool Selects circular and elliptical regions of the image Keyboard shortcut: Shift for circles
	Free Selection tool (Lasso) The cursor is used to make a free-hand selection Not precise, but simple and quick
	Fuzzy Selection tool (Magic Wand) Selects areas of an image based on color similarity
	Select By Color tool Similar to Magic Wand It selects areas based on color similarity
	Scissors tool (Magnetic Lasso) Click points of the edge of the area you want to select. Click carefully around the area to complete the selection, working back to the original start point. When back at the start, double click it to complete the initial selection. This free-hand tool produces a continuous curve that passes through the control nodes you've set and follows the high-contrast edges according to your settings. Difficult to handle
	Move tool Moves layers or selections Be careful when setting the tool's properties as selected areas may be cut if inappropriately set
	Path tool Creates and edits paths Paths let you capture regular objects very precisely as shapes and convert to selections
	Flip tool Flips layers or selections horizontally and vertically

3.1.2 Tips For Handling Selection Tools

The selection tools are essentially used to select one or more portions of an image for further editing. For example, you might want to create a filled shape to cover up the face of your ex-girlfriend, or experiment with the functions in Tools > Color to adjust a selected image part without worrying about affecting the entire image. Image selections (partial images) can be copied and pasted to create a photo collage, or they can be modified to create unusual image effects. You can also use the selection tools to cut and/ or delete a detailed area of an image.

The tools can be used to select specific shapes. If you want to select a four-cornered area, you would use the Rectangle Selection tool, while the Ellipse Selection tool would be chosen if you want to select a round area. Free-hand tools can be tricky for a beginner, but they come in handy when you want to trace around a detailed area for your selection. The Gimp pro-

vides the Free Selection tool (Lasso), the Fuzzy Selection tool (Magic Wand), and the Path tool. You can also select an area with a Color Selection tool, which can be adjusted to select a certain color or color attributes.

The shape tools (Rectangle and Ellipse) are also used to create shapes. Just select the tool, click on the image, and while holding the left mouse button down, diagonally drag the cursor over the image where you want to draw the rectangle or ellipse. These shapes are closed, which means that you can easily fill them with any color or pattern.

The color selection tools create one or more closed shapes, depending on the options selected. Just select the desired tool (Magic Wand, Select By Color) and click on the color of the image object you want to select.

When tracing any shape with the Free Selection tools, you must hold the left mouse button down to draw a selection (Lasso) or click (left mouse click) on distinctive points along an outline (Scissors). In addition, you must return to the starting point of your line; this will ensure that the shape is closed.

With an array of selection tools at your disposal, you'll be able to produce complex original shapes and do some very detailed editing work. Selections can be combined and parts can also be removed from a selection.

The following sections provide practical examples which will show you how the selection tools work. The Path tool is described in detail in Section 3.10.

Once you have created a selection, you can modify its properties. The Select menu contains many options and functions.

3.1.3 The Select Menu

The options available for modifying selection tool settings can be accessed by going to the Select menu.

All: This option selects the entire area displayed on the visible layer, which was selected in the Layers dialog. You can edit this area and/or copy it to create a new layer by using the *Edit* menu options.

None: This option removes the current selection. Alternatively, you can use the undo hotkey or menu item to deselect the area.

Invert: This option inverts the current selection, producing a negative of the selection. Say, for example, that you want to select an object on a transparent layer. It may be simpler to use the *Magic Wand* to select the transparent area around the object than to trace around the object. To do so, you would use the *Select > Invert* menu item after having selected the transparent area.

Float: This option creates a floating selection. Floating selections are temporary layers that are built when you paste an object that has been

Figure 3.3: The Select menu options.

copied to the clipboard. Floating selections must be anchored before you can continue working.

By Color: This option creates a selection from a one color surface.

From Path: This option creates a selection from a path (see Path tool).

The following options in the Select menu influence the attributes of an existing selection:

Feather: This option adds feathering to a selection, providing it with an additional selection edge. The feathering at the border of the selected object ranges from opaque to transparent.

This means that if a selection has an edge feathering of 0 pixels, it is referred to as "sharp-edged". When you cut or copy a selected object, its borders may appear choppy, as if they were cut with scissors. Feathering an image creates a nice smooth transition between object and background. Image resolution affects what feathering radius you'll want to choose. A radius of 1 or 2 pixels is often sufficient for low-resolution images, while 5 to 10 pixels or more is recommended for higher resolution images.

Sharpen: When a selection is feathered, you can use this option to reset the feathering radius to 0. However, it is recommended that you use the Undo dialog to reset feathering radius.

Shrink: This option reduces an existing selection by a numerical value, from the circumference inwards

Grow: This option enlarges an existing selection by a numerical value, from the circumference outwards.

Border: Use this option on a selection to create a border of the same shape. The "border shape" will now act like a new selection; it can be a preset width and can be filled like a frame.

Rounded Rectangle: This option rounds the corners of a rectangular or square selection with a settable radius, either convex (towards the outside) or concave (towards the inside).

Toggle QuickMask: This option toggles between selection mode (marching ants) and mask mode (red protective layer). In mask mode, you can use the brush or pen tool to add mask elements or create new layer shapes and borders; you can also use the eraser to remove elements.

Save to Channel: If you want to delete a selection temporarily, you can save the selection to a channel. It will then be saved with the image. It will remain in the Channels dialog where it can be accessed at your convenience. Remember, you have to use the XCF or PSD file format for saving an image with extra channels.

To Path: This option transforms a selection into a path (i.e., a vector shape that can be duplicated and transformed). If you go to the Paths dialog, you can set your new path as the active path.

3.1.4 The Edit Menu

Many of the options available in the *Edit* menu can only be used in conjunction with a selection. Below is a brief introduction of the options available on the Edit menu.

Figure 3.4: The Edit menu options.

Undo: This option lets you undo any unwanted adjustments, edits, or strokes; the number of backward steps you can take depend on the amount of memory you allocated when setting up the preferences.

 Redo: This option repeats your last painting or editing step, or redoes your last undo.

 Undo History: This option accesses the undo history.

 Cut: This option cuts a selected area and copies it to the Clipboard.

 Copy: This option copies the current selection and saves it to the Clipboard.

 Copy Visible: This option copies the image contents of all visible layers (or the visible content of a selection) to the Clipboard, where they are grouped and afterwards can be inserted as a new layer.

 Paste: This option places the Clipboard's contents onto the current image. The pasted section is a floating selection.

 Paste Into: This option inserts the contents of the Clipboard into an existing selection in the current image.

 Paste as New: This option inserts the contents of the Clipboard, creating a new image that contains the pasted data.

 Buffers: This command cuts the contents of a selection from the active layer, but instead of storing the contents on the global clipboard, it saves them in a special buffer. Use the pop up dialog to name the buffer.

 Clear: This function lets you delete all contents within a current selection.

 Fill with FG Color: This option fills a selected closed area (or the active layer if no selection was chosen) with the current foreground color.

 Fill with BG Color: This option fills the selected area (or active layer if no selection was chosen) with the current background color.

 Fill with Pattern: This option fills the selected area with the pattern currently selected in the Toolbox.

 Stroke Selection: This option draws a contour on the border of the current selection. The stroke width in the current foreground color can be adjusted. This option is suitable for contoured fonts.

 Stroke Path: This option draws a contour on the border of a selected path. The width in the active foreground color can be adjusted.

 Paste from Clipboard: This option is used when working with separate layers. The contents of the Clipboard are copied as a background layer of a new image.

 Copy to Clipboard: This option is also used when working with separate layers. It copies the active layer onto the Clipboard.

3.2 Touchup Work 3—Removing Red Eyes

3.2.1 Avoiding Red Eyes—Proper Use Of The Flash

If you use a flash when photographing people, you're probably aware that the eyes of your subjects can sometimes turn red and glaring. Known as the "red-eye" effect, this occurs because the flash is aimed directly at the people you're photographing and is reflected in their eyes.

This undesirable effect can be avoided when taking photographs:

▸ By using a flash with a swivel reflector and not aiming it directly at a person. Swivel the reflector so that the flash is aimed on a reflecting surface (like the ceiling) rather than a person's face.
▸ By connecting your flash to your camera with a cable and holding it either above you or to your side.
▸ By using the pre-flash setting. The first fired flash will cause the pupils of the photographed person to contract. The second flash fires when the shutter opens. Even if the red-eye effect remains, it will be smaller.

Not to worry. If you just can't stand seeing a picture of your boyfriend glaring at you with eyes as frightening as Dracula's, the GIMP can help transform the beast back to beauty (or handsome, at least).

3.2.2 Exercise Example

Unlike most image editing programs, the GIMP does not have a dedicated tool to remove the red-eye effect. For this reason, once you have selected the red area and masked the remaining "background" of the image, you will need to use color saturation, as well as brightness and contrast, to correct the selected area.

Figure 3.5: redeyes.pgn with guides.

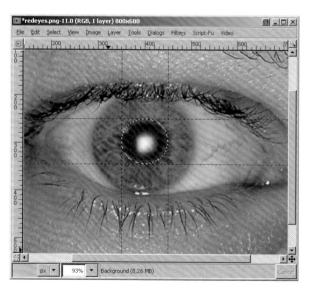

To do this exercise, open the image *redeyes.png* in the *SampleImages* folder on the CD and save it in your exercise folder.

Use the Magnify tool to zoom in to the eyes. Select the red pupil area using guides. To place guides over the area, click a ruler, hold the left mouse button down, and pull a guide from the ruler.

Select the Ellipse tool from the Toolbox. Point at the upper left corner of the rectangle formed by the guides you placed around the pupil. Click and hold the left mouse button while dragging it diagonally toward the lower right corner of the rectangle. The ellipse around the pupil is now marked by a border of "running ants", which also define the edge of your selection. (You can also use the Lasso tool, as it is quicker and easier. Draw the selection a bit outside the reddish area.)

You now have an active selection on your image. Your adjustments will modify only the actively selected area; the remainder of the image is mask-protected against changes.

In this exercise, you want the selection to have a **soft border**, or feathering. Without feathering, the adjustments you make will have a sharp-edged border, and look as if someone cut out an object with a scissors and pasted it on. Feathering the edges of the object will create a more natural appearance. Use the Select > Feather menu to access the feathering function. The Feather Edges dialog pops up. Enter a value of 10 pixels (see Figure 3.6) and click OK to accept your changes.

Figure 3.6: The Feather Edges dialog.

In the next step, remove the color saturation. Access the Layer > Colors > Desaturate menu. Only one click is required to remove the color levels from your selected area. You should only see the gray values now.

Next, access the Layer > Colors > Brightness-Contrast menu to correct the brightness and contrast according to your taste.

Finally, use the Select > None menu to deselect the area, remove the guides and check your image.

Name and save your image in whatever format you'd like in your exercise folder.

3.3 Introduction to Working with Layers

Imagine you want to compose an image from several images that you've stored on your computer. Well now, you can do just that! The process is similar to the production of animated cartoons. You begin with a background image. Then you place one or more transparent foils (which are layers comprised of image elements on top of transparent backgrounds) on the bottom, or opaque background layer. Certain file formats let you save several single images ("foils" or layers) to a single file, thereby creating a collage of images, one on top of the other. During the editing process, you can move these layers to the front or the back of the image to create the illusion of depth. In the GIMP, such file formats are XCF and PSD.

Figure 3.7: The layers of a collaged image:
1. Aircraft, 2. Shadow, 3. Hall, 4. Layer with
glass effect showing through, 5. Background
with landscape.

To edit images with layers in the GIMP, access the Layers dialog in Layers palette, or in the Layers, Channels, Paths, Undo dock. Go to the File > Dialogs menu in the Toolbox or the Dialogs menu in the image window.

Figure 3.8: Finished image
(FinishedImages> layers.xcf)
and Layers dialog.

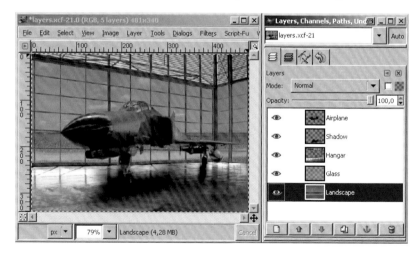

Working with layers has several advantages:

▸ Images with layers can be composed (collaged) from a stack of transparencies or image elements
▸ Layers/transparencies can be easily duplicated
▸ The transparencies are independent of one another so they can be freely positioned and changed
▸ Transparencies can be linked and edited jointly to save time. Afterwards, remove the link to edit the layers individually

▸ The order in which the transparencies are stacked can be changed; this enables you to create depth by placing one image on top of another.

▸ Layers can also have transparent areas, so that objects can be placed on top of your image without covering the background. The transparent image area appears as a gray-and-white checkered pattern.

▸ The opacity of layers can be changed (opaque or translucent). Translucency allows you to see through an image element.

3.3.1 The Layers Dialog

You accessed the Layers dialog either from within the File > Dialogs > Layers menu item in the Tools palette or from the Dialogs > Layers menu in the image window. By default, when you start the GIMP, it displays the Layers dialog in a window together with the dialogs for channels, paths, and the undo history. You can click a tab to select one of these dialogs (upper area in Figure 3.9).

Figure 3.9: The Layers, Channels, Paths, Undo window (Layers dialog).

You can also access this dock from the Toolbox by selecting the File > Dialogs > Add Tab > Layers, Channels and Paths menu.

The Auto button determines whether the Layers dialog should automatically display the layers of the current image window, if you have several image windows open concurrently.

The Mode option determines how a layer interacts with other layers. The default mode is Normal.

On the right-hand side of the Mode box, the checker-pattern button determines if the transparencies in a given layer should be kept. If this button is selected, you cannot draw over the transparent areas of this layer, nor can you modify the transparent portion.

The Opacity slider lets you adjust the opacity of the layer. Move the slider to obtain a translucent layer fill. In the example image, the Glass layer was set to semi-transparent opacity.

The main part of the window shows the layer list. The sequence from top to bottom corresponds to the layers stacked in the image. The top layer is on the top of the list, while the bottom layer is at its bottom.

The blue-highlighted layer is the active layer. If you wish to change active layers, simply click on the layer you wish to edit.

The Eye icon can be clicked to make a layer visible or invisible. Invisible layers are not printed when you print the stack. (They also won't appear if you save the image in a file format that doesn't support layers, such as JPEG.)

If you click the area beside the eye icon, you will see a chain icon. If you want to edit several layers simultaneously just link them together. To remove a link, click the visible chain icon.

The name of the object on a layer is displayed on the right of the thumbnail view. You can rename a layer by double-clicking its name and typing over the existing text. Double-clicking on the thumbnail image will pop up

the Layer Attributes window so you can enter a new name. It's wise to use descriptive names for the layers since you can't always see the details in the thumbnails.

Note: Before editing a layer, click the layer's name to activate it. The active layer will be highlighted in blue in the layer list.

The buttons below the layer list have the following functions:	
New Layer button	**New Layer** Lets you create a new layer; see Section 3.3.2.
Raise Layer button	**Raise Layer** Lets you move a layer up one. Press the Shift key to move the layer to the top of the list.
Lower Layer button	**Lower Layer** Lets you move a layer down. Press the Shift key to move the layer to the bottom of the list.
Duplicate Layer button	**Duplicate Layer** Lets you create a copy of the current layer; see Section 3.3.2.
Anchor Layer button	**Anchor Layer** Floating selections are a special feature of the GIMP. If you copy and paste the contents of an image selection, it will appear in the Layers dialog as a floating selection. You can then either double-click to paste the floating selection as a new separate layer in the image or click Anchor to merge the floating layer and the previously selected active layer. This is an efficient method when pasting multiple copies of your floating selection to an active layer, or when pasting a previously modified selection to a specific layer.
Delete Layer button	**Delete Layer** Deletes the active layer without popping up a dialog that will allow you to cancel the action.

Figure menu items:
- Edit Layer Attributes...
- New Layer...
- Duplicate Layer
- Anchor Layer
- Merge Down
- Delete Layer
- Layer Boundary Size...
- Layer to Image Size
- Scale Layer...
- Add Layer Mask...
- Apply Layer Mask
- Delete Layer Mask
- Show Layer Mask
- Edit Layer Mask
- Disable Layer Mask
- Mask to Selection
- Add Alpha Channel
- Alpha to Selection
- Merge Visible Layers...
- Flatten Image

Figure 3.10: The Layers context (right-click) menu.

3.3.2 The Context Menu in the Layers Dialog

Right-clicking on a layer in the Layers dialog accesses the Layers context menu. The context (right-click) menu lists several crucial tools, some of which can be accessed through the Layers dialog or in the Layers menu.

▸ **Edit Layer Attributes**: Lets you changes the name of the layer, which is displayed in the Layers dialog, where it can also be changed.

▸ **New Layer**: Creates a new layer in the image. Most often used when you wish to transform a floating selection into a new layer, (This command is equivalent the New Layer button in the Layers dialog).

▸ **Duplicate Layer**: Pastes a new layer onto the image. You might use this tool if you created an object on a different image layer and now want to paste it multiple times on one or more other layers (perhaps because you need it more than once or to create a pattern or depth in the background). Use the Duplicate Layer menu item to efficiently copy the desired object on a new layer. The copied objects will be stacked behind the original, which means that you won't see the objects if there are

several layers containing opaque objects on top of it. Now select the copied layer in the Layers dialog and use the Move tool to arrange it on the image.

▶ **Anchor Layer**: Anchors the floating selection to the active layer. It also assigns a floating selection (pasted layer) to a new layer. It corresponds to the Anchor Layer button in the Layers dialog.

▶ **Merge Down**: Merges the active layer with the layer below it in the layer list. It also can merge all visible image objects and all layers into a single layer to create a flat image. This merging is permanent. You only can undo it with Undo History, and only if you have not yet saved and closed the image, so be certain to make a copy if you plan to do more advanced editing.

▶ **Layer Boundary Size, Layer to Image Size, Scale Layer**: Initially, layers are only as large as the object placed upon them (see Text layer, dotted border). If you wish to add more objects to the same layer, you must extend that layer's size.

▶ **Add Layer Mask**: You can add a mask on top of a layer to change the appearance or opacity of that layer's elements without changing the layer itself. A layer mask is directly assigned to the selected layer, but it can be edited separately as a black-and-white channel or grayscale image (Edit Layer Mask).

▶ **Apply Layer Mask**: Once a layer mask has been edited and checked, it will be applied to the relevant layer.

▶ **Delete Layer Mask**: Deletes a layer mask, discarding the changes you made to the relevant layer.

▶ **Show Layer Mask**: Makes a layer mask visible.

▶ **Edit Layer Mask**: Edits a layer mask. Your changes will be displayed in the Show Layer Mask dialog. If you don't use this dialog, the changes to the mask will be visible in the image object or layer content itself.

▶ **Disable Layer Mask**: Disables a layer mask or its effect on the layer without deleting the layer mask itself.

▶ **Mask to Selection**: Transforms the active layer's mask into a selection mask. For example, if you created a mask with specific border attributes (i.e. sharp-edges or feathering), you can copy the mask's attributes to a new selection. Experimenting with this can result in some very unique effects.

▶ **Add Alpha Channel**: This item is available only for background layers without transparency, i.e., without an alpha channel. Adding alpha channel transforms a background layer into a normal layer, enabling you to add transparency, as well as work in Layers for more detailed editing.

▶ **Alpha to Selection**: Use this option to easily create a selection based on an existing object and including the feathering and/or transparency attributes assigned to that object.

▸ **Merge Down**: This option reduces all layers of an image to one single background layer (no alpha channel [i.e. transparency]).

3.3.3 Working with Several Images—Inserting Layers from Another Image

You can view the layers of an active image in the Layers dialog. If you have several images open at the same time, the active image will be the one at the foreground of the screen; the active image will also be highlighted with a blue title bar.

When working with several images, you can easily drag and drop layers from one image to another. (Click the layer of the first image in the Layers dialog, and while holding the left mouse button down, drag it on the image window of the second image and release the mouse button.)

So far you haven't needed to use layers for editing any images. You will begin working with layers in the following section.

3.4 Touchup Work 4—Using Perspective Correction to Remove Converging Verticals

3.4.1 Trying to Avoid Converging Verticals When Taking Shots

Layers play an important role when it comes to removing converging verticals in an image. Converging verticals occur mainly in architectural shots, when the camera is pointed upwards and focused on an object that is very close to a vertical object. What usually happens is that the building's edges converge vertically towards a third vanishing point.

The following hints can help avoid or reduce such image flaws:

▸ The greater the distance to the vertical object (i.e. sky-scraping building), the smaller the amount of distortion at the top of the image.
▸ Try not to use wide-angle subjects, since short focal distances will cause additional distortions (see example: image bulging). The longer the focal distance, the fewer problems you'll have with additional distortions.
▸ "Shift" objectives are available for cameras with interchangeable lenses. These cameras allow you to move the attached lens so that it's parallel to the shooting level (camera's rear panel). This will suffice to somewhat rectify the problem.

Because converging verticals may occur in spite of all your careful preparations, most digital image editing programs provide a variety of methods to remove such flaws from architectural images.

3.4.2 Steps Involved and Description of Work

The Main Steps

▸ Use a transform tool called Perspective to rectify an architectural shot.
▸ Adde an alpha channel to the background layer so you can add transparency and transform the layer.

The *convergingverticals.png* image has a vertical vanishing point, which means that the outer edges of the building converge vertically. Use the transform tools and options to straighten the shapes out. As you do this, consider the attributes of background layers compared to layers with alpha channels. You will need layers with alpha channels as you continue your exercises.

3.4.3 Removing Converging Verticals from an Image

▸ Open the image *convergingverticals.png* in the *SampleImages* folder on the CD.
▸ Set vertical guides along the outer edges of the building and a horizontal guide in the height of the eaves.
▸ Use the Magnify tool to zoom out a little, or pull the borders of the image window to enlarge it slightly, so that you will have a larger working surface around the image in the image window.
▸ Select the Perspective tool from the Toolbox. Click the image and drag the outer edges and the eaves edge of the building over the selected corner points parallel to the guides. As a result, the image may be heavily stretched horizontally. You can fix this by stretching the image vertically, using the *Scale* tool. If necessary, use the Image > Canvas Size menu item (see Section 3.12.2) to enlarge the canvas size.
▸ Use the Layer > Layer to Image Size menu item to resize the layer to the image size.
▸ Save the image with a new name in your exercise folder.

The technique described may not work when rectifying distortions that occur when photographing very high buildings. On the one hand, you would have to severely lengthen the building to prevent it from look disproportionate after the correction. But doing this would cause perspective flaws in the window embrasures to stand out.

In the example used in this exercise, you will note that bulging and distortion are still visible, even after the perspective correction. This is because the shot was taken with a wide-angle focal lens, and it is a panorama image composed of several individual shots. The GIMP doesn't provide features for removing these image flaws.

Though the Perspective tool used offers a way to remove perspective distortions from an object, the distortions in the example image were not

interlinked. If they were, you would have been able to distort the object over two axes from its corner points.

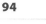

Figure 3.11: Using the Perspective tool for perspective correction.

3.4.4 Transform Tool Options

When selecting the Perspective tool, pay attention to the tool's settings. The following options are available:

- **Affect**: Similar to the other tools you've been working with, the Perspective tool may affect the Layer, the Selection, and the Path differently. Use these settings to choose which element of the image you wish to affect.
- **Transform Direction**: The Forward (Traditional) option performs a transformation according to the direction of guides. Backward (Corrective) will perform the transformation in the reverse direction of guides. This option is used to correct perspective deformations.
- **Interpolation**: This dropdown list allows you to choose the quality of the transformation. Select the Cubic (Best) option. Though it requires more time, it produces the highest quality.
- **Supersampling**: The surrounding pixels will be included when calculating newly inserted image dots. This improves the result of an interpolation, but the calculation requires more time.
- **Clip Result**: The transformed image will be clipped to the original image size.

▸ **Preview**: This dropdown list provides four options:
 - **Outline**: Applies a frame with a handle on each corner around the image. Movements affect the frame only.
 - **Grid**: Puts a grid with four handles on the image. Movements affect the grid only.
 - **Image**: The preview is a copy of the image superimposed on the image, with an outline. Movements affect the copy of the underlying image.
 - **Grid+Image**: Shows the image with handles and a grid. The transformed image will initially overlay the original.

Options with a grid activate a dropdown list with two options: Number of Grid Lines allows you to control the total number of displayed grid lines. Use the slider to set the number of grid lines. Grid Line Spacing allows you to control the distance between the grid lines. Use the slider to set the distance.

The tool settings described above are identical for all transform tools.

3.4.5 Background Layers and Layers with Alpha Channels

In the exercises dealt with so far, you have edited images without considering the layers' attributes. The GIMP automatically converts the background layer into a layer with an alpha channel when transforming the image.

Every photo opened in the GIMP is initially available as an image with a background layer. Background layers have certain attributes:

First of all, background layers are always called Background. This name appears in bold in the layers dock.

Background layers are always situated at the bottom of the stack; they cannot be moved within the layers dialog.

Background color: When you erase or delete a selection from a background, you'll see the opaque color of the background beneath the deletion. Background layers don't have alpha channels; hence, they are always opaque.

Now, if you want transparent surfaces on a background layer, you must access the right-click menu in the layers dialog so that you can assign an alpha channel to the background layer. Right-clicking on the layers palette pops up the context menu. Select the Add Alpha Channel menu item. You can then move the layer within the layer stack, or place other layers underneath that layer within the stack. You will be practicing these features in the next steps.

Figure 3.12: Adding an alpha channel (transparency attributes) to an image using the right-click menu in the layers dock.

3.5 Touchup Work 5—Freshening Up a "Dull Sky"

3.5.1 Steps Involved and Description of Work

The exercise discussed in this section involves the following steps:

▸ Working with selections or masks.
▸ Working with layers.
▸ Working with the Color Editor dialog.
▸ Working with the Gradient tool dialog.

In the image *dullsky.png* we want to replace the existing blue-gray sky by a color fill or feathering in a new layer. To this end, you will use the Magic Wand to select and delete the existing sky. The layer with the color fill underneath it will then appear through the transparent area of the next higher layer, the one with the landscape.

3.5.2 Step 1: Selecting an Area by Color, Deleting it, and Replacing it by a Color Fill

▸ Open the image *dullsky.png* in the *SampleImages* folder on the CD.
▸ Save it in your exercise folder. Name it bluesky and save in XCF file format.

▸ Run a tonality correction (Tools > Color Tools > Levels menu) and freshen up the image's colors by using the options from the Tools > Color Tools > Hue-Saturation or Color Balance menu.

▸ Access the Layers, Channels and Paths dialog for the image from the Dialogs > Dock menu. Click the New Layer button to create a new layer. Save as Sky.

▸ Duplicate the Background layer (the one with the landscape) by right-clicking on the layer in the Layers dialog. Save as Landscape. Make the Background layer invisible.

▸ Use the Select by Color tool and click on the color of the sky to select it. Pay attention to the settings (double-click on the Select by Color tool to open the docking window if you need to). Click the Add to Selection button next to Mode. For Threshold (color similarity), move the slider to select a value that determines how much tolerance for color variation will be allowed. For the purposes of the exercise, a value of 30 is recommended as the sky contains several shades of blue. By clicking the Magic Wand while holding the Shift key down, you can repeat this process of selecting by color to add more areas to the existing selection. This is necessary even if you use the Add to Selection button in the tools dialog, because you will be partially working within an existing selection.

Selection Tool Options

Let's have a closer look at the tool options for selections. Though these options vary, depending on the selected tool, they all have a Mode option that lets you use different selection tools consecutively to create a selection.

Example: Select by Color

The Mode function in this dialog offers the following options:

▸ **Replace the current Selection**: Clicking deletes an existing selection.

▸ **Add to the current Selection**: You can use this tool, or similar tools consecutively to add to an existing selection. (Note that the Mode > Add to Selection option must be selected prior to using the tool). The newly selected image areas will be grouped as a single selection.

▸ **Subtract from the current Selection**: This object allows the selected tool to subtract an area from an existing selection.

▸ **Intersect with the current Selection**: If a selection exists, you can use this option to create a new selection that will intersect with the existing selection.

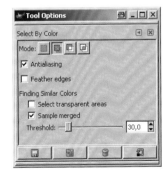

Figure 3.13: The options available in the Select By Color dialog.

Note: The options above are common to all selection tools. Have fun experimenting with different selection tools and settings as you create and edit your masterpiece.

Additional options, specific to the Select by Color tool, are:

▸ **Antialiasing:** This option removes the step effect (i.e., sharp "steps" at the border of a selection that result from cutting with a mask).

▸ **Feather Edges:** This option creates a "soft selection border". It feathers the border from opaque towards transparent, creating an integral, natural look when copying and pasting objects. Without feathering, a copied element will look like it was cut by scissors and slapped on the image. Move the *Radius* slider to set the feathering width. A value between 2 px and 5 px should be sufficient, depending on the desired effect and image resolution. You can leave this option unchecked and create the feathering of a selection afterwards.

▸ **Select Transparent Areas:** Allows the Magic Wand to select completely transparent areas. The tool will find an object's contour "automatically". If the option is not checked, transparent areas will not be included in your selection.

▸ **Sample Merged:** This option ensures that all visible image areas on all layers can be included when selecting by color. If this option is not checked, the tool will only select the desired color on the active layer.

▸ **Threshold:** Determines the range of colors that will be selected. The higher the threshold, the wider the range of colors.

Proceed as follows:

▸ Remove small defects from the sky, if you find any. Select these spots in the sky by circling them with the *Lasso* tool while holding the *Shift* key down.

▸ Remember that you can use the *Magnify* tool to zoom into the image area.

▸ When your selection is cleared of these defects, increase the selection size by approximately 3 px in the Select > Grow menu. Then go to Select > Feather to add feathering to the selection border (approximately 4 px). The horizon and the contour of the trees will now be feathered so that when you delete it, the landscape contour will look natural, and the scissors effect will be avoided. Alternatively, you can do this by using the Feather Edges option, under Select By Color.

▸ Select the Edit > Clear menu item to delete the sky on the Landscape layer.

▸ Select the Select > Save to Channel menu item to save your selection as an alpha channel, before deleting it in the image by selecting the Select > None menu item.

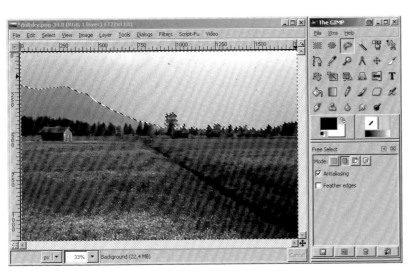

Figure 3.14: Extended Selection with feathered border.

Take a closer look at the image: Since the border of the selection was feathered, the contour of the image that remains is feathered towards transparency. The transition is smooth and professional looking.

In the following exercises, you will use GIMP tools to select colors and fill layers or selections with a color. In short, you will:

▸ Use the Color Picker from the Tools palette to select a light blue shade as the foreground color.
▸ Make the Sky layer your active layer.
▸ Select the Color Fill (Bucket) tool from the Tools palette and click it on the image. The Sky layer will be filled entirely with the selected foreground color.
▸ If your entire image turned blue, it happened because the Sky layer is on top of the stack. Move the layer underneath the Landscape by clicking the Lower Layer button in the Layer > Stack dialog.
▸ You can use the Dodge/Burn tool to darken the mountains in the background. Set the Burn control in the Dodge/Burn tool options. Set the Exposure settings to a lower value (about 20%), then select or create a big (about 200 pixels in diameter) brush pointer with soft edge. This will allow you to edit the area smoothly, and avoid abrupt dark patches. You can lighten up the overly dark meadow areas in the foreground by selecting the Dodge option. You can also use the same brush pointer and opacity to touch up the mountains if you so desire.
▸ Finally, save the image by the name *bluesky.xcf* in your exercise folder.

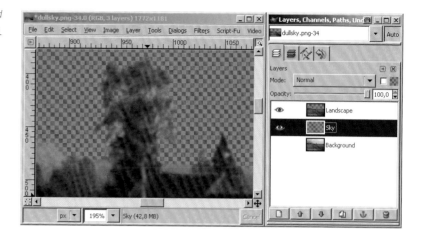

Figure 3.15: The Landscape layer with deleted
sky (transparent area).

Using the Eyedropper to Select a Foreground Color from the Image—Selecting a Color from within the Image

The Color Picker tool allows you to select any color on an active layer or image. If you select this tool and click on a color on your image, you can select this color as the foreground or background color. The foreground color is used when painting, filling or adding text. In the GIMP, the foreground color is also the default color for color feathering.

Using the Color Picker is the simplest and most comfortable way to select a paint, fill, or text color. Thus, you'll be learning it first, even though it is not useful for correcting the example image, a process that will require using more complex color selection tools.

For now, select the Color Picker from the Tools palette. The mouse pointer takes the shape of an eyedropper. Clicking an area on the image causes the eyedropper to siphon the area's color, which is also displayed in the Eyedropper window.

Figure 3.16: The windows of the Color Picker
(Eyedropper) tool.

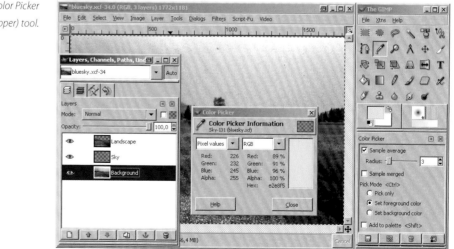

Tool Preferences (double-click the icon to open this dialog):

▸ **Sample Average**: The Radius slider adjusts the size of the square area used to determine an average color from a pixel of your image. Click the slider to select an area larger than a 1 × 1 pixel.

▸ **Sample Merged**: If the checkbox of this option is selected, it will display color information from all the visible layers of your image. If the checkbox is disabled, you can only pick colors from the active layer, which is the default setting.

▸ **Pick Only**: This option tells the tool to display only the color information of the selected area in the Color Picker window, but it won't change the foreground color.

▸ **Set Foreground Color**: The foreground color is shown in the Toolbox Color area and will be set to the color of the pixel you click on. It will now be used as the painting, filling and/or text color, and serve as the primary color for color gradients.

▸ **Set Background Color**: The background color is shown in the Toolbox Color area and will be set to the color of the pixel you click on. It will now be used as the active background color and serve as a secondary color for color gradients.

▸ **Add to Color Palette**: The color you select will be added to the existing palette of an image that has its own color palettes (Mode > Indexed Colors menu item).

The Color Picker in the Toolbox

The Color Picker lets you quickly select a color or toggle between two available colors.

The black field on the top-left of the window activates the Color Picker for the foreground color, the white field activates the background color.

The Foreground Color is the active color for painting, filling, and text tools, and the primary color for color gradients.

The Background Color is the secondary color for the gradient tool and the "color" used by the eraser tool for background layers without an alpha channel (without transparency).

Click the bent dual arrow (top right) to quickly change the painting color as you work, or to use the preset background color as the foreground color.

Click the small black-white icon to reset the default colors-black and white as the foreground or background colors.

Figure 3.17: Clicking the Color Picker in the Tools palette pops up the Color Picker window.

The Color Picker Dialog

The Color Picker is the GIMP's basic color palette. It consists of two colors, the Foreground and Background colors, and you can use it to mix colors for painting, writing, or filling. Clicking on any color brings up the Color Editor dialog. There is one for the foreground color and one for the background color.

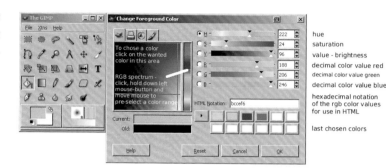

Figure 3.18: The Color Editor dialog and the
representation of the color selected in the
Toolbox.

In the Color Editor dialog, there are tabs which will allow you to change the way in which color is represented. The most common is RGB (and HSV), which is underneath the GIMP icon. This representation is found in most popular image editing programs.

The other color models are CMYK colors (four-color printing), color triangle and water colors (additive mixing colors).

Probably the most striking field is the Hue field on the left-hand side, which lets you select the lightness levels for a color. Just click the desired hue to activate it. It will be shown as a new color in the Current field.

The Spectrum field shows the RGB spectrum in the image, if the checkbox next to H is enabled. Click while holding the left mouse button down to pre-select a color range.

- ▸ **Checkboxes**: The H checkbox should be enabled for the default color display (see example). The other checkboxes activate different views of the Hue field for selection.
- ▸ **Sliders**: You can move the H (for Hue) slider to produce alternative colors with the same lightness, using the settings in the example. In general, the sliders serve to mix colors; an alternative for mixing colors is by selecting a color (or color range) with the mouse, as described above.
- ▸ **Numerical entries**: You can also type decimal (or hexadecimal) values for *Red*, *Green* and *Blue* to set or mix a color. This works well when you want to import an exact color from another program.
- ▸ **Buttons**: The OK button adds the selected color to the tools palette and closes the Color Editor dialog. The Reset button rejects the selected color and lets you select another color. The Cancel button closes the dialog without accepting the color you selected as the foreground or background color.

The Bucket Fill Tool

Getting back to the exercise, let's say you now want to insert a single-color sky. To achieve that goal, you will first need to fill a separate layer with color, which will be seen as the sky when viewed through the transparent areas of the landscape layer above it. The Bucket Fill tool will be used for this.

The Bucket Fill tool also has its own tool options (double-click the tool icon in the Tools palette).

You don't need to change any options. Once you select the desired foreground color and activate the appropriate layer in the Layers dialog, just click the tool on your image. The layer will be automatically filled with the selected color.

3.5.3　Step 2: Creating and Positioning an Image Object on a New Layer

Next, you'll be painting and positioning the sun. Creating a new layer, *Sun*, should not prove difficult. The Move tool and its options will be described in detail further below, but first, here is an overview of the work you'll be doing:

▸ Create a layer named Sun and position it underneath the Landscape layer.
▸ Select a light yellow shade as the foreground (painting) color.
▸ In the Brush dialog (Dialogs > Brushes menu item), select a round, soft brush. Increase its diameter to approximately 300 px by selecting a brush in the Brush dialog, clicking the Edit button, and setting the radius in the Brush Editor.
▸ Draw a round sun by clicking the Painting Tools > Paintbrush tool on the Sun layer. Use the Move tool's Move the Active Layer option to move the sun to the desired position in your image.

Using the Move Tool to Position Layers and Objects

In this exercise, you'll use the Move tool on a new image object that is positioned freely on a separate layer. This is one of the most important functions of this tool. You can also use the Move tool to move guides and selections or paths, but those functions will be introduced later on.

The Move Tool Options

The three tool toggle buttons allow you to choose which entity the Move tool should affect: Layer, Selection, or Path.

If you want to move a guide, select the Pick a Layer or Guide to Move option.

The Move the Active Layer option allows you to move the layer defined as active in the Layers dialog.

If you select a layer (or image object) in the Layers dialog and then click the Move tool on this object (or layer), you should be able to move the object freely while holding the left mouse button down, releasing it after you've positioned it where you want it.

Figure 3.19: The tool options dialog for the Bucket Fill tool.

Figure 3.20: Move tool setting for positioning layers or objects.

You can alternatively use the cursor or arrow keys on your keyboard to move an element with pixel-size accuracy. Each time you press one of the four arrow keys, the element will move in the direction of the arrow by exactly 1 pixel. To move 10 pixels at a time, hold the Shift key down while pressing the arrow keys.

That was a simple process. The next exercise—which concerns itself with creating an unique color gradient, is more complex. Let's take a closer look at the steps involved.

3.5.4 Step 3: Creating a Multicolor Sky—the Gradient Tool

The Gradient tool works with two colors by default—a gradient blend of the foreground and background colors. Once you set these two colors with the appropriate color pickers, you can use the Gradient tool directly on the image to fill an area or background with a two-color blend. Select the tool, click on the image and drag it while holding the left mouse button down. A "rubber band" trailing behind the cursor shows you the direction of the (linear) blend.

If you wish to use a more sophisticated blend of colors, you can access prefabricated gradients from the Gradient Select window. In addition, you can create and save custom gradients.

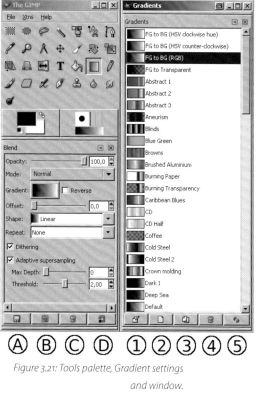

Figure 3.21: Tools palette, Gradient settings and window.

Creating a Gradient— the Gradient Select and Gradient Editor Windows

A	Save	1	Edit
B	Undo	2	New
C	Delete	3	Repeat
D	Revert	4	Delete
		5	Refresh

By left-clicking the mouse on the area with the gradient symbol (bottom right) in the Tools palette of the GIMP, the Gradient window pops up.

This window offers you a set of pre-made gradients. Simply click and your selection will instantly be available in the Gradient tool.

Clicking on the 2 New button (Figure 3.20) will cause the Gradient Editor dialog to pop up so that you can edit the gradient blend.

The Gradient Editor dialog displays the pre-selected gradient blend (in this case, the default blend ranges from black to white). Underneath the gradient blend, you'll notice a gray slider with black arrows at the left and right margins and a gray one in the center.

By right-clicking on the slider, the context menu for the Color Editor pops up. In the context menu, click the left mouse button on the Left Endpoint's Color option. Another pop-up window, Gradient Segments left Endpoint Color, will appear. Select a color as described above and click OK to accept your changes. The color you selected should now appear at the left endpoint of the Color slider.

Repeat the steps to select a color for the right endpoint.

Because this exercise requires you to create a three-color gradient blend, you'll need to right-click on the slider underneath the blend in the Gradient Editor window to open the context menu. Select the Split Segments at Midpoints option.

The gradient blend is now split in the slider underneath the gradient display, although it initially appears the same. Double-click the left half of the slider to see how it works. You'll notice that the left section turns dark gray, while the right half turns light gray. Next, open the right-click menu and select the Right Endpoint's Color option. Double-click the right half of the slider, and then open the right-click menu and select the Load Left Color From > Left Neighbor's Right Endpoint option.

Figure 3.22: The Gradient Editor.

Figure 3.23: The right-click menu in the Gradient Editor.

*Figure 3.24: Color sliders for gradient blends
with an option to set the opacity A.*

You will now be able to hold the mouse button down and move the center triangle on the slider. When you're satisfied, enter a name for the new custom gradient in the Gradient Editor window and save it by clicking the Save button (bottom left in Figure 3.21).

A final note to the Endpoint's Color Picker:

You can also add Transparency to a gradient blend to create interesting effects. To decrease the opacity of a gradient, change the value (A) in the Color Picker window. The default setting for opacity is 100%.

*Figure 3.25: Tools palette and Gradients
window with selected gradient blend—
Gradient tool options.*

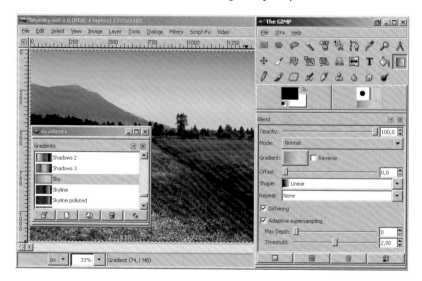

Next, you have to apply the gradient blend to the intended layer of your image.

Make sure that you've selected the desired gradient blend in the Gradients window. Then select the Gradient tool from the Tools palette and double-click on it to reveal the tool options.

The Gradient Tool Options

The Gradient tool includes an option called Opacity that allows you to create a fully opaque, slightly transparent, or fully transparent gradient.

The Mode dropdown list provides a selection of paint application modes. Leave the default Normal, which is opaque without mixing attributes.

Gradient offers you to choose from a dropdown list of gradient patterns. You can also select the Reverse checkbox to interchange the foreground to background colors.

The Offset value determines the "slope" of the gradient. When you increase the offset value, the center of the gradient moves to one side (which side it slopes to will depend on the direction chosen for the gradient).

The Shape dropdown list offers a choice of several gradient shapes. Linear refers to a parallel color gradient. You'll be using a linear gradient in the following exercise.

Below is a list of other shapes:

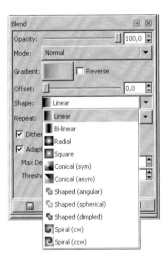

Figure 3.26: The Shape menu for gradient fills.

▸ **Bi-Linear**: Proceeds in both directions parallel from the starting point.
▸ **Radial**: Gives the appearance of a sphere.
▸ **Square**: Renders an equal-sided pyramid.
▸ **Conical (symmetric)**: Renders a cone that appears to be illuminated.
▸ **Conical (asymmetric)**: Renders a cone that appears to have a ridge.
▸ **Shape (angular, spherical, dimpled)**: These shapes create color gradients that adapt to the contour of a selection in the image.
▸ **Spiral (clockwise or counterclockwise)**: Renders spiraling gradients.

Use the Repeat option to decide whether the gradient should be applied once (None), or whether it should be repeated with hard transitions (Sawtooth Wave) or soft transitions (Triangular Wave).

Set the gradient options for the sample image: Opacity = 100%; Mode: Normal; Offset = 0.0; Shape = Linear; Repeat = None.

Using the Gradient Fill Tool

In the Layers, Channels, Paths… window, activate the layer you wish to fill with color. The Gradient Fill tool should be selected in the Tools palette.

Position the cursor on the image and it will change to a cross hair pointer. Click on the top of your image and drag while holding down: A kind of "rubber band" trails the mouse cursor. The fill process will be executed when you release the mouse button.

Depending on the direction you drag the cross hair cursor (and depending where you clicked on the image), you can add an angle to the gradient.

Furthermore, you can determine the width of the gradient, depending by pulling the "rubber band". Play with it! You can repeat the fill process several times in a row. When you are happy with your results, save your image.

Here is a summary of the most important steps of the exercise:

▸ Creat a new layer, Sky-Gradient
▸ Open the Gradient Select window from the Tools palette
▸ Creat a three-color gradient using "strong sky blue, silvery light blue, and light sky blue", and applying this gradient to the new layer
▸ Save the image as *bluesky.xcf*

You have used graphical tools to replace the sky in the image. But there is a third possibility to enhance the image: you can replace the dull sky entirely by adding a photo of a more lively sky.

3.5.5 Step 4: Adding A New Object Or Layer (Sky) To An Image

The GIMP offers several alternatives for importing images as layers and combining several different image files into a single file. Importing images is pretty easy: Simply drag and drop an image on to another image from within the Layers dialog. However, it is a good idea to adjust the size and resolution of the image layers you intend to import so they correspond to the target image's size and resolution. When importing images, only the layers are copied. The original images remain unchanged.

Below is an overview of the most important steps of this exercise:

▸ Open the images *bluesky.xcf* and *hazysky.jpg* from the *SampleImages* folder on the CD.
▸ Position the two image windows so that they partly overlap, arranging the Layers dialog on the side.
▸ Click on the *hazysky.jpg* image to make it the active layer. Click the Background layer in the Layers dialog and drag it partly over the visible *bluesky.xcf* image while holding down the left mouse button. Upon releasing the mouse button, the layer will be pasted into the *bluesky.xcf* image. This process copies layers rather than moving them.
▸ Rename the Background layer as *Hazy-Sky*. Move Hazy-Sky in the Layers dialog so that it is positioned beneath the Landscape layer. (The easiest way is by dragging and dropping, or by using the arrow keys at

the bottom of the Layers palette. Remember that the layer must be active in order to move it.)

Finally, you must scale the layer so that it fits into the image. To scale the layer, go to the Tools > Transform > Scale menu and follow the description below.

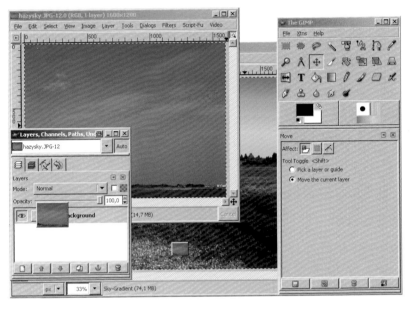

Figure 3.27: Dragging a layer.

Transformations—Scaling a Layer

In previous exercises you scaled entire images, changing their size, from the Image > Scale Image menu item.

In this exercise you will scale a single layer and transform it.

Take a look at your image. You will see the Hazy-Sky layer in the image window. The largest part of the layer is hidden behind the Landscape layer, but if you activate the layer in the Layers palette, you will see its contour, as indicated by a black-and-yellow dashed line. You now want to freely transform this layer and fit it into the image.

Alternatively, you can enter numerical values in the Layer > Scale Layers menu item. This is the preferred method when changing a layer to a size that has already been numerically defined. However, for this exercise it is preferable to use the mouse, as you will be scaling to fit the layer aesthetically within the image. The Scale tool from the Toolbox provides you with options necessary to do this. You can also find these options in the Tools > Transform > Scale menu.

Figure 3.28: Copied layer with dashed border.

Figure 3.29: Scaling a layer.

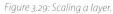

By activating the transform tool the Scale window pops up which you can use to insert numerical values as described above. However, since you want to make the transformation based on its visual appearance, you need to use the mouse. Select the Preview > Image+Grid item from the dropdown list in the Tool Options dialog. Click on the image to display the grid. You can drag the grid by pulling at its border while holding down the left mouse button. Furthermore, by holding the mouse button down, you can move the grid within and over the image.

Increase your working space around the image by pulling the window borders outward. Then click the mouse on the grid borders and drag or move them so that they look the same as the second image.

Click the Scale button in the Scale window to produce the preset scaling.

If you are not satisfied with the result, undo the process and repeat the above steps. Save your image.

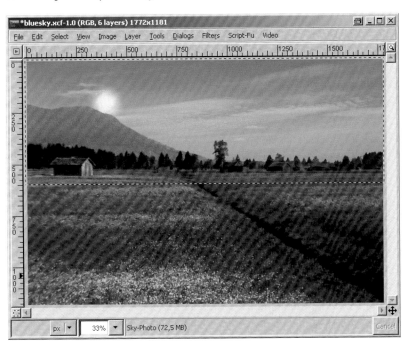

Figure 3.30: After the scaling. The dashed border marks the new size and shape of the scaled layer. It was touched up with the tonality correction.

You have now learned several important methods for "freshening up" a sky in an image using a number of complex tools. Perhaps you're so proud of your beautiful image that you want to create a greeting card with it. All you need now is to learn how to use the text tool so you can add some words. .

3.6 Typing in the GIMP—Adding Text to an Image

3.6.1 Introduction to Fonts

This section will cover features that you'll need to know when dealing with fonts:

Sans-serif fonts, such as Arial, Avant Garde, Verdana, or Helvetica, possess a clean, sober, contemporary style. They are often used for titles, captions, and heading. They are not suitable for lengthy reading material as the harder lines can tire the eyes.

Serifs are stylistic flourishes, like cross strokes or curves, added to the end of the strokes in a character. Popular serif fonts include Times New Roman and Garamond. Serif fonts are the primary fonts used in books, magazines, and newspapers because the softer, yet more detailed shapes of the letters make them easier to read.

Another feature that distinguishes fonts refers to the space between characters:

Proportional fonts: With proportional type, each alphabetic or numeric character takes up only the space it needs. Today, most fonts are proportional, including those mentioned above. Using proportional type can add visual variety to your text, especially in Web pages.

In contrast, **monospace type** is familiar to anyone used to working with a typewriter or teletypewriters. In monospace type, each alphabetic or numeric character takes up the same space. For example, a monospaced "1" takes as much space as a monospaced "w". Today, monospace types are commonly used to highlight source code in documents or Web pages, or to imitate typewriter text. One of the most commonly used monospace fonts is Courier New.

Extraordinary stylistic flourishes are the deciding characteristic of so-called **ornamental or fancy fonts** like Comic Sans MS or Dauphin which sometimes imitate handwriting or calligraphy. These fonts are suitable for short text like invitations, or to achieve a creative graphical effect with type. Fraktur and Comic both have a futuristic flair.

Font sizes are defined in **points** (pt) or **picas** (pc), where 1 point (pt) = 1/72 inch = 2.54 cm/72; and 1 pica (pc) = 12 points (pt) (standard font sizes).

Note: When you installed the GIMP, you simultaneously installed several fonts from the Linux world under Windows, including Sans-serif and Serif fonts.

3.6.2 Typing in the GIMP—the Text Tool T

The Text tool in the GIMP's Toolbox allows you to create "dynamic text" in an image. It's called "dynamic" because the process is based on vector representation, in spite of the fact that the text is added to an image as a pixel element. Vector representation allows you to edit the text, as well as its attributes, such as color, font type, and font size. When you type text onto an image, the process creates independent text layers, which means that the text is not "baked" on a background or another layer.

This tool is suitable for adding headings, small text pieces, or brief explanations to an image. It is not normally used for long text.

Figure 3.31: The Text tool options, the GIMP Text Editor, and text layers in the Layers dialog.

3.6.3 Typing Text and Defining the Text Attributes

Select the Text tool in the Toolbox. Double-click on the icon if the text options dialog does not pop up automatically.

The mouse pointer changes to a text cursor. Click the cursor wherever you want to type text.

You cannot type text directly on to an image. Instead, text is typed in the GIMP's **Text Editor**. The Text Editor dialog is used for typing new text, inserting line breaks, and/or correcting and editing existing text. You can click the Open button in order to load text from a file on your computer. Clicking the Delete button removes all text from the editor window and simultaneously the corresponding text layer in the image.

The two buttons LTR and RTL in the top right corner of the Editor window let you choose between your text being written from left to right or right to left. Apparently, this also depends on the settings of your computer. With western standards, it changes between left-justified and right-justified text. More options for justifying text are located in the Text tool options dialog.

Text typed in the Editor will appear in the image. Simultaneously, a separate text layer will be added in the Layers dialog.

All other text attributes, such as font, size, and color, are defined in the tool options dialog. You can set these attributes in advance, and change them whenever you wish. To change existing text, select the text's layer in the Layers dialog. Select the Text tool and click it on the text in the image. The Text Editor dialog pops up to display the text, which you can now edit along with its attributes.

Figure 3.32: The GIMP Text Editor.

▸ **Font**: Clicking the button next to Font accesses a dropdown list that lists all fonts installed on your computer, along with a small sample.

▸ **Size**: Lets you set the size of the font in the currently selected unit of measurement. The dropdown menu beside it allows you to choose a unit: px (pixel) – in (inch) – mm (millimeter) – pt (point) – pc (pica:

1 pica = 12 points = standard font size) and More. (**Note**: 1 point (pt) = 1/72 inch = 1/72 inch = 2.54 cm/72.)

▸ **Hinting**: Hinting or Auto-Hinting is an unique function of the GIMP which optimizes the representation of text in an image, while automatically correcting representation errors.

▸ **Antialiasing**: Renders text with much smoother edges and curves. By slightly blurring and merging the edges of the text, the antialiasing option radically improves the appearance of rendered typeface. (Also see also Section 1.2.1 and Figure 1.1).

Figure 3.33: The Text tool options dialog.

Color: By default, the GIMP uses the color set in the Foreground Color to Text option in the Color Picker. With the Text tool options dialog, you can set or change a text color before, during, or after writing text. Just click on the colored button and the familiar Color Picker will pop up.

Justify: If your text is more than one line in length, you can justify it according to the options available in the Editor: Left-justified, Right-justified, Centered, or Block. Additionally, you can choose whether the Text will read From Left to Right or From Right to Left. This is particularly useful when switching from Western languages to Middle Eastern languages, since the latter is often read from right to left.

Indent: You can modify the values to indent the first line of text, or a block of text, from the left margin. Negative values can be used as well.

Line Spacing: This option controls the spacing between successive lines of text. You can reduce or increase the value.

Create Path from Text: Paths will be discussed in a later section. All you need to know right now is that this button will convert your text into a vector or path. Paths are used to efficiently create selections according to a figure's contour.

Adding Special Characters

The Text Editor of the GIMP lets you type all characters you find on your keyboard. Special characters, such as the copyright character ©, or accented characters, such as ñ, are not included. If you need to type such characters, you will find them in the ASCII or Unicode tables at the following Internet addresses:

▸ http://www.utf8-chartable.de
▸ http://mandalex.manderby.com/a/ascii.php
▸ http://www.sql-und-xml.de/unicode-database/

Visit any one of these pages to find the desired character or symbol. The process should be familiar if you've worked with symbols on word-processors. Simply select the symbol with the mouse, right-click, and select the Copy option from the right-click menu.

Then return to the GIMP's Text Editor window and click on the spot where you want to insert the symbol or accented character. Right-click, select the Paste option from the right-click menu, and—voila!—the character is now pasted into the text line.

Alternatively, you can enter the hexadecimal number of the desired Unicode character in the Text Editor, while holding the Ctrl and Shift keys down. For example, to generate the copyright sign, you would type A9 while holding down the Ctrl+Shift keys. (The letters A, B, C, D, E, and F are numerical characters in the hexadecimal number system.) When you type hexadecimal numbers, you have to use your regular keys on the keyboard, not the keys of the number block. The font you selected must also support the character or sign you want to add.

Windows users can find special characters and Unicode key positions in the Character Map, which can be accessed from Start > Programs > Accessories > System Tools.

3.6.4 Creating Text and a Script-Fu Drop Shadow

A drop shadow is a special effect that adds dimension to image elements and text. The following sections describe how you can use selections and fills to create shadow layers for any image object, including text.

The simplest way to produce a shadow effect is by going to Script-Fu Shadow > Drop Shadow. A dialog will pop up so you can set the attributes for the shadow.

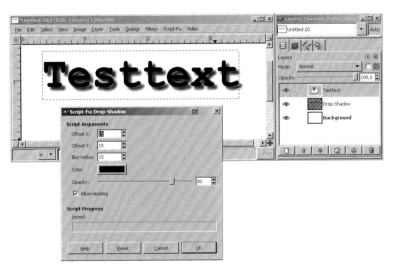

Figure 3.34: The Script-Fu window: Drop Shadow and the automatically generated Drop-Shadow layer in the Layers dialog.

The Offset values will determine the direction of the shadow in relation to the image object. Positive values for Offset X will place the shadow at the right, while negative values will place it at the left. Positive values for Offset Y will place the shadow below the selected object or character, while negative ones will place the shadow above it. The program defaults are set to mirror morning light, which comes from the top-left corner.

To make the shadow appear more natural, you can apply a soft brush to the borders and set the radius (edge sharpness), since shadows normally don't have hard edges.

The default color for the shadow is black, but you can select any color you wish to attain the desired effect. For example, if you select a white shadow on a dark background, the image object would appear to glow.

Real shadows are rarely pitch black and opaque. For a realistic look, you can move the Opacity slider to give the shadow some transparency.

A drop shadow is larger than the object casting it. For this reason, leave the control box next to Allow for size change checked. The shadow will then grow proportionally larger than the object casting it.

When you are satisfied with your changes, click OK. The drop shadow will be automatically generated and inserted as a new, separate layer into the image.

The GIMP is a true filter workshop. In this book, you'll only be introduced to a few of the filters available, so don't be afraid to explore the effects of the filters on your own. The next chapter provides descriptions of certain filters, along with tips on how to use them.

Using the Text Tool and Drop Shadow—a Practical Exercise

It's now time to practice what you've learned about the Text tool. And while you're at it, you can play with some filters and effects, such as the ones available in the Script-Fu > Shadow > Drop Shadow menu:

▸ Open your image *bluesky.xcf.*
▸ Set the text color (foreground color) you want to use.
▸ Create a greeting card text, using the default settings. Since you will be painting Easter eggs to add to the image later on, it is recommend that you write text that is appropriate to the greeting.
▸ Modify the text attributes in the Text tool options dialog.
▸ Access the Script-Fu > Shadow > Drop Shadow menu and using the settings described in the previous section, create a shadow effect for the active text layer.
▸ Save the image as *greetingcard.xcf.*

3.7 Using Graphic Filters to Add Effects to Your Images

The GIMP comes with a set of filters you can access from the Filters or Script-Fu menus. You are already familiar with a few of them, such as Gaussian Blur (Filters > Blur > Gaussian Blur menu) and Sharpen (Filters > Enhance Filters > Sharpen). Now take a look at the Unsharp Mask filter. This

filter is helpful when trying to find the edges and borders in blurry images, and can also be used to sharpen the details of an image.

In contrast, the Selective Gaussian Blur filter helps to smooth out a smoky image; it can be helpful when adding areas and borders.

The filters available in the Noise category can further improve your images. For example, an image that was heavily compressed in a JPEG file (compression artifacts) can be improved by adding noise. Though an image may sometimes become "jittery" due to the addition of color pixels, the additional pixels produced by the noise filter suffice to "cover up" the compression artifacts.

So far in these exercises, you have been using filters to edit an entire image with a single background layer. When applying filters to images with several layers, be sure to activate the layer that you want to adjust.

Some filters cannot be applied on single layers. If this is the case, and if you want the filter to be applied equally over the entire image, you will need to merge all image layers into one. To reduce the layers of an image, right-click on a layer in the Layers dialog and select the Merge Visible Layers or the Flatten Image menu item from the context menu. Make sure that the layers that should not be visible are set to invisible by selecting the Eye icon, or better yet, delete them. Remember to always work on a copy of the image. Never use the original.

You can apply several filters consecutively to the same image.

The GIMP comes with a large set of artistic and graphic filters. The GIMPressionist (Filters > Artistic Filters > GIMPressionist menu) is particularly impressive—a true filter lab! Another large collection of effects can be found under Script-Fu. You're already familiar with the Drop Shadow effect when you modified your text. But you can also use the Drop Shadow to create effects on independent image objects on separate layers, as mentioned above. Experiment with these filters on your images. Have fun playing with all the filters so you'll know how to best utilize them to achieve the look you want.

3.8 Creating Your Own Image Frames and Vignettes

You've now learned quite a bit about filters and effects. Now let's look at the possibilities available for designing an image frame. It could be a single-color frame, or a frame filled with patterns, such as a wood texture. Or you might decide that your image will look more impressive in a frameless glass picture holder. Or you can create a vignette in the form of an oval overlay—or another shape such as a keyhole—as was often done with old black-and-white photos. Any shape created with a selection tool can be transformed into a frame. Of course, you can find effects to individualize your new frame in the Script-Fu menu.

3.8.1 Single-Color Image Frames

Single-color image frames are the simplest to create. You can set the options in the Script-Fu menu to almost automatically produce a frame. Optionally, you can enlarge the canvas to frame the image so that it appears to be on a mount. Or, you can place the frame directly on the image.

The Procedure

▸ Open the *girl-color.png* image, which is in the *SampleImages* folder on the CD.

▸ Access the Image > Canvas Size menu item to increase the width or height of the canvas to the desired size. Press Enter. The chain icon should be closed (default), so that the sides of the canvas will adjust proportionally. Click the Center button, then click Change Size to enlarge the canvas.

▸ Optionally, you can add an alpha channel (right-click menu in the layers dialog) to the background layer of your image. Add a new layer underneath the existing one and colorize it; white or any other color will do.

▸ Select the Script-Fu > Decor > Add Frame menu item. In the Script-Fu: Add Border window that pops up, select a width and height for the frame in the Frame X Size and Frame Y Size options. Clicking the Frame Color button pops up the familiar Color Picker, where you can select the desired color for your new frame. The Color exchange option can be used to set the brightness for various areas of the frame. The higher you set the value, the more variance in the brightness of your frame. Click OK to accept your changes. You've created a frame with four different shades of your desired color to set off your image.

Now you can add a three-dimensional bevel or a shadow to your frame. You'll be once again using the automatic tools from the Script-Fu menu:

▸ Select the Script-Fu > Decor > Beveling menu item. The Beveling Index option sets the bevel width, limited to 30 pixels. Check the Use Layers control to ensure that the effect is applied to a copy of your image. Checking the Leave Bevel Bump Map control lets you choose whether the layer that was automatically generated by the effect will be saved in the image or on the previously selected frame layer.

▸ Finally, use the Script-Fu > Shadow > Drop Shadow menu item (see also Section 3.10.1) to add a shadow to the frame layer. This will result in a strong three-dimensional effect, adding considerable depth and richness to your image.

▸ Save your image.

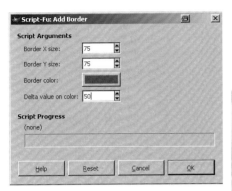

Figures 3.35 and 3.36: Settings in the Script-Fu: Add Frame dialog and the result in the image window.

Figure 3.37: The finished image with frame and drop shadow.

3.8.2 Creating a Frame with Pattern

The basic steps for creating a frame with a pattern are almost identical to those described above. The only difference is that you'll need to create a border pattern for your frame.

The Procedure

▶ Open the *girl-color.png* image from the *SampleImages* folder on the CD.

▶ Access the Image > Canvas Size menu item to increase the width or height of the canvas to the desired size. Press Enter. Since the chain icon is closed, each side will be increased proportionately. Click the Center button; then click Change Size to enlarge the canvas.

▶ Add an alpha channel (right-click menu in the Layers dialog) to the background layer of your image. Add a new layer underneath the existing one in the image and colorize it. (Choose a color that will nicely set off the image, as this will serve as a "matting" of sorts.)

▶ Access the View > Zoom > Fit Image to Window menu item, and adjust it so you can see the entire image in the working window. Make the rulers visible (View > Show Rulers menu item). Pull guides from the rulers and position them so that the width distance between the frame and the image borders is equal. The dimensional information provided by the rulers will help you measure the border accurately.

Figure 3.38: The image with guides and selection before inverting the selection.

▸ Use the Rectangle Selection tool to draw a rectangular selection over the guides. Use the Select > Invert menu item to invert this selection. This selects the frame area to be filled.

▸ Create a new layer called Frame in the Layers dialog.

▸ Click the Pattern button in the Toolbox. Select a filling in the Pattern window that pops up. Note that the patterns appear smaller as image resolution increases.

▸ Select the Edit > Fill with Pattern. The selected area is filled.

▸ Remove the selection (Select > None menu item).

Figure 3.39: The Pattern window with the prepared fillings and their use in the image. The red circle marks the Pattern button in the Toolbox.

You can repeat the steps you followed when you created the single-color frame if you wish to bevel this frame or add a drop shadow. Don't forget to save your image.

3.8.3 Vignettes for Images

In the early days of photographing, creating photo vignettes was very popular. For example, a cut-out overlay in the shape of a heart might be placed on top of a photo to add emphasis and drama to the picture. Some people placed several photos in frames with several cut-out shapes to create a photo story, or vignette; hence the name. You can use any selection created with the GIMP for a vignette. Be creative!

The Procedure

▸ Open the *girl-color.png* image from the *SampleImages* folder on the CD.

▸ Create an area of about 50 pixels all around the image by dragging in and positioning guides.
▸ Select the Ellipse tool from the Toolbox. Create an elliptic selection over the area by clicking the upper left corner of the guides and pulling the ellipse diagonally to the bottom right corner.
▸ Select the Select > Invert menu item. Click to invert the selection.
▸ Access the Select > Feather menu item to give your selection a wider border feathering. 75 pixels will be appropriate for this image.
▸ Select the Edit > Clear item to delete the surrounding image contents within the selection.
▸ Save your image.

Figure 3.40: The image with the selection for producing a vignette. The image contents within the selection have been deleted.

You should be proud of yourself. You've learned how to use several of the GIMP's effects to artistically manipulate images, including shadows, which give the image a neat, three-dimensional look.

In the following section, you will create your own three-dimensional objects and effects. Of course, you will also continue to work with layers and selections, as well as discover how to apply more complex tools, such as the painting and transform tools.

3.9 Creating and Editing Image Elements— Lighting Effects and Shadow Layers

Though the GIMP is primarily an image editing program, it also includes tools which you can utilize to create new image elements and objects, such as logos. In this respect, the GIMP seconds as a painting program.

In the following exercise, you will learn several ways to create new image objects. You can use *greetingcard.xcf* to produce an Easter greeting card, complete with a few hand-painted Easter eggs. You will learn how to use masks to create simple image objects. You will also learn how to create, copy, group, change, transform, and position image elements.

3.9.1 Overview of Part 1—Creating a New Image and New Image Objects

Let's say you want to turn your vacation image into a spring greeting card with self-painted Easter eggs. Of course, you could create the eggs directly in the *greetingcard.xcf* image. However, there is a safer and more practical way of doing this: Create a new image, construct an egg in this new image, and add lighting and shadow effects to it. You'll use a familiar technique, Drag-and-Drop, to export the "pattern egg" to the actual image layer.

▸ Create a new image (File > New menu item from the Toolbox): size w × h = 4 × 6 in or approximately 10 cm × 15 cm; resolution = 300 dpi; background color = white; file format = *xcf*. Name it *easteregg.xcf* or something similar, and save.

▸ Create a new layer, Circle, in the Layers dialog. On this layer create a circular selection by using the Ellipse tool while holding the Shift key down. Fill the circle with the color red. Delete the selection (Select > None menu item).

▸ Create a guide on the horizontal center axis of the circle. Then create a new rectangular selection over the top half of the circle. Use the Scale tool to transform it, vertically pulling the transformation grid from the upper border while holding down the Alt key. Remember to set the tools options to Affect > Transform Selection. When the shape resembles an egg, accept your changes in the Scale window. You will now find a Floating Selection (Transform) layer in the Layers dialog. Right-click on this layer and select the Anchor Layer option from the context menu.

▸ Use a Brush with low opacity to create light and shadow effects on the egg. Create a new layer for each effect. Use the Magic Wand tool to produce a selection of the egg first, so that its contours will be maintained. Finally, delete the selection.

3.9.2 Creating a New Image

Figure 3.41: The New Image window.

The Toolbox's File > New menu item enables you to create a new, empty image document. If you select this menu item, the Create a New Image dialog will pop up. Enter the image size. The values for width and height are not linked in this case. Select the desired measuring unit if you prefer not to work with pixels. Alternatively, you can select a pre-defined size from the Template dropdown list.

Click Advanced Options to select a resolution for your image. In this case, the values for width and height are linked.

In the Colorspace item under Advanced Options, you would normally select RGB color. Grayscale is used for black-and-white or grayscale images. However, it is often preferable to use the RGB color space for grayscale images as well, since the RGB option supports all of the GIMP's features.

Fill provides you four options to choose from: The foreground and background colors as shown in the Main Toolbox, as well as white and transparent. Select Transparent if you wish to create an empty layer.

You can use the Comment text field to write a descriptive comment. The text will be attached invisibly to the image file.

3.9.3 Transforming a Selection

You've already used the Ellipse tool to create a shape on the new layer titled Circle. It will appear as a real circle once you've dragged it into that shape. Select the circle and drag it while holding down the Shift key.

Use the Bucket tool or select the Edit > Fill with FG Color menu item to fill the object with the red shade selected in the Color Picker (pure red: RGB 255.0.0).

Drag a rectangular selection across the upper half of the red circle (lines within the grid area) on the Circle layer. This selection can be larger than the intended object. The program will find the object borders automatically, since the remaining area is on a transparent layer.

Select the Scale tool. In the tool options, select the View > Image + Grid menu item. The option Affect is set to Transform selection. Click on the image to access the Scale dialog. The transformation grid that was initially limited to the selection surface now must be pulled upwards from the upper edge (see figure). The circle should only be scaled on its y axis. To this end, hold the Alt key and drag. You can also set the tool options to Constraints > Keep width.

Click the Scale button in the Scale dialog to accept your changes.

You'll have to combine this transformation with the Circle layer in the Layers dialog. Right-click the Floating Selection (Transformation) layer and select the Anchor Layer item from the right-click menu, or simply click on the Anchor Layer button.

3.9.4 Using the Paintbrush Tool to Create Lighting and Shadow Effects—Fuzzy Painting

Lighting and shadow effects add depth, realism, and perspective to an image or object. There are several methods available to produce such effects. One way is to simply paint them on.

Use the Select by Color tool to create a selection across the red egg. The selection is helpful as it prevents you from painting outside the contour of the selection.

Note: Create a separate layer for each lighting effect. If something goes wrong, you can simply discard the layer and start fresh.

Access the Brush Editor to create a new brush. Select a 250 px diameter and a 100% spacing (hardness = 0.00). Use a large, round brush with full feathering when painting surfaces without transitions.

In the tool options dialog, set the Opacity for the brush application to a value of about 10%. This is suitable for fuzzy painting.

With these settings in place, paint with the Paintbrush in semicircular strokes. For the light, start at the tip; for the shadows, start at the bottom

of the object. Begin painting the outside the egg; don't worry about staying inside the line, the area is protected by a mask. Paint across the object in steady strokes. While painting, hold down the left mouse button, release it after each stroke, and begin again. If you want to increase the opacity at the bottom of the shadow, you can repeat this process several times.

Figure 3.43: The Paintbrush tool options, the image, and layers for lighting and shadow effects in fuzzy (semi-transparent) painting technique.

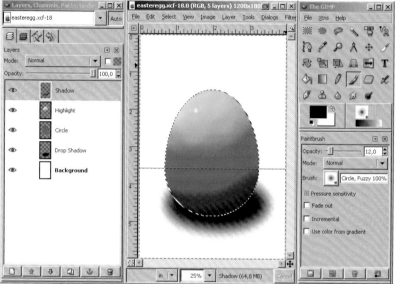

Use a smaller, softer brush to set a light reflex spot on the lighter area. You may have to repeat these strokes if you want to achieve a uniform application of color.

The Eraser tool may be helpful. It works similarly to the Paintbrush tool. Reduce the opacity in the tool options dialog so that you can erase in "fuzzy" strokes rather than erasing everything at once.

3.9.5 Overview of Part 2—Inserting, Duplicating, and Colorizing Image Objects

Before exporting your Easter egg, you'll want to add a drop shadow. Moreover, all layers should to be reduced to one (otherwise, you will need to export, position, and touch up each layer individually). Below you'll find an overview of the steps involved.

▸ The shadow that the egg would naturally cast onto the ground is missing so you'll have to create that effect. First create a new layer **Drop-Shadow** in the Layers dialog. Produce a horizontal elliptic selection with a soft border of 150 pixels or so (Select > Feather). Fill the ellipse with black by selecting the *Bucket* tool, or the Edit > Fill with FG Color menu item. Delete the selection. Make sure that the layer is positioned

beneath the Egg layer in the Layers dialog. If it is not beneath the Egg layer, use the Move tool to reposition the shadow layer.

▸ Save the image as *workingegg.xcf*.

▸ Delete the Background layer (white background) by selecting that layer in the Layers dialog and clicking the Delete button (dustbin icon).

▸ Right-click on the Layers dialog to select the Merge Visible Layers item from the context menu. Click OK in the Merge Visible Layers dialog to accept your changes.

▸ Open the *greetingcard.xcf* image.

▸ Drag the recently modified layer titled workingegg onto the *greeting-card.xcf* image window and drop it.

▸ Give the new layer a descriptive new name in the Layers dialog, anything akin to Red-Egg will do. The important thing is to choose a name that accurately describes the image item. Now position the layer underneath both the text and the text shadow layers.

▸ Scale the size of the egg (go to Layer > Scale Layer or Tools > Transform > Scale). Then place it in the image and use the *Rotate* tool to slightly adjust it.

▸ Right-click on the Red-Egg layer in the Layers dialog, then select Duplicate from the context menu. Click on duplicate twice to make two new layers. Name one layer Blue-Egg and the other Yellow-Egg.

▸ Position the newly created eggs (which are still red) on the image where they are entirely visible. (Activate the layer, click the Move tool on it, and drag).

▸ Select the Blue-Egg layer in the Layers dialog. Go to Tools > Color Tools > Hue-Saturation. Move the Hue slider until the egg turns blue. Repeat for the Yellow-Egg layer, but tweak the Hue slider to color the egg yellow this time.

In the following section, you'll take a closer look at the wonderful Hue-Saturation device.

3.9.6 Changing the Color of an Image Object— the Hue-Saturation Function

Hue-Saturation is an extremely flexible tool. It can be used to completely change an image's color scheme, increase the saturation of one or more colors, create shades of gray by intensifying or decreasing color, or adjust the color of a selection. You can even use the Hue-Saturation slider to easily colorize old black-and-white photos, or add color to new black-and-white photos to produce an artsy, nostalgic effect. In the exercise below, you'll use Hue-Saturation to decorate your Easter eggs.

Activate the layer that you wish to modify. Go to Tools > Color Tools > Hue-Saturation. Select the Master button in the center of the color rectangles. You can move the Hue slider in the Modify Selected Color control box

to change the hue of the selected object. Moving the Saturation slider will either intensify the colors in the image or reduce them (until it becomes a grayscale image). To correct the image's (LAB) lightness, move the Lightness slider.

Check the Preview control at the bottom of the Hue-Saturation window so you can interactively view your modifications as you go in the image window. (Rendering a full-size image in a high-quality format would require too much time if done step after step.)

Figure 3.44: The options for the Hue-Saturation menu item.

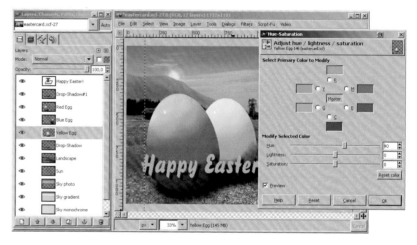

What's still missing?

▸ You will need to position, scale, and rotate the eggs until your composition is balanced to your satisfaction.
▸ Save your image as *eastercard.xcf*.

You have learned quite a bit about working with layers and masks. You know the most important color tools, and you can now create digital brushes used to produce original image objects, paint existing and new objects, insert text, and transform objects. And you've only touched the tip of the iceberg. The GIMP offers a tool that enables you to create arbitrary shapes. It's called the Path tool. You can use it to cut an image object exactly at its contour, or to create free, transformable shapes. The following section will define how the Path tool works and what it is typically used for. You will also learn more about filters for light effects.

3.10 Using the Path Tool as a Masking Tool— Using Filters for Light Effects

The *Path* tool has multiple uses: On the one hand, it enables you to produce free (vector-based) shapes that can be transformed, filled, and otherwise edited. On the other hand, the GIMP supports a variety of methods to create paths from selections and, vice versa, transforms selections into paths.

Paths are not limited to straight-line objects and edges. On the contrary, they are extremely useful when creating and tracing complex objects and shapes. Paths can be aligned to the contours of very complicated selections with great precision, or it can be used with regularly shaped objects.

In the next exercise, you will use paths to copy a wine glass (a somewhat regularly curved object) from an image. This task would be a difficult procedure to perform with one of the selection tools you've been introduced to thus far, but with paths, it's fairly easy.

3.10.1 Cutting a Wine Glass and Creating a Drop Shadow—Overview of the Steps Involved

▸ Open the *wineglass.png* image from the *SampleImages* folder.
▸ Select the Path tool to create a path, following the contours of the wine glass.
▸ Create a selection from the path; add 5 px of feathering to the selection.
▸ Select the Edit > Copy menu item to copy the wine glass. Go to Edit > Paste and insert the glass as a new layer in the image. Remember to name the layer.
▸ Save the image (without combining the layers) as *wineglass.xcf*.
▸ Next, insert two new layers underneath the wine glass layer: Glass-Shadow and Background-Gradient.
▸ Copy the path and transform it so that the wine glass casts a perspective shadow.
▸ From the Shadow path, copy-create a selection with a strong, soft border, then fill the border with the color black on the Shadow layer.
▸ On the Background layer, create a linear gradient blend from pale pink to burgundy red (below).
▸ Reduce the opacity of the layer with the pasted wine glass to about 90%. Alternatively, you can use a large eraser with 10% opacity to erase some color from the wine glass. Whichever method you choose will serve to increase the transparency of the glass.
▸ Use the Light Effects > FlareFX filter to create two highlight spots: one at the upper rim of the glass and another at the base of the glass.
▸ Save your image.

3.10.2 Creating and Editing a Path—the Design Editing Mode

Select the Path tool to create a path. Make sure that the *Design* editing mode is selected in the tool options. The Polygonal option should also be checked.

Click the tool on a distinctive point on the image object you want to outline. Black dots or "anchor points" will appear. Find the next distinctive

point and click again. The two anchor points along the path are now connected by a line. Continue setting anchor points until you have almost outlined the entire object. Set the last anchor point nearby the first. Then hold the Ctrl-Key. Point to your starting anchor point again. The mouse pointer now shows a path tool icon with the symbol of a magnet (an "U" upside down). One left mouse click, and the path is closed.

Figure 3.45: The Path tool and options used to create a path, and, subsequently, a path with anchor points (in the image window).

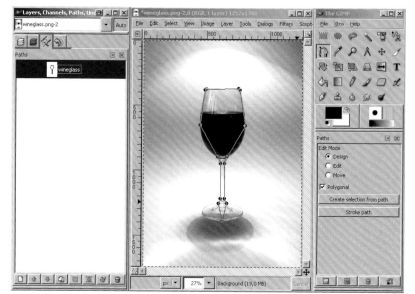

As you can see in the example, the anchor points were placed only in the places where the object curves sharply or where the contour changes direction. A few anchor paths should be sufficient, even if you're working with a curvy, complicated object, since the contour lines between points can be further modified by using the anchor point handles (see below).

3.10.3 The Path Editing Mode

Continue using the Path tool in the Edit mode to position the anchor points around the wine glass. Be aware that the checkbox Polygonal still has to be checked. Although the wine glass in the example is a fairly simple object, the path tool is often used with complex or detailed objects. You may want to take advantage of the magnify tool and zoom into your image. Feel free to add more path anchor points by clicking the mouse on any path line. You can also delete any superfluous anchor points by clicking on them while holding down the Shift key.

When you are satisfied with the positioning of the anchor points, convert the path to path curves so that the path line will precisely trace the contours of the object. Stay in Edit mode, but click the Polygonal control to disable it.

If you click on an anchor point and drag it while holding the left mouse button down, two empty squares at either side of the point will appear: These are "handles" that can be used to define the direction and intensity of the path or curve. Each anchor point has two handles. To adjust a curve on a specific section of the path, you simply move the handle of a nearby anchor point with the left mouse button. Using handles requires a little practice, but once you get the hang of it, you'll love the way it performs. Play around with the handles until you've succeeded to create a path that exactly traces the contours of the wine glass.

Note: If you press the Ctrl+Shift keys while clicking on an anchor point, the handles of that anchor point will work parallel to each other (i.e., be dragged in the opposite direction). This option enables you to easily create tangents and turning points while avoiding awkward-looking bends.

Figure 3.46: Path anchor points on an object.

Manipulate the path using the anchor point handles until you're totally satisfied with the selection path. If you feel you need a more precise curve, just add another point to the path.

Simply click the curve next to an existing anchor point and a new one will be created. If it got there by mistake, you can quickly get rid of it by using Undo History, or click on the point while pressing the *Shift* key to delete it. When deleting, the mouse cursor becomes a Path tool icon with a minus sign.

When you have completed the path around the wine glass, your image should look similar to the one in the example. Remember to close the path selection by merging the first and last anchor points (see 3.10.2).

3.10.4 The Paths Dialog

Paths created in the image window will also appear in the Paths dialog. Go to the File > Dialogs > Paths menu in the Tools palette window. The Paths dialog allows you to manage and activate paths, which is helpful when you have multiple paths in an image. Active paths appear blue in the dialog and are visible in the image. Non-active paths are not displayed or shown in the image. A non-active path is invisible, but it nevertheless exists!

When you create a new path, it will appear as an *Unnamed* path. To rename the path, click on the text field next to the preview thumbnail and enter a name. (It is wise to choose a descriptive name so that you can easily find it if you want to copy or modify it for use in another image.)

The Paths dialog works similar to the Layers dialog. You can click the eye icon to make a path visible, or click the chain icon to link a path to other paths in the image, so that you can manipulate them together.

To complete the exercise, you'll need to use the buttons at the bottom of the dialog. From left to right, these buttons are: New Path, Raise Path, Lower Path, Duplicate Path, Path to Selection, Selection to Path, Stroke Path (Contour), Delete Path.

Figure 3.47: A path in the image window (contour line) and the Layers, Channel, Paths, Undo dialog with activated path dialog (elevated tab).

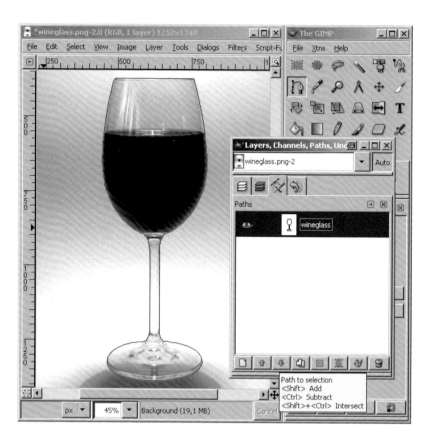

3.10.5 Transforming Paths—the Shear Tool

Continue working on your image. In the Paths dialog, click the Duplicate Path button and enter a name for the new path, such as Wineglass-Shadow. Activate the *Wineglass* path and select the Path to Selection button. You'll know the object has been selected when you can see by the "marching ants" around it. Access the Select > Feather menu item to define a border feathering of 5 px.

Go to Edit > Copy and make a copy of the wine glass. Check the Layers dialog to make certain that the layer that you're copying from is active (blue). Then go to Edit > Paste and insert the copied object as a new layer into the image. A floating selection will appear in the Layers dialog, but it won't be visible on your image. To see the selection in the image, you must first change it from a floating selection to a new layer. To do this, simply right-click on the layer palette and select New Layer.

You can now check the quality of your work more precisely by making the background layer invisible. Just click on the layer with the eye icon.

Continue by making Wineglass-Shadow your active path. You'll be using the Shear tool to tilt the glass. Select the Shear tool from the Tools

palette. (As in the previous exercise, the Transform Path button should be selected to ensure that the tool affects the path.)

From within the image, drag the cursor in a thirty-degree angle or thereabouts. This will tilt the image accordingly. Then click the Shear button in the info dialog to accept your changes.

A similar method will be used to scale the path. Next, use the Perspective tool to align the shadow with the wine glass. Play with the options until you've attained perfection.

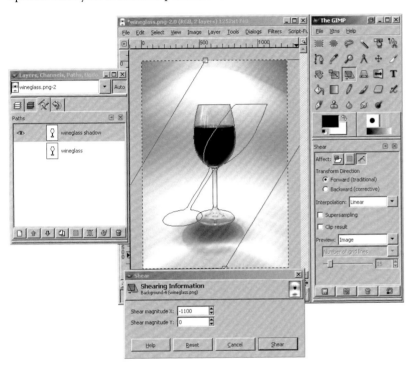

Figure 3.48: The Shear tool and the tool options for transforming paths.

Use the Move tool to position the path. The Transform Path option in the tool options dialog must be selected to move a path.

For the next step, select the button in the Paths dialog to create a selection from the Wineglass-Shadow path. Access the Select > Feather menu item to define a border feathering of approximately 25 px. Activate the Glass-Shadow layer. Then use the Fill tool or go to Edit > Fill with FG Color to fill the selection with black. The layers should be stacked as follows: Wineglass > Glass-Shadow > Background-Gradient.

Reduce the opacity for the active layer (Glass-Shadow) to approximately 70%.

The Eraser tool can be used together with a large, soft brush and a reduced opacity (about 10%) to produce transparent surfaces in the wine glass and its base. Experiment until you're satisfied. Then fill the Background layer with a two-color gradient blend of your choice. Save your image.

Figure 3.49: The finished image with the Layers dialog and the Gradient tool options. The paths are set to invisible in the Paths dialog.

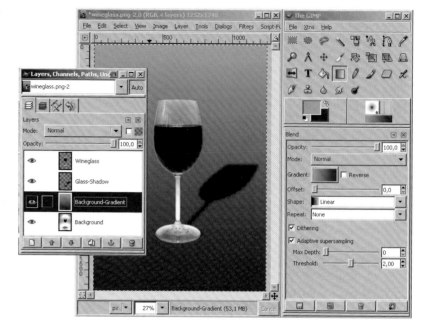

3.10.6 Using Filters to Produce Lighting Effects

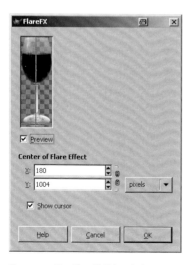

Figure 3.50: The Filters > Light Effects menu.

In the previous exercises, you've learned how to use painting tools and other lighting effects to create highlights, emphasize the sculptural appearance of objects, and add depth to an image.

You can use paths to produce light reflection and highlights. You can also use paths to create small star-shaped paths in the image, which can be transformed into selections. The selections are given a soft border or feathering, and filled with white color, sometimes repetitively, until the desired effect is achieved.

In addition to the options already mentioned, the GIMP offers a variety of filters that can be used to create certain lighting situations, highlights, and reflections.

The FlareFX Filter

When highlights are properly placed on an image, glassy materials will appear three-dimensional, shiny, and realistic. The FlareFX filter works wonders when applied to glass. You can find this filter by going to Filters > Light Effects. Like many filters, it applies only to the active layer. So firstly, you'll want to check to make sure that the wine glass layer is currently active.

When you select the Flare FX Filter, a dialog with a preview image will pop up. Use this dialog to numerically define the position where you want to set a highlight.

Figure 3.51: The Flare FX Filter dialog.

It is easier if you select the Show Cursor option and subsequently click the preview image in the dialog. You can now use your mouse to select and/or change the position of a highlight. When you're done, click the OK button to accept your changes. The effect will be calculated and added to the image.

Repeat this process if you wish to increase the brilliance, modify the position of the highlight, or set another highlight. Simply go to the Filters menu and select the Repeat Last option (if you want to repeat the exact process) or one of the filter options.

When you're done working with filter effects, save your image.

Figure 3.52: The Repeat Last option in the Filter menu.

3.11 Using Layers, Masks, and Paths to Create Three-dimensional Objects—Shadow Layers

You already succeeded in creating simple image objects— for example, the Easter eggs. With the GIMP tools, you can create three-dimensional objects that are far more complex than eggs. In the next exercise, you will work with paths and selections, and learn about transformations in more detail. In addition, you'll learn how to create a three-dimensional, complex object.

The following exercise is rather complex, as it requires many steps, most of which are repetitive. You'll be creating several paths and selections, as well as working with the Layers and Paths dialogs to fill and transform those paths and selections.

Take your time. You will gain experience and speed as you work.

3.11.1 Creating and Transforming Image Objects

Imagine that you want to create an image of your Easter card on a television. To do so, you will need to build both the image and the television. The following exercise will show you a relatively simple way to produce rather complex image objects with 3D effects. Don't get too stressed out; this is not a test. It's an exercise designed to give you lots of experience and practice.

You should already be familiar with many of the steps required in this exercise. Nevertheless, we will briefly discuss each of the steps involved, including the ones you've already learned, just in case you may need a review.

Proceed as follows:

▸ Create a new image (File > New from the Toolbox) with the following properties: resolution = 300 dpi; width = 6 in; height = 4 in; mode = RGB; background color = white. Save the image as *monitor.xcf*.

▸ Open your *eastercard.xcf* image and save it as *eastercard.png*. The visible layers in the *eastercard.png* image should be merged into one layer, so go to the Layers dialog, right-click the top layer to access the context menu, and click Merge Visible Layers. Minimize the image, but don't close it. In a few minutes, you will need to export a layer from this image.

▸ Return to the *monitor.xcf* image. The first thing you want to do is create three empty layers in the Layers dialog: Front (for the monitor's front), Screen (for the monitor's screen), and Bezel (for the monitor's housing).

▸ Make Front the active layer. Use the Rectangle Selection tool to create a rectangle that measures about one quarter of the image size.

▸ Use the Color Picker to select a light gray color for the foreground. Then use the Bucket tool to fill the selection.

▸ Save your image.

*Figure 3.53: The monitor.xcf image
with the new layers.*

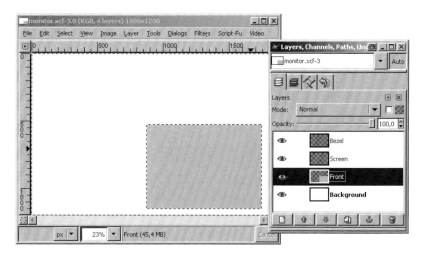

Now get ready to paste *eastercard.png* on the new image. You will be virtually integrating it into the television.

▸ Use the Measure tool to measure the width and height of the gray rectangle. Write down the two values.

▸ Return to the *eastercard.png* and select the Image > Scale Image menu item. Scale the image so that its width will be roughly 100 px smaller than the rectangle in *monitor.xcf*.

▸ In the *monitor.xcf* image, use guides to mark a border of about 50 px in the gray rectangle. Export the main layer from the *eastercard.png* image and align it along the marked border.

▸ You may need to scale the height of the gray rectangle. Select either the Scale tool or go to Layer > Scale Layers. Make sure that the border beneath the exported image should be wider than the one above it.

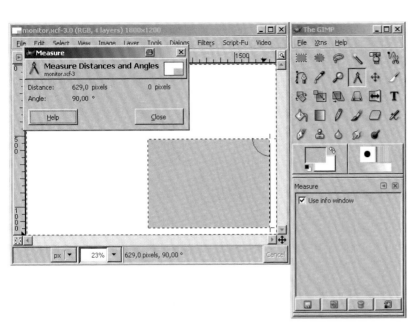

Figure 3.54: *Using the Measure tool to measure height and width.*

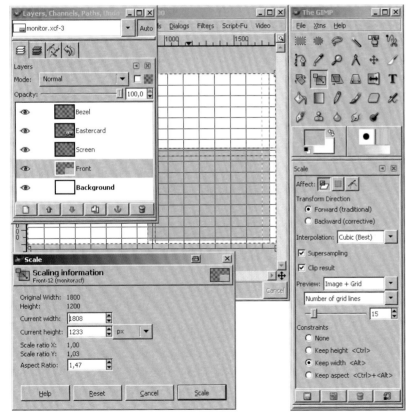

Figure 3.55: *The main layer from eastercard. png has been inserted; subsequently, the Front layer was scaled.*

What we need next are surroundings for the screen.

▸ Create a selection along the surroundings of the imported *eastercard* layer. Since you don't want the program to find the Front layer's surroundings, set the Front layer to invisible in the Layers dialog. Make sure that the Select Transparent Areas and Sample Merged options for the Magic Wand tool are selected. Click the Magic Wand tool on the transparent area around the image object in the image window. Everything around the object has been selected. Now use the Select > Invert function to precisely select the object's contour.

▸ Access Select > Rounded Rectangle to round the selection's corners by 25% or so.

▸ Access Select > To Path and save the selection as a path.

▸ Access Select > Invert and invert the selection again. Then go to Edit > Delete so you can delete the corners of the *eastercard* image object.

Next you'll want to create a screen for your television, so let's do that now.

▸ Invert the selection once again to reselect the actual image object in the layer.

Figure 3.56: The flare reflex on the Screen layer shines through the semi-transparent Easter-Card layer.

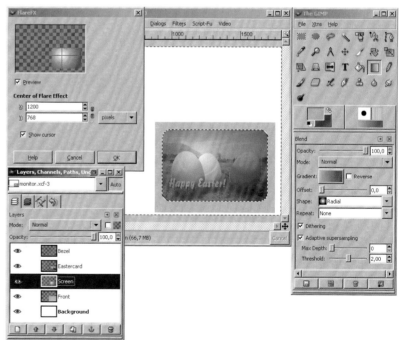

▸ Switch to the Screen layer in the Layers dialog. Fill the selection with a circular gradient blend. Select a pale green-gray as the foreground color and a dark green-gray as the background color.

▸ On the Screen layer, go to Filters > Light Effects > Flare FX to set a highlight.

▸ Reduce the opacity of the *Eastercard* layer to approximately 40%.

To create a realistic illusion, the screen should appear to be inside the monitor, you can offset the screen in the monitor by creating a recessed bezel:

▶ Switch to the Bezel layer. Select a very light silvery gray as the foreground color. Invert the selection. Access the Edit > Stroke Selection menu item to trace the contour of the selected object. Apply a stroke width of 15 px. Then remove the selection by going to Select > None.

▶ Use a smaller hard brush to erase the upper left edge of the bezel on the Bezel layer. This should create an illusion of depth, as the bezel will look as if it has disappeared due to a natural perspective distortion. Zoom into the remaining corners and use the Eraser to carefully round them out.

▶ Save your image.

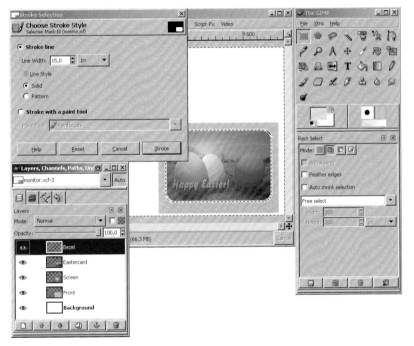

Figure 3.57: The Bezel layer on the selection's contour, and the Edit > Stroke Selection menu.

You've now completed the front of your monitor. In the following steps, you will use the Shear tool, the Perspective tool, and the Scale tool to apply a series of transformations to the existing image layers in order to jointly bend their perspectives.

To ensure the transformations will affect all layers of the image concurrently, you should link them with the chain icon you'll find near the preview in the Layers dialog. Make the chain icon visible on each layer, with the exception of the white background layer.

Make sure that all layers have the size of the image. The layer *Eastercard* may not – which is indicated by a dashed black-yellow border in the image. This would lead to an incomplete transformation – when transformed, the

layer would be cropped to its original size. Right-click the layer in the Layers dialog and select Layer to Image Size.

Figure 3.58: Using the Eraser to erase the bezel and round the corners.

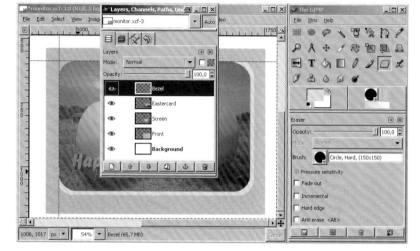

> ▸ Now select the Shear tool to bend the layer vertically. Use a shear shift of about -400 for the y axis.
> ▸ Next, use the Perspective tool to bend the right edge of the layers.
> ▸ Finally, scale the layers horizontally from right to left, approximately 70%.
> ▸ Save the image.

Figure 3.59: Using the Shear tool.

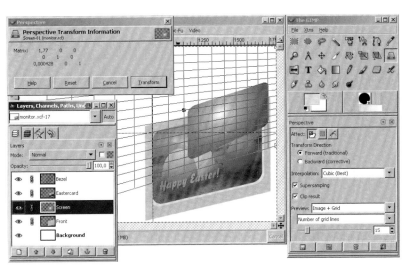

Figure 3.60: Using the Perspective tool.

You're almost finished with the front of the monitor. What's missing? Most monitors have control knobs or buttons of sort, so why not create a couple of knobs, as separate image objects on a new layer.

▸ Create a layer titled Knob on the top of the stack in the Layers dialog. Zoom into the left bottom corner of the image. Use the *Ellipse* tool to create an ellipse. Fill the ellipse with a gradient blend wherein the top is white and the bottom, black.

▸ Use the Move tool to move the elliptic selection slightly horizontally. Pay attention to the tool options: Select > Transform selection.

▸ Access the Color Picker and select a light silvery gray as the foreground color. Use the Edit > Fill with FG Color menu item to fill the selection. Voila! You're done with the first knob.

▸ Now duplicate the Knob layer (by clicking the Duplicate Layer button in the Layers dialog) and paste it on the right bottom corner. Scale the new layer to about 90% of its size to make it proportionately smaller.

▸ The front of the monitor is done. Save your image.

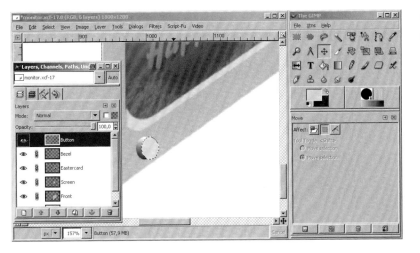

Figure 3.61: Using an elliptic selection with a gradient fill to create a control knob.

You've probably noticed that the image is still missing the left and top sides of the television, along with the monitor shadow. Begin by creating three new layers: The Top layer will naturally be on the top of the stack in the Layers dialog. Insert the Shadow and Side layers directly above the background layer.

You can use paths in Design mode with the Polygonal option set in the tool options to produce the necessary objects on these layers.

Start with the Side layer. Create a square with a closed path that attaches to the left side of the front part of the monitor. Create a selection from this path. Then fill it with the same gray tone you used for the Front layer.

Figure 3.62: Using a path and a selection from that path to create a cabinet side.

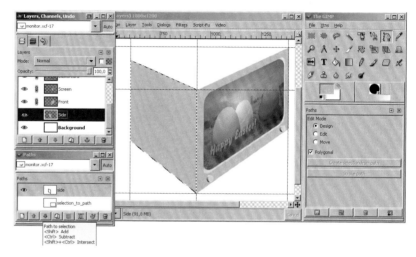

▸ Duplicate the Side layer (right-click menu in the Layers dialog) and call it Side-Shadow. Fill the selection with black this time. Reduce the layer's opacity to about 50%.

▸ Create the cabinet top on the previously prepared layer. To create the path, just follow the corner points of the surfaces. Use a very light gray to fill the area.

The cabinet is finished, except for the shadow, which will, of course, add perspective, depth, and realism to the image.

▸ Create a shadow near the monitor's base. Use the path tool to create the shadow; then turn the path into a selection. Apply a soft border gradient (Select > Feather) of 50 px to the selection. Fill with black.

▸ In the layer's dialog, reduce the layer's opacity (transparency) to 70%.

▸ Success! You've done it. Time to save your image.

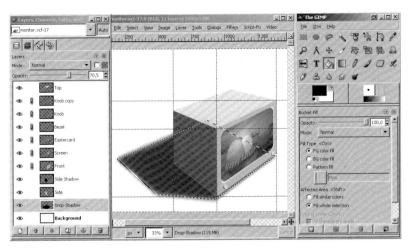

Figure 3.63: The monitor.xcf image with all its layers.

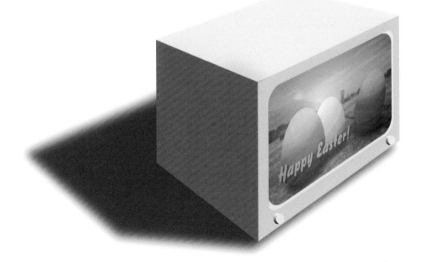

3.12 Using Masks and Selections to Dissolve Images

Sometimes it is desirable to crossfade two images, or seamlessly combine several images to produce a panoramic photo. These goals can be achieved by using masking techniques or soft border gradients (i.e. selections with a large amount of feathering).

3.12.1 Dissolving Two Images with Different Motives

In order to dissolve two images, they must be approximately the same size and resolution. However, they don't have to be the same file type. The images you'll be using in the following exercise have already been prepared.

The Procedure

▸ Open the two images called *lido.png* and *shells.png* from the *SampleImages* folder on the CD.

▸ Duplicate the *Background* layer in the *shells.png* image. Call the duplicated layer *Shells*. You will be editing and exporting it later.

▸ Create a new empty layer in the image and name it Gradient.

▸ Fill the new layer with a gradient issuing from the foreground color (black) and fading to transparent. You will find a pre-made gradient of this type in the Gradient window. The opaque color must be applied to the upper part of the image, which will be deleted later. The gradient should become transparent near the bottom, where the image content that you'll be keeping is currently positioned.

▸ Select the Layer > Transparency > Alpha to Selection menu item. A selection appears, but it has a feathering according to the gradient.

▸ Activate the Shells layer.

▸ Use Edit > Clear to delete the image content within the selection on this layer. Any content placed in the layer should now be feathered in accordance with the gradient.

Figure 3.64: Black to transparent gradient on a separate layer, created by using the Layer > Transparency > Alpha to Selection menu item.

- Export the Shells layer by dragging and dropping it onto the second image: *lido.png*. Adjust the position of the inserted layer on the image; then scale it so that the shells extend to the visible horizon.
- You may need to adjust the brightness and contrast of the Shells layer to fit the *lido.png* image (go to Tools > Color Tools > Brightness-Contrast).
- Save the image (with its layers) as *fenice.xcf*. You will be using this image in a later step.
- Save the *shells.png* image in the *xcf* format.

Figure 3.65: The gradient is applied to the layer with the shells. Image content is deleted using the Edit > Clear menu item.

Figure 3.66: The finished collage with the transformed Shells layer.

3.12.2 Composing a Panoramic Image from Several Images with the Same Motive

Panoramic Photos

Images composed of several distinct shots assembled into one image are often called "panoramic photos". You can shoot such images free hand. Unfortunately, panoramic photos often suffer from horizontal or vertical mismatches, distortions, or canted sides of the distinct images where they join one another. If you use a tripod when shooting panoramic photos, it will be easier to combine the images. In any event, make certain that about one third of each image can overlap onto the other images so that the dissolve will appear natural and smooth. It is extremely important to use the same focal distance and depth of focus when taking the photos. If you don't, you'll end up with a disjointed, odd-looking panorama that just doesn't fit together.

Depending on the model and focal depth of your lens, the photos may also have distorted edges. This means that the photos must be transformed and/or modified in order to fit together. Although this is a delicate venture, it is possible with the GIMP.

The images used in this exercise were shot with a light telezoom and a miniature mirror reflex camera. They are predominately free of distortions.

Note: When combining photos into panoramic images, prepare them first so that they are all the same size and, more importantly, the same resolution.

The Procedure

‣ Load the *Garda1.png* image from the *Gardapanorama* folder in the *SampleImages* folder on the CD.
‣ In the Layers dialog, add an alpha channel to the Background layer. This will add transparency attributes to the layer, including the ability to reposition the transparency or other objects. Just right-click to open the context menu. Then select Add Alpha Channel.
‣ If you want to insert all the images into one, you'll have to increase the canvas size. Extend the image surface to the right. Select Image > Canvas Size and enter a width of 70 in and a height of 20 in.
‣ Display the image by selecting View > Zoom > Fit Image in Window.
‣ Use the Move tool to position the *garda1* layer approximately at the center of the image along the left margin.
‣ Save the image by the name *gardapanorama.xcf*.
‣ Load the images *garda2.png* through *garda4.png,* one after the other. In the Layers dialog, drag and drop these layers to export the working surface of the *gardapanorama.xcf* image. Try to position them so that they overlap.

- Save and name the layers. Now that they've been exported, you can close *garda2.png* etc.
- Save your *gardapanorama.xcf* image. It should now roughly look like the example in Figure 3.67.

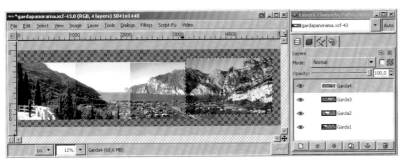

Figure 3.67: The gardapanorama.xcf image with pre-positioned, imported layers and the open Layers dialog.

- Next, use the Layer > Colors > Levels (tonality correction) menu item to edit each of the layers. Match the colors, contrast, and brightness of the images. Use the *Garda3* layer as the reference image since the color and brightness is of higher quality than the others.
- Use vertical guides to select the overlapping areas of the layers. Hold down the left mouse button while dragging the guides from the rulers.
- Use the Rectangle Selection tool to create a selection. This selection should begin at the center, where the *Garda1* and *Garda2* layers overlap. It should reach beyond the borders of the *Garda1* layer (see Figure 3.69). Choose a soft selection edge of 120-200 px (Select > Feather) for this selection. The feathering depends on the width of the overlapping area.

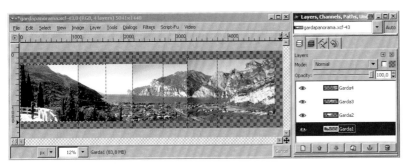

Figure 3.68: The gardapanorama.xcf image after tonality correction and with guides marking the overlapping areas of the layers.

- The *Garda1* layer remains unchanged. Make *Garda2* the active layer and select Edit > Clear to delete the left part of the overlapping area.

Figure 3.69: The cross-layer selection with feathering over layers garda1 and garda2. Garda2 is the active layer.

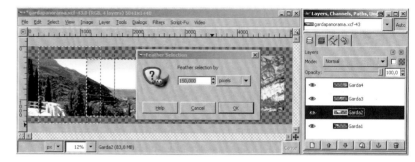

▸ Repeat the steps above for the *Garda3* and *Garda4* layers.

Figure 3.70: You can also use the Move tool to position the existing selection onto the overlapping area between the Garda2 and Garda3 layers, and so on. Make sure that the option Transform Selection is checked. If it isn't, using the tool would actually cut out a part of the Garda2 layer below.

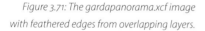

▸ After you delete the overlap of layers 2 through 4, go to Select > None to remove the selection. Next, remove the guides from within the toggling View > Show Guides menu item. Your *gardapanorama.xcf* image should now look more or less like the example shown in Figure 3.71.

Figure 3.71: The gardapanorama.xcf image with feathered edges from overlapping layers.

▸ You still have to position layers *Garda2* through *Garda4*. First use the Magnify tool to enlarge the image window as much as possible, zooming into the overlapping area between layers 1 and 2. Make the overlapping layer the active layer, which is *Garda2* at this point. Use the Move tool to position this layer so that there are no visible shifts in the image. **Note:** Remember to set the Move tool options to your preferences.

▸ After you've finished positioning all the layers, you'll want to crop the image.

▶ When you're done, save your image.

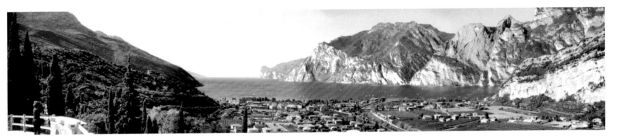

Figure 3.72: The finished gardapanorama.xcf image.

3.12.3 Programs for Creating Panoramas Automatically

Several programs are available through the open-source community which will automatically produce panoramic images. Some of these tools were still in the development al stage when this book was being written. Currently, there are tools or plug-ins readily available for all popular operating systems, including Windows, Linux, and Mac OS. Two notable programs are **Hugin** and **PTGui** (Panorama tool). Another user-friendly tool is **Autostitch** (for JPEG files; Windows, shareware only). You will find information pertaining to installation, handling, and download sources at the following Internet sites

> http://hugin.sourceforge.net/download/
> http://panotools.sourceforge.net/
> http://www.cs.ubc.ca/~mbrown/autostitch/autostitch.html

3.13 Image Collages—Using Masks and Selections to Cut and Paste Image Objects

In the previous section, you learned how to use various techniques to compose images from separate image objects and images; you've learned how to create a collage.

To summarize the principle, let's look at one simple and one sophisticated example.

3.13.1 Copying an Image Object with a Selection and Pasting it in Another Image—the Procedure

The Copy and Paste functions in the Edit menu can be used to easily transfer image objects from one image to another image. To copy and paste image objects, the objects must be selected first. Then the border attributes can be set by going to Select > Feather and entering a value. The Edit > Copy

function pastes the selection in the global clipboard of your computer. The Edit > Paste function lets you paste the selection on another image (or in another application, such as a word processing program).

▸ Open your *fenice.xcf* image, along with the *moon.png* image from the *SampleImages* folder on the CD.
▸ In the *moon.png* image, use guides to select a rectangle around the moon. Use the guides like tangents; they should lie slightly inside the moon's circumference. (Drag the guides from the rulers into the image window while holding down the left mouse button. If you need to correct the guides, use the Move tool options.)
▸ Select the Ellipse tool and using the guides, draw a selection around the moon.
▸ Set a weak feathering of about 5 px. (Select > Feather).
▸ Access the Edit > Copy function and copy the object within the selection—the moon—to the clipboard. Then close the *moon.png* image.
▸ Switch to the *fenice.xcf* image.
▸ Activate the top layer in the Layers dialog.
▸ Go to Edit > Paste. Since the top layer is active, the content from the clipboard—still the moon—is inserted on top of this layer.
▸ Accept the pasted layer as the new layer by selecting the item New Layer in the right-click menu of the Layers dialog. Call this layer Moon.
▸ Position the layer and use the scale tool to enlarge it to the desired size.
▸ Now transform the moon into a sickle. To do this, first drag an elliptic selection with strong feathering (about 200 px) partially over the moon. Select the Edit > Clear menu item to delete the elliptical selection. Reduce the opacity of the moon to about 75% in the Layers dialog.
▸ In the Layers dialog, select the Addition option from the Mode pulldown menu.
▸ Save your image.

Most of the steps described above will soon become routine as you use them again and again on your images. So far, we haven't used any Mode options. Normal mode produces overlays that act as you would intuitively expect them to: covering the object without changing the representation. Sometimes, however, it is necessary to change the manner in which the superimposed layer and the background layer are "blended" in order to achieve a specific effect. Check out the next section to learn more about Mode options.

3.13.2 The Mode Options in the Layers Dialog

Figure 3.73: Selecting an overlay mode in the Layers dialog.

The Mode pulldown menu provides options that allow you to determine exactly how the active layer should overlay on the layer beneath it. The default mode is Normal, which generates a simple overlay. All other modes change the values for brightness, contrast, or colors. The names of the options offer a clue as to what effect each mode will have on your image. These modes are derived from photographic techniques, such as cross-fading and double exposure during processing. However, the actual effect will differ from one image to another, depending on the attributes of the superimposed layers. It is recommended to play with these options to find out which one leads to better results. You can even optically melt layers together.

3.13.3 Using Painting Tools to Paint a Mask with Different Border Attributes

If you've done all the exercises, you've learned how to use selection tools based on shapes (Rectangle Selection, Ellipse, and Path tools) as well as those which select related areas (Magic Wand and Select By Color tools). All of these tools initially produce selections with "sharp-edged" borders; feathering these borders subsequently affects the entire selection equally.

The GIMP provides two methods to paint and edit masks. Since you can set border attributes for the brushes or the eraser, a single selection may have multiple border attributes, depending on the brush pointer you used.

The first method lets you paint the mask on a separate layer using various painting tools and black color. The Layer > Transparency > Alpha to Selection item is then used to create a selection. You should already be familiar with this item. In the simple example in Section 3.12.1, you used

this method to create a selection with a feathered border from a filling ranging from black to transparent.

The second method requires that you use standard selection tools to create a (rough) selection on the desired image object or area. This is done by selecting the QuickMask button in the bottom left corner of the image window to switch to mask mode. You can then use the painting tools or the eraser (along with various tool pointers) to add, remove, or edit mask areas. When you are done working, just switch back to selection mode to disable QuickMask).

You'll have a chance to practice the second method in the following section.

Clipping an Image Object with a "Painted" Selection— The Procedure

The first few steps in this exercise prepare the selection by using the "regular" selection tools. It may be helpful to first select the background around the actual object since it has similar colors which, of course, will allow the Select By Color tool to easily select it. The selection can then be inverted. Now you'll have selected your image object, exactly as you wanted it.

▸ Open the *lion.png* image from the *SampleImages* folder on the CD.
▸ Use the Magic Wand tool to roughly select the area around the lion. Your selection will probably have holes, and it is likely that the selection areas might also extend into the lion. You may want to reduce the Threshold value in the tool options to about 15, as this will help prevent too large of an area from being selected at once. Pay attention to the lion's straggly mane and make sure it obtains a good contour—hair strands are among the most difficult elements to capture when selecting an object.
▸ Once the area around the lion is selected, use the Select > Invert menu item to invert the selection. Before this step, the area around the lion was selected; now the lion itself has been selected.

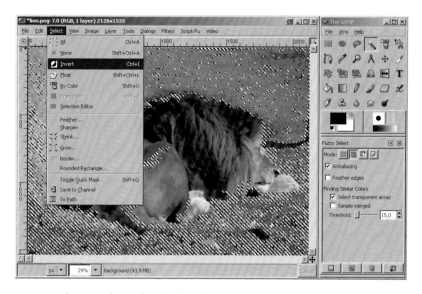

Figure 3.74: The selection around the lion was inverted (Select > Invert menu item), so that the lion itself is selected.

▸ Switch to mask mode, which will show you the covered image area (the red "protective layer"). You can now start editing the mask by using other selection and painting tools. First select the QuickMask mode by either clicking the button on the bottom left corner of the image window or by selecting the Select > Toggle QuickMask menu item.

Note: Areas selected in an image appear in natural colors. The remaining image areas are covered by a red transparent layer, i.e. the mask.

You can see clearly where the mask extends into the lion. These areas must be touched up with the eraser. You will also find holes and inexact contours around the lion. These areas must be filled. Use the mask options and painting tools to edit and shape the mask.

▸ Roughly select the area around the lion again, using the Lasso tool, in additive selection mode (you may need to hold the Shift key down).

▸ Use the Edit > Fill with FG Color menu item to fill this new selection with black foreground color. The black is applied as a transparent red filling in the selection above the mask.

Note: On masks, black serves to add surfaces. Applying white color on masks would cause an effect corresponding to erasing on the mask. To remove part of a mask, or to delete it, you can also use the eraser.

▸ Use painting brushes with a 50% hardness for the variously-sized brush pointers to fill the remaining holes around the lion, or to draw along the lion's contour. Use the Eraser tool with the same brush pointers to remove the masked red areas on the lion. Use the Magnify tool to zoom into the image for more accurate erasing. Take your time and strive for precision.

▸ Check the result by toggling between mask and selection modes, selecting either the button in the bottom left corner of the image window or the Toggle QuickMask menu item.

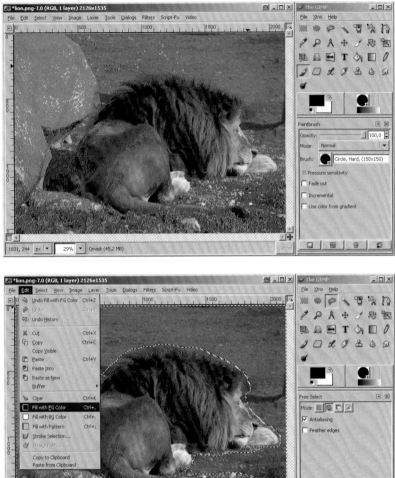

Figure 3.75: The Select > Toggle the QuickMask menu item (or the button in the bottom left corner of the image window) is used to toggle between the selection and mask views.

Figure 3.76: The selection created around the lion with the Lasso tool is filled with black foreground color. This completes the mask in this area.

▸ When you are satisfied with the results, change to *selection* mode.

▸ Use the Clone tool to remove the grass still showing on the lion's back and tail.

Figure 3.77: The finished lion's mask. The Clone tool should be used to remove grass left on the lion's back and tail. This fine touchup work is done in selection mode, since this mode preserves the lion's contours.

Figure 3.78: The Toggle QuickMask option was used to switch between mask and selection modes. Unwanted image contents (grass) were touched up with the Clone tool. The lion can now be copied (Edit > Copy).

The lion has been selected and the unwanted elements have been removed. You can now copy the lion.

▸ Access the Select > Feather menu item to define a soft edge of about 10 px for the selection.

▸ Go to Edit > Copy to copy the lion onto the clipboard.

▸ Open your *fenice.xcf* image.

▸ Select the Edit > Paste menu item to insert the lion as a new layer. Complete this process by clicking the New Layer option in the Layers dialog (or its right-click menu). Call the new layer Lion.

▸ Position the lion in your image and scale it.

▸ Select the Layer > Colors > Brightness-Contrast menu item to match the lion's brightness to the environment. You may have to repeat this process a few times.

The lion has been inserted in the desired image. You will now add a drop shadow to the lion on the background. Proceed as follows:

▶ Select the Layer > Layer to Image Size menu item. This resizes the layer so it fits within the entire image. This is a preparatory step for filling the lion's selection; it ensures that we won't inadvertently fill other image areas.

▶ On the layer with the lion, use the Magic Wand tool to select the area around the lion. Check out the tool options: In this case the Select Transparent Areas control should be checked, while the Sample Merged option should be unchecked. Access the Select > Invert menu item to invert the selection. Access the Select > Feather menu item to select a soft border feathering of 25 px.

▶ Create a new empty layer in the Layers dialog, name it and make it the active layer.

▶ Fill the selection with black foreground color.

▶ Go to Select > None and remove the selection.

▶ Position the layer in the Layers dialog underneath the layer with the lion.

▶ Use the Move tool to move the layer with the shadow within the image window so that the shadow is slightly slanted beneath the lion.

▶ Set the opacity (Layers dialog) for the shadow layer to about 70%.

▶ Save your image.

Figure 3.79: The fenice.xcf image with a Venetian lion and the Layers dialog.

4 Working with Black-and-White and Color Images

Naturally, the GIMP is not limited to color representation. You can also edit black-and-white photos with the program.

In addition to the functions and tools used when editing color images, the GIMP also offers specific tools for modifying black-and-white images. What's more, you can use the GIMP to colorize old black-and-white photos.

4.1 Converting Color Images Partly or Entirely into Grayscale Images

4.1.1 Hints for Working in Grayscale and RGB Modes

By default, the GIMP works in **RGB color mode**, which supports the representation of approximately 16.7 million colors. This color mode supports all the tools available for manipulating colors or color values in an image.

In addition, the GIMP offers the **Grayscale** color mode. Grayscale corresponds to a limited color palette of 256 gray levels, including black and white. All tools used to manipulate brightness and contrast levels are supported in grayscale mode. However, tools, filters, and options which directly manipulate colors are not supported in the grayscale mode. This means that certain tasks, such as the subsequent coloring of black-and-white images, must be performed in RGB color mode. Perhaps you're asking: what's the point of working in grayscale mode?

Suffice it to say that there are occasions when the conversion of color images into grayscale images may be required. Reasons for this may include:

▸ Image design
▸ Technical concerns, i.e., perhaps you want to create a selection on a high-contrast original document, although this task can be somewhat achieved by using a copied layer of an image
▸ Reduction of an image's file size, as grayscale images have a maximum number of 256 colors, so changing to that mode will reduce the file size

Nevertheless, you'll normally be editing black-and-white photos in RGB mode. When scanning an image as a grayscale image, it will initially be available in grayscale mode. Even so, it is recommended to convert the image into RGB mode prior to editing it.

4.1.2 Removing Color Partly or Entirely

To toggle between RGB and Grayscale modes just go to the Image > Mode menu in the image window.

You can easily convert a color image into a black-and-white photo by opening it in RGB mode and selecting the Grayscale Mode menu option. When converting an image, the color information is rejected, and you're left with the bright-dark values of the image in the form of gray levels. If you convert the image back to RGB mode, the gray levels will remain, but you will be able to colorize the image again.

When you open an image in RGB color mode, there are two other methods to partly or entirely remove color from an image. These methods modify color saturation, making it unnecessary to change the color mode of an image.

▸ Select the Layer > Colors > Saturation menu item to remove the color information from an image or layer, reducing it to pure bright-dark values (gray levels).

▸ Select the Tools > Color Tools > Hue-Saturation menu item (for individual layers in the Layers menu) and move the corresponding slider to the left to reduce the color saturation of an image to pure gray levels, or as desired.

4.1.3 Graphic Effects with Gray Levels—an Example

You can reduce the colors of an image to create drama in an image, or to bring a certain object in your photo into focus. Let's experiment with this effect.

▸ Open your optimized image, *miami-impro.tif* or *miami-impro.xcf*.

▸ Save the image as *miami-car.tif*.

▸ Create a path along the car's contour (or simply use the *Lasso* tool to create a selection).

▸ Click the Path to Selection button in the Paths dialog to create a selection from the path.

▸ Access the Select > Feather menu item to define a soft edge of 5 pixels for the selection.

▸ Go to Tools > Color Tools > Hue-Saturation: Hue to colorize the car in a color of your choice.

▸ Invert the selection.

▸ Go to Tools > Color Tools > Hue-Saturation: Saturation and remove the colors from the surrounding area of the image.

▸ Access the Filters > Blur > Gaussian Blur menu item to heavily blur the selected image area with a radius of about 20 pixels.

▸ Access the Select > None menu item to remove the selection.

▸ Save your image.

Figure 4.1: The image with the selection from the path around the car before the last two editing steps.

4.2 Touching Up Black-and-White Images— Levels, Brightness, Contrast

As mentioned in the introduction, you can edit the brightness, contrast, and (color) values of images both in the RGB mode and in the grayscale mode.

Modifying black-and-white images is similar to modifying color images. For this reason, this section will be limited to providing an overview of those functions available by both modes, and how they differ. The functions discussed below can be found in the Layer > Colors menu and in the Tools > Color Tools menu.

Function	RGB Mode	Grayscale Mode
Color Balance	Yes	RGB levels only
Hue-Saturation	Yes	RGB levels only
Colorize	Yes	RGB levels only
Brightness-Contrast	Yes	Yes
Threshold	Yes	Yes
Levels (tonality correction)	Yes	Yes, but main channel only (no individual color channels)
Curves (gradation curves)	Yes	Yes, but main channel only (no individual color channels)
Posterize	Yes	Yes
Remove Saturation	Yes	RGB levels only
Invert	Yes	Yes
Automatic:		
Equalize	Yes	Yes
White Balance	Yes	RGB levels only
Automatic Contrast Spread	Yes	Yes
Color optimization	Yes	RGB levels only
HSV Autostretch	Yes	RGB levels only
Normalize	Yes	Yes
Histogram	Yes	Yes
Color Space Analysis	Yes	Yes

As shown in the above table, it is both possible and recommended to edit black-and-white or grayscale images in RGB mode. Keep in mind that many editing features can be utilized only in RGB mode.

Converting an image to grayscale mode is recommended in the following cases:

▸ To simplify an image
▸ When the options and tools available in grayscale mode are sufficient for your editing needs
▸ To produce certain graphic effects
▸ When pure gray levels are sufficient for image rendering
▸ To optimize the file size of a black-and-white representation (grayscale reduces the number of colors to 256 values)

4.3 Cropping Hair—a Tricky Task

Cropping a portrait of a woman with cascading hair, or a tree with a maze of branches, are difficult tasks even for professional digital editors. You'll have more success if there is a good degree of contrast between the objects you wish to crop and the background. You can tackle this task relatively simply by using the Magic Wand and the Select by Color tools. However, you may have to prepare your image first by increasing the contrast of the image. Finding the correct tool (and tool options) requires practice: you'll soon get a feel for it.

4.3.1 The Threshold Function

The Threshold function (Layer > Colors > Threshold menu) converts a color or grayscale image into a pure black-and-white graphic. More specifically, it represents areas with a brightness value of less than 50% black and a brightness more or equal to 50% white.

If the Preview control is checked, you will see a pure black-and-white representation in the image window. The Threshold Range input boxes allow you to manually select the upper and lower intensity ranges, i.e., the black-white distribution in the image. You can either enter numerical values in the intended fields or you can move the slider with the left mouse button.

The Linear and Logarithmic buttons in the upper right corner can be clicked to determine how the histogram will be represented in the visual graph.

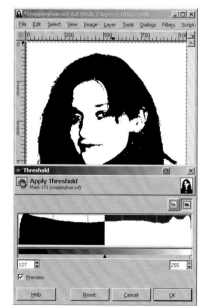

Figure 4.2: The Threshold window with a preview of the results in the image window.

4.3.2 Using the Threshold Function to Crop Hair—The Task

The following example focuses on increasing existing contrast levels so you can achieve the most exact selection of fine structures possible. Though this solution is not perfect, it may serve as a brain-teaser for developing your own solutions.

First you'll want to go to Layer > Colors > Threshold so that you can create a mask layer with high contrast. You can employ painting tools to touch up this layer, and, subsequently, use it to create selections that will help you to edit the actual image.

The selected image object should stand out from the rest of the image, to some extent.

- Open the *girl.png* image in the *SampleImages* folder on the CD.
- Save it as *croppinghair.xcf* in the layer-enabled XCF format.
- Select the Image > Mode menu item and make sure that the image is in RGB Mode; if it isn't, change the mode.
- Duplicate the Background layer (in the Layers dialog). Name the new layer *Mask*.
- Use the Threshold function (Layer > Colors > Threshold menu) to set the Mask layer so that the hair strands are fully displayed—there should be an adequate amount of contrast between the hair and the background of the image. Be aware that a solitary hair is extremely difficult to capture, even with this tool.

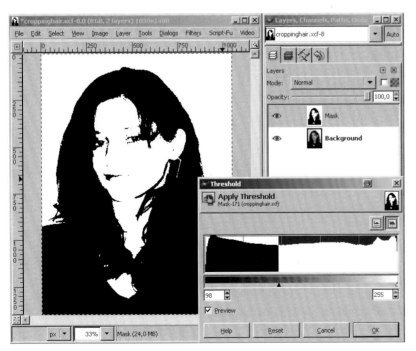

Figure 4.3: The Mask layer is being created; it will serve to crop the hair.

▸ When the hair is defined by contrast, access the Select > By Color menu item (or use the Select by Color tool) to create a selection on the white image areas on the Mask layer. In order to work as accurately as possible, the selection should be sharp edged, i.e., no feathering.

▸ Access the Edit > Clear menu item to delete the white image areas. Check the result.

▸ Create a selection across the image areas surrounding the hair contour. In this case, that would be the face.

▸ Access the Edit > Fill with FG Color menu item to fill the selection on the Mask layer with black.

▸ Right-click on the Mask layer in the Layers dialog to open the context menu of this layer. Select the Alpha to Selection option.

▸ In the image window, click the bottom left icon to activate the QuickMask. You can also select it from within the Select menu.

▸ You are now ready to do some touchup work on the mask. Select a thin, soft paint brush (depending on the image and its resolution; in this case, use 3 to 7 pixels). Touch-up the incomplete hair strands in the example image. You may have to use the Eraser tool to correct the protruding hair.

Figure 4.4: Touched up hair strands on the Mask layer with the Background layer visible from underneath.

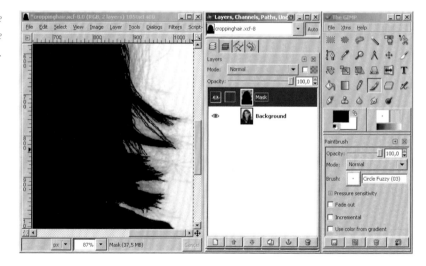

▸ Switch back to selection mode and remove the selection (Select > None).

▸ In the Layers dialog, right-click on the Mask layer to open the context menu; then select the Alpha to Selection option again. This selection now reflects the touch-up work performed on that layer.

▸ Duplicate the Background layer and name it something like Hair-Cropped. Click the eye icon in the Layers dialog to make the Background layer invisible.

▸ Select a soft edge or feathering of approx. 3 pixels, and reduce the selection slightly (Select > Feather: 3 pixels and Select > Reduce: 1 pixels.

Remember that these values are contingent on the image and your intent).

▸ Go to Select >Invert to invert the selection.

▸ Make the Hair-Cropped layer the active layer, and click the eye icon to turn the Mask layer to invisible.

▸ Use the selection to remove the background from the Hair-Cropped layer (Edit > Clear).

▸ Remove the selection (Select > None).

Now you'll want to create or modify the background, so that the subject of your photograph really stands out.

▸ In the Layers dialog, create a new layer named Background-Colored.

▸ Use a color of your choice to fill the new layer.

▸ Use the tonality correction (Layer > Colors > Levels > Midtones menu item) to make the Hair-Cropped layer a little lighter. The hair should appear shinier, and more strands will become visible.

▸ Use a large, soft eraser with reduced opacity to touch up transitions on the Hair-Cropped layer, if necessary.

▸ Save your image.

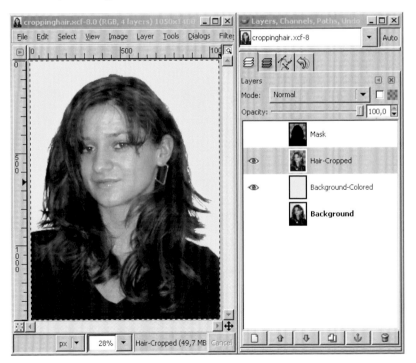

Figure 4.5: The finished image with layers.

4.3.3 Using Channels to Crop Hair

What Are Channels?

As you know from Section 1.2.3, the colors you see on your monitor are created from three primary colors—red, green, and blue. The same holds true for images in RGB mode: All colors in an image are mixed from these three primary colors. Accordingly, each image in RGB mode consists of three channels: red, green, and blue. Each channel is a chromatic component, representing the share of the corresponding color in the image.

You were somewhat introduced to channels in the previous exercises, by the user interface of a tool or function dialog. Do you remember how color cast was corrected in the *Levels* dialog (tonality correction)? Hint: It was in the exercise wherein you edited only the red part of the image.

Decomposing and Composing the Channels of an Image

You can use the Image > Mode > Decompose menu item to decompose an image into its color channels. These channels can be accessed for editing purposes in the Layer dialog. For example, you can target a single color and apply a filter or option to it. The Image > Mode > Compose menu item will combine the channels again, so you can go back to working with the full RGB channel in this image.

Consider the following information about color channels:

▸ The red channel offers the best contrasts.
▸ The green channel has the highest sharpness.
▸ The blue channel shows the image quality most clearly.

The Channels Dialog

You can find the Channels dialog in the Layers, Channels, Paths dock, you can go to File > Dialogs > Add Tab in the Toolbox, or you can access an individual dialog from within the Dialogs menu in the image window.

The Channels dialog works similarly to the Layers dialog. However, the Channels dialog is separated into two parts. The upper part always shows the red, green, and blue color channels. In addition, there is an alpha channel to control transparency attributes. When working on images with indexed colors, the three main channels will be replaced by a single channel called Indexed, which usually won't possess an alpha channel. These channels cannot be renamed.

Each of these channels can be made visible or invisible by clicking the eye icon. The visible colors in your image will be modified accordingly.

By clicking a channel in the Channels dialog, channels can be set to active (blue) or inactive (white). When you edit an image, your changes affect only the active channels. Setting a channel to inactive will ensure that any subsequent changes to the image will not affect the channel.

In contrast to the Layers dialog, in which only one layer can be active at a time, the Channels dialog allows you to activate more than one channel at a time. In fact, when you work on an image in full RGB view, all color channels must be active.

An image can have more channels than the three color channels. These additional channels are displayed at the bottom half of the Channels dialog. You can create these channels yourself. For example, you can select the Select > Save to Channel menu item to create a channel from a selection. This channel will then be listed in the Channels dialog as a custom channel (black-white image) and saved together with the image (only when saving in the XCF format). Now you can load your custom channel whenever you want, and create a new selection from it.

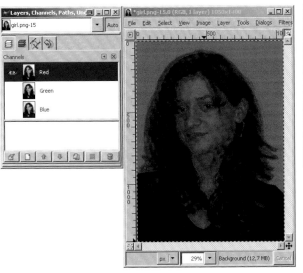

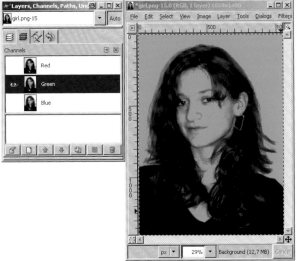

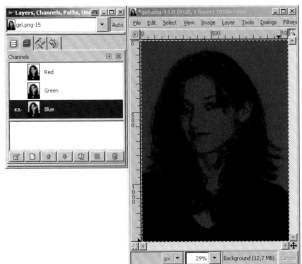

Figures 4.6, 4.7, 4.8: The single color channels (of a black-and-white image in RGB mode) and their representations in the image window. An RGB representation does not necessarily mean that the image is colorized.

Notice that the channels of the three primary colors cannot be renamed. Duplicated channels or selections saved to channels can be custom named. Also, the position of the three main channels cannot be moved within the dialog; custom channels can be repositioned in the layer stack.

Custom channels can also be linked by clicking the familiar chain icon in the Channels dialog. Any changes you make will then affect all the linked channels.

The Channels dialog has its own context menu, which can be accessed by right-clicking on a channel. The options in the right-click menu let you duplicate channels, or quickly create a selection from a channel.

As long as there are only the three standard channels in an image, some of the functions will be grayed out; this means they are not available. The same holds true for the buttons at the bottom of the dialog, which offer the most important functions from the context menu.

Figure 4.9: In RGB mode all three color channels are initially set to active in an image (including black-and-white images). The right-click menu is also displayed on the right-click menu.

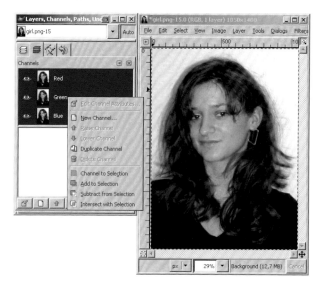

Using Channels to Crop Hair—the Procedure

You will basically perform the following tasks in this exercise: Use the Image > Mode > Decompose menu item to create a mask layer from the channel that has the best contrast values. The mask layer (i.e., the channel) can then be touched up with painting tools and exported into another image. Using this layer, we can create a selection and use it to edit the actual image, in order to emphasize and increase the contrast.

▸ Open the *girl-color.png* image in the *SampleImages* folder on the CD.
▸ Open the context menu in the Layers dialog and add an Alpha Channel to the image, so that you can use transparencies.
▸ Call the layer Portrait.
▸ Save the image by a new name, such as *portrait.xcf*, in the XCF format.

▸ To keep the color channels available as layers for further editing, select the Image > Mode > Decompose menu item and click OK. A copy named *portrait-RGB.xcf* with the red, green, and blue channels as image layers will be created.

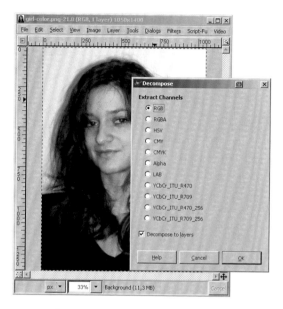

Figure 4.10: The Image > Mode > Decompose dialog, wherein you can select a color model when transforming channels to layers. Select RGB or RGBA (RGB with Alpha Channel), and make sure that the Decompose to Layers control is checked. When the option is disabled, the color channels are individually output in a separate image window

.**Note:** The CMYK option in this window can be used to separate the color channels as color extracts for prepress (CMYK—four-color printing).

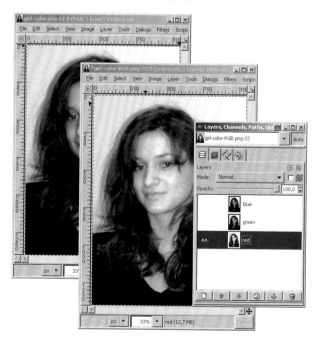

Figure 4.11: The original portrait.xcf and portrait-RGB.xcf, the copy with the channels as image layers which was created automatically.

▸ In the new *portrait-RGB.xcf* image, right-click to open the context menu and duplicate the Red layer in the Layers dialog.

▸ Make the new Red-Copy layer the only active layer and make it visible. Red provides the best contrast values.

▸ Use the tonality correction (Layer > Colors > Levels menu item) to increase the contrast.

▸ Access the Select > By Color menu item or use the corresponding selection tool to create a selection in the image window. Click a gray image area, so that all gray and white tones in the image will be selected. Set a Threshold of about 100 (Threshold option in the tool options). Experiment with different threshold values until you find a value that provides the desired result. You may have to delete the selection and start fresh until you find the appropriate value. You can also set a smaller threshold in the Add to Selection tool option.

Figure 4.12: The tonality correction is used to increase the light-dark contrast on the image layer.

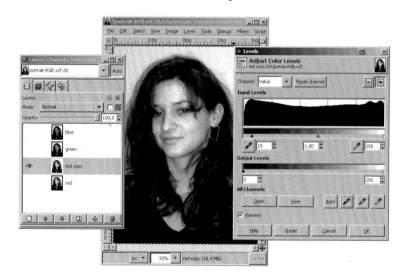

▸ All white and gray areas in the image are initially selected. However, since the selection should capture only the hair contour, you'll need to use the Lasso tool to remove the face from the selection. By now, you should know which tool options are appropriate for this.

▸ In the image window, change to QuickMask mode (from within the Select menu, or by clicking the small button in the lower left corner of the image window).

▸ Use the painting tools and the eraser to touch up the mask, where necessary.

Note: The mask will be gray as this is a grayscale image.

▸ When you're done touching up the mask, change back to selection mode (Select > Toggle QuickMask menu item).

▸ Access the Select > Feather menu item and select a soft edge of about 3 pixels for the selection.

▸ Delete the image background of the Red-Copy layer (Edit > Clear menu item). This creates the actual mask.
▸ Open or load the *portrait.xcf* image.
▸ Export the Red-Copy layer from the Layers dialog of *portrait-RGB.xcf* by dragging and dropping it (click while holding down the left mouse button) onto the *portrait.xcf* image.

Figure 4.13: In grayscale images (Image > Mode > Grayscale menu item) the QuickMask appears as a pale gray transparent layer, but you can use painting and touchup tools to edit it just as if it were in RGB mode.

▸ Now you'll find the Red-Copy layer in the Layers dialog of the *portrait.xcf* image. Set it to active. Right-click on this layer to open the context menu and select the Alpha to Selection option.
▸ Invert the selection.
▸ Click the eye icon to make the Red-Copy layer invisible.
▸ Set the Portrait layer to active.
▸ Go to Edit > Clear and delete the background from the Portrait layer.
▸ Delete the selection (Select > None).
▸ Create a new layer called Background.
▸ Fill this layer with a color or feathering of your choice.
▸ Save your image.

4.4 Coloring Grayscale Images

Any black-and-white photo that can be opened in RGB mode can be colorized. There are several options available to apply a color tone to an image. You can even use sepia, which will make your image look like an old photograph. Various tools can be used to assign several different colors to an image, or to colorize or brighten specific image areas.

You will probably use these options frequently when working with scanned images. If you scan an image with a color depth of 24 bits rather than in grayscale mode, the image will take on a slight color cast, corresponding to the color space of your scanner. In such a case, or when simply editing a color image in grayscale, it's best to use the Layer > Colors > Saturation menu item to convert an image into pure gray levels. There is no need to convert it to grayscale mode.

However, if you scanned an image in grayscale mode (with a color depth of 8 bits), you'll need to convert it to RGB in order to edit it; just go to Image > Mode > RGB and make the change.

Note: The functions described below only work in RGB mode.

Please use the *garden.png* image from the *SampleImages* folder on the CD for the following exercise.

4.4.1 Using the Colorize Function to Color an Image

Use the colorize tool to transform an ordinary black-and-white into an old-fashioned looking one by adding sepia brown, cobalt blue, or chrome yellow. This process colorizes image areas according to levels of brightness. You can access this function in the Layer > Colors > Colorize menu item in the image window.

How to perform the process:

▸ Move the Hue slider to select the desired coloration.
▸ Move the Saturation slider to the right to increase saturation, or to the left to reduce color, and thereby add more gray values.
▸ Move the Brightness slider to make the image lighter or darker.
▸ Make sure the Preview option (in the image window) is checked.

Figure 4.14: The Colorize options with a preview in the image window.

4.4.2 Using the Levels Function to Color an Image

You already learned how to use the Levels function (tonality correction) to increase the contrast and color values of an image. And you know that this function allows you to edit the color channels separately (Sections 2.4.8 and 2.5.3).

Likewise, on black-and-white photos, you can add (or mix) optional colors by modifying a single color channel, or by editing all three channels at once.

This function is found in the Layer > Colors > Levels menu.

Start by selecting a color channel from the Channel option (top left) in the Levels window to edit the color range. In this exercise, you will edit the blue channel.

Move the Midtones slider—the middle triangle on the grayscale bar underneath the histogram curve—to select the desired color. If you want to use a mixed color for your image, select a second color channel and repeat the process. This will colorize all image areas equally according to their brightness.

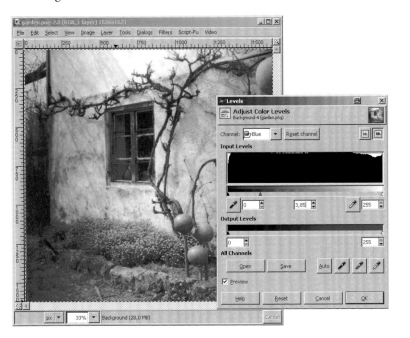

Figure 4.15: The Levels options dialog.

If you want to use the same option settings to colorize several images, simply click the Save button to save your settings in a folder. To apply the settings to other images, just click the Open button and they will be reloaded.

4.4.3 Using the Curves Function to Color an Image with One or More Colors

You should already be familiar with Curves (or graduation curves) as you used this function in Section 2.4.9 to edit the brightness, contrast, and color values of the sample image.

This function is found in the Layer > Colors > Curves menu.

To colorize black-and-white photos with the Curves function, you must click the Channel button to select a color range. In contrast to the similar Levels function, the Curves function allows you to colorize an image with several colors; the amount of colors available will be dependent on the quantity of points created on the color curve, as well as how these points are moved on the histogram curve.

Since you can reuse the settings for each color channel, you can use one, two, three, or more colors to colorize images. This enables you to create sophisticated image designs comparable to solarized color images.

You can also save the Curve settings and reload them for future use.

Figure 4.16: The settings of the color curve for the blue channel.

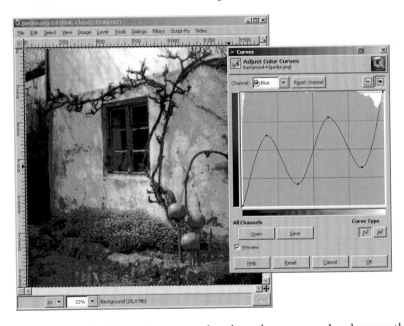

In this example, four points were placed on the curve and, subsequently, moved about in order to achieve a multicolor coloration of the image. You may repeat this process for each color channel. Whether or not this will result in mixed colors or new color shades in the image depends on the shape of the curves.

4.4.4 Using the Colorize Filter to Color an Image

Filters provide yet another method to colorize images. You can find the colorize filter in the Filters > Colors > Colorify menu.

If you select this filter, a dialog pops up that allows you to select a color from a prepared color palette. Alternatively, you may click the Custom Color button to select a color. Clicking this button will display the familiar Color Picker, where you can select any color. Using the Color Picker or the Colorify dialog, click OK to accept the color you selected.

The image will be uniformly colored with the chosen color. However, you may notice that the colorization looks rather like a color overlay, much more so than it would if you used the Layer > Colors > Colorize method. Be aware that additional options, such as saturation or brightness, are not available for this function.

The only way to modify brightness is by using the Layer > Colors > Brightness-Contrast menu item. You can also correct the lightness and saturation by using the Layer > Colors > Hue-Saturation menu item.

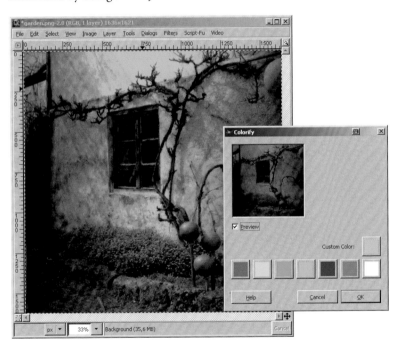

Figure 4.17: The Filters > Colors > Colorify dialog.

4.4.5 Using Transparencies and the Colorize Filter to Color Image Areas by Brightness

The Filters > Colors > Colorify function can also be used to colorize image areas by brightness and to overlay them on the original black-and-white photos, using transparencies. This results in an image with both gray levels and colored areas.

Let's try it:

▸ Duplicate the background layer of your black-and-white photo in the Layers dialog. This layer must be set to active.

▸ Access the Filters > Colors > Color to Alpha menu item and select the From: [white] to Alpha option. Click OK to accept your changes. The white or bright image areas turn transparent.

▸ Access the Layer > Colors > Invert menu item to invert the dark areas of the layer. In the next editing step, the bright image areas will appear much more intense than the dark areas, while the transparent areas will remain transparent.

▸ Go to Filters > Colors > Colorify and proceed to color the bright image areas of the layer with any color you prefer.

▸ Finally, use the Dodge mode on the active layer in the Layers dialog. This produces a natural looking overlay with the original background layer.

Figure 4.18: The coloring effect of the overlaying layer is opaque in mixed mode.

Figure 4.19: The mixed mode of the overlaying layer creates an actual partial coloring effect (after applying the Dodge mode, in this case).

4.5 "Hand-colored" Collages from Black-and-White Photos

The techniques described in the previous section taught you how to colorize segmented objects on separate layers, in addition to colorizing entire images. To colorize distinct objects on separate layers, the basic steps normally involve scanning a black-and-white image, duplicating the background layer (several times), selecting the area to be colorized on each layer, deleting the other image content, and applying the desired color to the remaining image content on the active layer. Finally, the layers must be stacked in the right order in order to properly render the finished image. This process allows you to apply several colors to images, similarly to the *portrait.xcf* image in the previous exercise.

The steps necessary to complete the following exercise are quite repetitive. Furthermore, since they have been described in detail in the previous sections, we will just briefly outline the work involved.

▸ Open your *portrait.xcf* image. The rest of the work will be done using copies of the Portrait layer with the segmented hair. Save the image with a new name, such as *portrait-colored.xcf* in your exercise folder.

▸ Rename the Portrait layer to Portrait-Colored. You can open the original layer later for the sake of comparison.

▸ Rename the Red-Copy layer to Portrait.

▸ Using the Portrait-Hair layer, duplicate the Portrait layer and rename it Portrait-Hair. Go to the Layer > Colors > Levels menu and use midtones to lighten the hair. Go to the Layer > Colors > Curves menu and use the Red and Green channels to colorize the layer to dark brown. Go to the

Layer > Colors > Brightness-Contrast menu to correct contrast and brightness.

▸ Using the Portrait-Cloths layer, duplicate the Portrait-Hair layer and rename it Portrait-Cloths. Position it above the Portrait-Hair layer in the Layers dialog. Go to the Layer > Colors > Levels menu and move the midtones slider to lighten the cloths. Use the Select by Color tool to select the visible area of the cloths; then use the Lasso tool to correct the selection. (**Note**: Some of the chair-back shows behind the shoulder on the left side. The visible part extends from the top of the image to the hair curls on the shoulder.) Go to the Select > Feather menu and choose 15 pixels. Go to the Select > Invert menu and delete everything, except the cloths. Go to the Edit > Clear menu and the Select > None menu. Then go to the Layer > Colors > Levels menu and use the Blue channel to apply dark blue color to the cloths, and set the midtones for the channel. Go to the Layer > Colors > Brightness-Contrast menu to correct the contrast and brightness.

▸ Using the Portrait-Face layer, duplicate the Portrait layer and rename as Portrait-Face. Position it above the Portrait-Cloths layer in the Layers dialog. Use the Select by Color tool to select the face. Use the Lasso tool to remove excessively selected areas from the selection. Go to the Select > Feather menu and choose 20 pixels. Go to the Select > Invert menu. Go to the Edit > Clear menu. Go to the Select > None menu. Access the Layer > Colors > Levels menu and use the Red and Green channels, modifying the midtones, to color the face. Go to the Layer > Colors > Brightness-Contrast menu to correct or reduce the contrast and brightness.

▸ Using the Portrait-Lips layer, duplicate the Portrait layer and rename as Portrait-Lips. Position it above the Portrait-Face layer in the Layers dialog. Use the Lasso tool to select the lips. Go to the Select > Feather menu and choose 15 pixels. Go to the Select > Invert menu. Go to the Edit > Clear menu. Go to the Select > Invert menu. Go to the Layer > Colors > Levels menu and use the Red channel, modifying the midtones, to color the lips. Go to the Layer > Colors > Brightness-Contrast menu to correct the contrast and brightness of the lips. Go to the Select > None menu.

▸ Return to the Portrait-Face layer. Now use the Lasso tool to select the whites of the eyes and the pupils. Go to the Select > Feather menu and choose 15 pixels. Go to the Layer > Colors > Saturation menu. Go to the Select > None menu. Use the Ellipse tool to select the pupil area. Use the Lasso tool to remove excessively selected areas from your selection. Go to the Select > Feather menu and set it to 10 pixels. Go to the Layer > Colors > Colorize menu to select a color for the pupils. Go to the Select > None menu.

▸ Save your image.

5 Appendix

5.1 How to Proceed from Here

Congratulations! You made it through the tutorial. You've learned many basic techniques to touch up and edit digital photos and images. You are now acquainted with the most important tools necessary for producing collages from image elements. You now should have a fairly good idea of how to create your own image elements and text, and how to insert these elements into an image.

But this is not even close to the end. If you want to get an advanced grasp of digital image editing, you should consider purchasing a reference book on the GIMP, which describes all the program functions and filters in detail. Recommended texts include "GIMP 2" by Jürgen Osterberg, available from dpunkt.verlag. You will find more books in the list of references below, including free e-books. Be aware that many of these books are based on the GIMP Version 1.2.X, which is somewhat outdated.

There are also plenty of websites that provide tips and tricks for digital image editing. Go to: http://www.gimp.org/tutorials.

In addition, you can find many how-to and tutorial webpages on competitive products. Launch your favorite search engine and look for "photoshop" or "photoshop tutorials". You will find many pages with examples and instructions that can be helpful when working with the GIMP, particularly in the general sense.

If you are interested in viewing the author's digital image editing work, please visit his website at: http://www.lichtschreiber.de.

5.2 Acknowledgements

First and foremost, I would like to thank Dr. Michael Barabas and René Schönfeldt of dpunkt.verlag who picked up the idea for this book and provided moral and practical support throughout its production. I would also like to thank Jürgen Osterberg, whose latest book on the GIMP (available from dpunkt.verlag) helped me shape my thoughts. Osterberg's book on the GIMP is an excellent source; it discusses aspects of the program that were not covered in this tutorial.

Much appreciation is due to my editor, Barbara Lauer. Her critical mind and practical suggestions influenced the final tone of this book, and she always found an encouraging word for the author.

Thanks also to Angelika Shafir who did the translation, and to Diana Hartmann who added the finishing touches.

Most importantly, I would like to thank the large number of people who worked to develop and publish the GIMP as free software under the GPL license. Their contributions brought forward a program that's fun to use, works safely, and offers everything that you'd want in an image editing programs. The GIMP is a great tool for professional work.

5.2.1 Further Reading on the GIMP: References

▸ *GIMP 2—Anspruchsvolle Grafikbearbeitung unter Linux und Windows* (2nd edition, German). Author: Jürgen Osterberg. Format: paperback; 520 pages; ISBN: 389864295X; publisher: dpunkt.verlag GmbH, 2005.

▸ *Beginning GIMP: From Novice to Professional. Author: Akkana Peck. Format: paperback, 552 pages; ISBN: 1-59059-587-4;* publisher: Apress 2006. Website: http://gimpbook.com/.

▸ *GIMP—The Official Handbook.* Authors: Olof S. Kylander, Karin Kylander. Format: paperback, 895 pages; publisher: Coriolis Value/ November 1999. ISBN: 1-576-10520-2; Web site: ftp://ftp.gimp.org/pub/ gimp/docs/ (available for download in PDF format).

▸ *Grokking the GIMP.* Author: Carey Bunks. Format: paperback; 352 pages; ISBN: 0-735-70924-6; publisher: Pearson Education, 2000. Web site: http://gimp-savvy.com/BOOK/index.html (available for download in HTML format).

▸ *Essential GIMP for Web Professionals.* Author: Michael J. Hammel. Format: paperback; 376 pages; ISBN: 0-130-19114-0; publisher: Pearson Education, 2001. Web site: http://authors.phptr.com/essential/gimp.

▸ *Guerilla Guide to Great Graphics with The GIMP.* Author: David D. Busch. Format: paperback; 370 pages; ISBN: 0-7615-2407-X; Publisher: Premier Press (Prima Tech), 2000.

▸ *See also* http://www.gimp.org/books/

5.3 What's on the CD

First of all, you will find this book in PDF format (*GIMP.pdf*). You may want to copy this to your computer so that you can quickly search for specific topics. The CD also contains a folder named *SampleImages* where you'll find master copies of all images used in this book. You can use them to practice the exercises found in the tutorial. You will also find the finished images

from all exercises in the *FinishedImages* folder so you can compare your work.

In addition, the CD includes the GIMP installation files for three operating systems—Windows, Linux, and Mac OS. To download more recent program versions or installation files, it is recommended that you visit the websites listed in this book. You can access them directly from the *LinkList* on the CD.

Windows users will find all files necessary to install the GIMP Version 2.2.12 on the CD, including various helper programs and plug-ins.

Linux users will find the GIMP source code for Version 2.2.12 on the CD.

Users of Mac OS Version 10.2 and higher will find the installation file for the GIMP Version 2.2.11 on the CD.

The GIMP is open-source software that can be distributed for free under the condition that the development software, or source code, is included in the distribution. You don't have to install the source code unless you're a Linux user, or you want to further develop or reprogram the software. The source code is not required to work with the GIMP.

Open-source software is distributed under the GPL license, excluding all warranties. You should understand and be aware of the fact that neither author nor publishers provide a warranty for the software shipped with this book; nor do they guarantee that it will flawlessly operate on your computer.

The CD includes the **IrfanViewer** freeware program for Windows. IrfanViewer is a free image viewer that does much more than view images (See *iview398.exe* and *plugins398.exe* in the *Programs > Irfanview* folder).

Some of the files on the CD, as well as most of the files available for download on the Internet, are compressed ZIP archives. To unpack or decompress such a file, you will need a piece of software or shareware, like the popular **WinZip** (http://www.winzip.com) for Windows or **Stuffit** for Mac OS, Linux, or Windows (http://www.stuffit.com/).

In order to view the PDF format of this book from the CD, you need a PDF viewer, such as **Adobe Acrobat Reader** (http://www.adobe.com/products/acrobat/readstep2.html) for all three operating systems, or **GhostScriptViewer** (http://www.cs.wisc.edu/~ghost/gsview/get47.htm) for Windows or Linux.

5.4 Native GIMP File Formats

The file formats listed in the following table are native to the GIMP, which means that you don't need additional plug-ins to use them.

File Type	Extension	Open	Save
Alias\|Wavefront Pix image	*.pix, *.matte, *.mask, *.alpha, *.als	Yes	Yes
Autodesk FLIC Animation	*.fli, *.flc	Yes	Yes
BMP—bitmap	*.bmp	Yes	Yes
Bzip archive	*.xcf.bz2, *.bz2, *.xcfbz2	Yes	Yes
"C" source code	*.c	No	Yes
"C" header file	*.h	No	Yes
DICOM image	*.dcm, *.dicom	Yes	Yes
Encapsulated PostScript	*.eps	Yes	Yes
FITS—Flexible Image Transport System	*.fit, *.fits	Yes	Yes
G3 fax image	*.g3	Yes	No
GIF—Graphics Interchange Format	*.gif	Yes	Yes
GIMP Pattern	*.pat	Yes	Yes
GIMP Brush	*.gbr, *.gpb	Yes	Yes
GIMP Brush (animated)	*gih	Yes	Yes
GIMP XCF Image	*.xcf	Yes layer-enabled	Yes layer-enabled
Gzip archive	*.xcf.gz, *.gz, *.xcfgz	Yes	Yes
HRZ—Slow Scan Television	*.hrz	Yes	Yes
HTML—Formatted Table	*.html, *.htm	No	Yes
JPEG—Joint Photographics Expert Group	*.jpeg, *.jpg, *.jpe	Yes	Yes
KISS CEL	*.cel	Yes	Yes
Microsoft Windows Icon	*.ico	Yes	Yes
Microsoft Windows MetaFile	*.wmf, *.apm	Yes	No
PSP—Paint Shop Pro	*.psp, *.tub	Yes	No
PDF—Portable Document Format	*.pdf	Yes	No
PGM Image	*.pgm	No	Yes
PNG—Portable Network Graphics	*.png	Yes	Yes
PNM—Portable AnJmap	*.pnm, *.ppm, *.pgm, *.pbm	Yes	Yes *.pbm only
PPM image	*.ppm	Yes	Yes
PSD—Photoshop Document	*.psd	Yes layer-enabled	Yes layer-enabled
PS—PostScript	*.ps	Yes	Yes

SGI—Silicon Graphics IRIS	*.sgi, *.rgb, * bw, *.icon	Yes	Yes
Sunras—Sun Rasterfile	*.im1, *.im8, *.im24, *.im32	Yes	Yes
SVG—Scalable Vector Graphics	*.svg	Yes	No
TGA—Targa Bitmap	*.tga	Yes	Yes
TIFF—Tagged Image File Format	*.tif, *.tiff	Yes	Yes
XBM—X Bitmap	*.xbm, *.icon, *.bitmap	Yes	Yes
XPM—X Pixmap	*.xpm	Yes	Yes
XWD—X Window Dump	*.xwd	Yes	Yes
Zsoft PCX image	*.pcx, *.pcc	Yes	Yes

In addition, the GIMP Version 2.2.12 supports the following **RAW camera formats** (RawPhoto): bay, bmq, cr2, crw, cs1, dc2, dcr, dng, erf, fff, hdr, jpg, k25, kdc, mdc, mrw, mos, nef, orf, pef, pxn, raf, raw, rdc, sr2, srf, sti, tif, ufraw, x3f.

Index

Uwe Steinmueller · Juergen Gulbins

Fine Art Printing
for Photographers

Exhibition Quality Prints with Inkjet Printers

Uwe Steinmueller · Juergen Gulbins
Fine Art Printing for Photographers
Exhibition Quality Prints with Inkjet Printers

Today's digital cameras produce image data files making large-format output possible at high resolution. As printing technology moves forward at an equally fast pace, the new inkjet printers are now capable of printing with great precision at a very fine resolution, providing an amazing tonal range and significantly superior image permanence. Moreover, these printers are now affordable to the serious photographer. In the hands of knowledgeable and experienced photographers, they can help create prints comparable to the highest quality darkroom prints on photographic paper.

This book provides the necessary foundation for fine art printing: the understanding of color management, profiling, paper, and inks. It demonstrates how to set up the printing workflow as it guides the reader step-by-step through the process of converting an image file to an outstanding fine art print.

October 2006, 246 pages
ISBN 1-933952-00-8, $44.95

Rocky Nook, Inc.
26 West Mission St Ste 3
Santa Barbara, CA 93101-2432

Phone 1-805-687-8727
Toll-free 1-866-687-1118
Fax 1-805-687-2204

E-mail contact@rockynook.com
www.rockynook.com

> "You don't take a photograph, you make it."
>
> ANSEL ADAMS

Alain Briot
Mastering Landscape Photography
The Luminous Landscape Essays'

Mastering Landscape Photography consists of thirteen essays on landscape photography by master photographer Alain Briot. Topics include practical, technical, and aesthetic aspects of photography to help photographers build and refine their skills. This book starts with the technical aspects of photography; how to see, compose, find the right light, and select the best lens for a specific shot. It continues by focusing on the artistic aspects of photography with chapters on how to select your best work, how to create a portfolio, and finally concludes with two chapters on how to be an artist in business. Alain Briot is one of today's leading contemporary landscape photographers. He received his education in France and currently works mostly in the southwestern part of the United States. Alain Briot is a columnist on the highly respected Luminous Landscape website.

November 2006, 256 pages
ISBN 1-933952-06-7, Price: $39.95

Rocky Nook, Inc.
26 West Mission St Ste 3
Santa Barbara, CA 93101-2432

Phone 1-805-687-8727
Toll-free 1-866-687-1118
Fax 1-805-687-2204

E-mail contact@rockynook.com
www.rockynook.com

rockynook

Sascha Steinhoff

Scanning
Negatives and Slides

Digitizing Your Photographic Archives

"I have discovere
photography.
Now I can kill my
I have nothing
else to learn."

PABLO PICASSO

...cha Steinhoff
...nning Negatives and Slides
...tizing Your Photographic Archives

...y photographers have either
...ed into digital photography
...usively or use both analog
... digital media in their work. In
...er case, there is sure to be an
...ive of slides and negatives that
...not be directly integrated into
...new digital workflow, nor can
... archived in a digital format.
...easingly, photographers are
...ng to bridge this gap with the
... of high-performance film scan-
...s. The subject of this book is
...to achieve the best possible
...tal image from a negative or a
..., and how to build a workflow

to make this process efficient, re-
peatable, and reliable. The author
uses Nikon film scanners, but all
steps can easily be accomplished
while using a different scanner.
The most common software tools
for scanning (SilverFast, VueScan,
NikonScan) are not only covered
extensively in the book, but are
also provided on a CD, which also
contains other useful tools for im-
age editing, as well as numerous
sample scans.

Dec 2006, approx. 300 pages, Includes CD
ISBN 1-933952-01-6, $44.95

Rocky Nook, Inc.
26 West Mission St Ste 3
Santa Barbara, CA 93101-243.

Phone 1-805-687-8727
Toll-free 1-866-687-1118
Fax 1-805-687-2204

E-mail contact@rockynook.co
www.rockynook.com